GARY WEST is a senior lecturer in Scottish
Edinburgh. He is also an active traditional musi
a weekly programme, *Pipeline*, on BBC Radio Scotland. Originally from
Pitlochry in Perthshire, he played for many years with the innovative Vale
of Atholl Pipe Band, winning the Scottish and European Championships. In
his late teens he moved sideways into the folk scene, playing, recording and
touring with the bands Ceolbeg and Clan Alba, and becoming a founder
member of the ceilidh band Hugh MacDiarmid's Haircut. He has performed
on around 20 albums, including his debut solo release, *The Islay Ball*, and
his most recent collaboration, *Hinterland*s, with harpist Wendy Stewart.

Voicing Scotland
Folk, Culture, Nation

GARY WEST

Luath Press Limited

EDINBURGH

www.luath.co.uk

First published 2012
Reprinted 2013

ISBN: 978 1 908373 28 1

The publisher acknowledges the support of

ALBA | CHRUTHACHAIL

towards the publication of this volume.

The paper used in this book is used in this book is recyclable. It is made from low chlorine pulps produced in a low energy, low emissions manner from renewable forests.

Printed in the UK by Bell & Bain Ltd., Glasgow

Typeset in 11 point Sabon

For Mum and Dad

Contents

Acknowledgements

I am very grateful to all those artists or their families who have given permission to quote from their work: Dick Gaughan, Patsy Seddon (for her late husband, Davy Steele), Adam McNaughtan, Rod Paterson, Michael Marra, Nancy Nicolson and Kirsten Bennett (for Martyn Bennett), and to the Gordon Duncan Memorial Trust. Thanks also to the European Ethnological Research Centre at the University of Edinburgh for permission to quote from work I have previously published in their series, *Scottish Life and Society: A Compendium of Scottish Ethnology*, to Neill Reay, editor of the magazine *Scottish Life*, to Ian Green of Greentrax Recordings, to BBC Scotland, to Shannon Tofts Photography, to Agnes Rennie at Acair Books, and to Nathan Salsburg of the Alan Lomax Collection, American Folklife Center, Library of Congress. Thanks also go to all of my colleagues and students in Celtic and Scottish Studies at the University of Edinburgh for debates and discussions over the years which have inevitably informed my thoughts, and in particular for help with oral and photographic archive material to Cathlin MacAulay, Caroline Milligan, Stuart Robinson and Colin Gateley, and to the department's late photographer, Ian MacKenzie, sadly missed. I'm grateful too, to Iain MacInnes, my producer on the BBC Radio Scotland programme *Pipeline*, whose knowledge I draw on weekly, and which I'm sure has found its way into these pages in many ways. I would also like to thank Wendy, Charlie and Eilidh for their patience and help at home, and all at Luath Press, especially Gavin MacDougall and my editor, Jennie Renton, whose keen eye, wide knowledge and (mostly!) gentle prodding has helped turn my notes and thoughts into an actual book. Finally, I offer my sincere gratitude to all those writers, singers, poets, musicians and 'ordinary folk' whose voices form the foundation of this book, many of whom I have had the pleasure of knowing and working with personally over the years. I offer this small tribute back to them in return.

Gary West
Edinburgh, July 2012

Introduction

WE LIVE, WE ARE told, in a 'post-traditional' world. This is the world of globalisation, of instant communication, of a sprint down the fast lane towards 'progress'. It is a world where community is often virtual, our interaction electronic, where more and more of us blog and tweet our way through our days. Ours is a liquid society, where nothing stays still long enough to solidify into anything of substance, where roots are tethers and cultural baggage a debilitating burden. To successfully negotiate this world, to 'get on', we must be fleet of foot, ready to divert elsewhere at a moment's notice; crucially, we must be mobile. Our skills must be varied, flexible and transferable rather than creatively crafted and carefully honed, and to manage anything at all we must show that we can 'drive through change'.

This is a picture of our modern world painted for us by many commentators, the sociologist Zygmunt Bauman chief amongst them. Bauman has set up quite an industry for himself in the production of a plethora of books explaining the concept of 'liquid modernity', arguing that recent decades have witnessed a fundamental shift in how we operate and organise ourselves in western society.[1] Globalisation means that 'traditional' ways of thinking and acting lack the reach required, and conventional politics, the way we control and influence where we want to go, is a toothless endeavour. He is not, I should stress, advocating all this, simply asserting that we already have it.

Is this the kind of world we actually now live in? Is Bauman right? We will all no doubt have differing views, but I suspect most of us recognise at least some truth in this picture. When did you last read a professional job description that did not ask for evidence of success in managing change? What was the most recent 'crash' of the world's finances if not the catastrophic pile-up of an overcrowded fast lane? Perhaps the sight of the wreckage will slow us down a little. Perhaps.

This view of modernity is sometimes termed 'negative globalisation', and we can add to it the fear that the fast lane of progress is leading inexorably towards a universal sameness. Even if this is confined to

'the west' it predicts an homogenisation of cultural values and forms which will see us all eat the same food, listen to the same music, watch the same films, read the same books, while wearing the same clothes. A more encouraging picture might be painted, however, if we see globalisation as having a much more positive side to it. This philosophy might see mass and instant communication not as a threat, not as a vehicle for the inevitable homogenisation of the world's cultures, but rather as a wonderful means to recognise, display, share, understand and celebrate cultural difference. In such a vision, 'tradition' remains entirely relevant – indeed, crucial – to the modern world. For it is partly within tradition that cultural difference is stored, that the vast richness of human creativity is represented and that place, locality and belonging are given meaning. It is this realisation that has led to UNESCO's preoccupation with heritage, and in particular, with what it now terms ICH – 'intangible cultural heritage'. There is a fascinating story behind this – it involves hammers, nails, sparrows and snails – which I shall come back to a little later, but in short this is about recognising and celebrating the non-material cultural traditions to be found throughout the world. Rather than revering only buildings, artefacts, landscapes and monuments, this is about song, music, storytelling – it is about voicing the community, the region, the nation. In Scotland we now tend to call these 'the traditional arts', and it is from amongst these arts that the themes of this book are drawn.

What is their role in the modern world? What have they got to say to us about the big themes which we must wrestle with in the 21st century? What do these voicings tell us about humanity, inhumanity, morality, conflict, place, identity, belonging, environment? Do these arts belong in the present, or should they be consigned to the past? How might they shape the future? I raise these questions within the spirit of what I'd like to call 'positive globalisation', which has at its root a basic philosophy of understanding something like this: start with the local, build towards the national, and aim, from there, for the global.

Tradition is not the antithesis of change. As I hope to show, change is a crucial ingredient within the process of tradition itself: it does move and develop and reshape itself to fit into each new manifestation of the present. If it does not, it tends to disappear. A favoured metaphor for such progress here in Scotland is Hamish Henderson's idea of a carrying stream – the stream of tradition flows through time, picking

up new flotsam as it goes, leaving some things on its banks in the process. At any given point, then, its content and form may be a little bit different to other places further up or down stream, yet it remains recognisable as the same tradition. As a conceptualisation this is not without its limitations, but the key thing is that it reminds us that tradition flows, that it, too, is liquid. It is not static, it is not a pond, which is perhaps a better metaphor for 'convention', where things do tend to remain unchanged. A convention is encoded in strict rules which are unthinkingly adhered to because 'it has always been this way'. A convention is a dead tradition.

Yet change within tradition tends not to be revolutionary or even rapid, but incremental, considered, evolutionary. That is not to say that radical new ideas or approaches do not appear within a tradition on occasions. They do, but time tends to be the judge, the barometer of acceptability, the arbiter of taste. Roots are important, as is an appreciation of where things have come from, where we stand within the stream, and how to use that knowledge to create fresh and meaningful art going forward. Tradition, then, can be of great use in a liquid modern world, a questioning, solidifying force, and a reminder that society cannot spend its entire time in the fast lane. Yet it can still help us to move forward, to move positively, and to embrace the future with the confidence that comes from knowing where we've been.

You will have guessed by now that I generally think well of tradition, that I view it as a largely positive part of our cultural landscape, or cultural ecology, to use a phrase which is coming into common currency here in Scotland. But there is a caveat to that, for we must recognise that tradition can sometimes be used as a negative force, as an excuse for not changing, even when change is clearly needed. We can sometimes hide behind tradition, use it to persecute, to fuel intolerance, to justify the unjustifiable. UNESCO, to its credit, is wise to this, and has built a defence into its ICH charter to ensure any application for official recognition based on such unethical use of the concept is rejected. It doesn't mean it doesn't still happen, of course, but it is a start, and we will do well to follow their lead in at least keeping an eye out for it.

I'll turn now to the geographical focus of this book. What of Scotland? What might our place be within the spirit of a philosophy of positive globalisation? We live in interesting times, for constitutional debate and change has led to the conceptualisation of the beginning of

the 21st century as bringing a 'new' Scotland into being. You may well be reading this with the referendum already in the past, you may be in an independent Scotland, or in an 'enhanced devolution' Scotland. In either case, the 'new' label will probably be justified. Or you may indeed be in a Scotland which is constitutionally identical to the one in which I am writing this sentence, in 2012. Indeed, you may not be in Scotland at all, but simply looking in from afar, or from next door, and wondering what all the fuss is about.

But even now, pre-referendum, plenty has happened over the last dozen or so years to give credence to the idea that many aspects of 'the old' Scotland have been replaced with something fresh or revived, and in some cases at least, entirely new. Some of these changes relate to the political process, the creation of the Scottish Parliament at Holyrood being the obvious example, while many involve the cultural fabric of the nation. The National Museum of Scotland on Edinburgh's Chambers Street, a long long time in coming, is now a teenager, and proudly displays 'Scotland to the world', adding to the grand building next door which for a century and a half has been displaying 'the world to Scotland'. It, too, has had not so much a face-lift as a complete reworking, and reopened its doors to a chorus of a million approving voices in 2011. Likewise, the National Portrait Gallery on Queen Street in the capital has received a complete overhaul, revitalising a space which was beginning to feel daunting in its darkened deference to the faces of the great and good of the nation displayed on its walls. In Glasgow we now have the excellent Riverside Museum to add to the city's already extensive cultural landscape, a magnificent new concert hall graces the centre of Perth, and the architects Page and Park have created a marvellous new set of spaces with their complete refurbishment of the Eden Court Theatre in Inverness. As I write, the brand new Mareel Centre in Lerwick is about to open and we are soon to welcome a radical new-build on the Tay with the arrival of the V&A at Dundee. There are many more examples of new capital investment in Scotland's cultural sector and the message we can take from this is that Scotland has been gearing herself up well to ensure her cultural infrastructure is fit to face the challenges ahead.

As well as buildings, the organisational framework for the support of the arts within Scotland has also been reshaped, with the founding, after a somewhat protracted gestation, of Creative Scotland, in 2010.

Bringing together the former Scottish Arts Council and Scottish Screen, the seeds of the idea of a new body can be traced back through various Scottish governments or executives. The key stepping stones were the Cultural Commission, chaired by James Boyle and established in 2004, and the National Cultural Strategy which preceded it. Clearly, 'culture' has been very much on the mind of our Scottish parliamentarians from the outset.

Not all of us will agree about how this commitment to culture should be handled, and whether what has emerged from this process of reflection and consultation is as good as it could possibly be, but what is not in doubt, surely, is that there is a burgeoning degree of cultural confidence in Scotland these days. We seem to have got past the tired old struggles and squabbles between traditional sparring partners – 'high' art versus 'popular', east versus west, urban versus rural – and are moving forward with a new-found vigour. We have international recognition for the quality of our creativity, with Edinburgh as a UNESCO City of Literature and Glasgow being awarded the equivalent accolade as a City of Music. The National Theatre of Scotland, founded in 2006, has produced some excellent work, again internationally acclaimed, as indeed have the other nationally supported companies in the fields of dance and classical music. Cultural festivals take place virtually all year round now in Scotland, with over 350 annual offerings at the latest count, while across the length and breadth of the country individual artists, venues, teachers, promoters, and all manner of organisations combine to make Scotland a culturally rich and diverse nation.

We are aiming high. Creative Scotland's ten-year vision includes an ambition for us to be recognised as one of the world's leading cultural nations and one of the world's top ten places to visit for culture, to have the highest levels of participation in the arts within the UK, and to be an international leader for the arts among children and young people.[2] While such things are of course difficult to measure, they are nonetheless achievable aims, and the plan which supports this vision is aimed at investing in Scotland's culture in a way which gives ourselves every chance of reaching these heights. 'Investing' does not just mean giving out cash to venues and artists, but goes much wider into the whole infrastructure, providing support and advocacy for audience development, education, international links, cross-sector initiatives and all of the other needs of a healthy cultural community.

I realise I am painting a very positive picture of Scotland's cultural ecology here, and I know that not everyone will agree with me. Of course there are less rosy stories to be told too, with some organisations falling by the wayside, others struggling just to make ends meet and keep their doors open, and artists who give up as they just cannot get the start or the break they need. Yet, looking at the bigger picture, I remain convinced that there is much to be positive about.

And so what of the traditional arts? Where do they fit into this? In many ways, the story follows a similar plot, for there is much to celebrate. We have come a long way over the last generation, with traditional music, song, storytelling and dance now much further up the national cultural agenda than has ever been the case before, and they are seen to have a crucial part to play in helping to bring a unique stamp to the nation's creativity. Having commissioned a detailed report into the traditional arts sector, published in 2010,[3] the Scottish Government's formal response confirms its strong commitment to these art forms, and outlines its views on the need for ongoing development and support. As the Cabinet Secretary for Culture and External Affairs, Fiona Hyslop, commented:

> the traditional arts make a significant contribution to the cultural heritage of Scotland not just as a legacy, but because they actively provide a way of taking forward that heritage, shaping the culture of our future generations and ensuring their contribution to wider public life.[4]

How are we doing that? What are the roots of these arts? What is the story of 'tradition' in Scotland? How has it been voiced? These are some of the issues I would like to pick up as we move through this book.

I begin with an overview of what tradition actually is, or rather with what various people and institutions and movements consider it to be, for in actual fact there is no universal agreement on this. In Scotland we have been trying to make sense of tradition for rather a long time, mainly through 'collecting' it, and in many respects we have been international leaders in this. I notice that Brenda Chapman, one of the writers of the Disney-Pixar animation *Brave*, has mentioned that she considers the film to be a fairy tale in the tradition of the Brothers Grimm, but there is little need to look to Germany for such inspiration given the strength of the oral narrative tradition here in Scotland. The

Grimms themselves looked to Scotland for their own guidance, and in particular to a schoolmaster from Badenoch who enjoyed his own equivalent of a Hollywood blockbuster in the mid-18th century, taking his own native oral tales of ancient Celtic heroes and weaving them into the seamless garment which brought him international fame and not a little controversy. Chapter One picks up this story and others, and sketches out a framework of how we have come to perceive, view and explore cultural tradition down to the present day.

All of this was part of the long pre-history of the 20th century folk revival in Scotland, and one of the outcomes of that was the links it forged between the culture of our local communities and the creative output of the 'professional' artists. In many respects, the revival wasn't actually 'reviving' very much at all, it was simply reminding us of what had slipped our minds, but which still existed in the mouths and homes of us all. That great bothy ballad singer from the north-east, Jock Duncan, complained to me recently that there is no need to call it a revival. It never went away. But it did disappear from our national view, and so in Chapter Two I take a quick peek into the homes of a few generations of the people of Scotland to see and hear just what did happen by way of 'tradition' before it left the kitchen and made for the stage and the archives.

Thereafter, I move in to explore the creativity of those whose work, rightly or wrongly, has usually been 'filed under folk'. We lend our ears to those who have added their own stones to the cairn of tradition, who have seen themselves as belonging to it, who are part of the continuum of the carrying stream, but who take on the responsibility of shaping its future. These are the songwriters, the singers, the composers, the dramatists and the performers who voice the tradition in their own terms. What do they have to say to us? How are they speaking to the world? What are their themes, their preoccupations, their philosophies? What is their value to us here in the 21st century? How, if at all, are they moving us along the road towards a positive form of globalisation? Are they bringing a sense of solidity to this liquid society? Chapters on 'Voicing Place', 'Voicing War' and 'Lands and Lyrics' are my attempts to explore some of these questions and to contemplate how they are 'voicing' Scotland.

In Chapter Six, by way of conclusion, I explore the wider cultural contexts of tradition within Scotland. In many respects, this has been

a story of both survival and revival, for the course of tradition seldom runs smooth, but rather tends to ebb and flow, wither and thrive as society develops and changes through time. We have been a rather self-examining nation at times, asking ourselves what our culture really is, whether it is healthy, to what extent it needs re-shaped or even whether it should be ripped apart and thrown away, clearing the path for a fresh start. That, indeed, was the radical suggestion put forward by some in the 1980s, and before that, in the 1930s, periods that gave rise to complaints about the dominance of 'Balmorality' and 'Tartanry' and the reliance on a hackneyed set of romanticised representations. Folk culture played a complex role in this, as for some it was part of the problem, while others saw it as having the potential to contribute to the solution. Revivalism was a key ingredient, as Scotland fed off what was happening in the folk movement across the Atlantic where the likes of Woody Guthrie, Leadbelly, Pete Seeger and Bob Dylan were forging a new and politically charged approach to popular music-making. Our own version of the revival took root, but in different cultural soils, producing different kinds of crops.

I should take a moment to explain where I myself am coming from – this is my pre-emptive strike on potential accusations that my journey through this theme is very partial, and that there is much more which has been left out than put in! I am certainly not making any claims for comprehensiveness here, or putting this book forward as a detailed study of the traditional arts in Scotland today. I say next to nothing about those traditional art forms which I have not been directly involved with myself, especially the area of dance, and as it has been dealt with very well elsewhere I say little about formal storytelling either.[5] Rather, I have been guided by my personal experience as a musician, band member and teacher, and most of the artists and creators I write about here are people I have known personally and have worked with over the years. In that respect, this is a very personal journey, almost autobiographical in places, and is more of an account of those who have inspired me than an objective work of academic rigour. Having said that, highly reflexive works of 'auto-ethnography' are all the rage within academic circles these days, so I do hope that I have something useful to say here to formal students of culture as well. But I have tried to throw off the fancy gowns of my day job as a university scholar, keeping footnotes to a minimum and ridding myself of the self-congratulatory jargon that

seems to be increasingly demanded in the academy.

It may be helpful to briefly sketch out my own journey through folk culture, if only to justify my credentials for writing on this topic. Born in Aberfeldy and brought up in Pitlochry, Highland Perthshire was my stomping ground until my late teens, although with a maternal grandmother from the north coast of Sutherland I've always had a fascination for the ways of the Gaels too. Hours spent listening in on family chats in both counties seemed to spark an interest in 'the old days' centred around Lowland farming and Highland crofting, and although I had never heard the phrase, oral tradition was all around me when I was growing up.

From around the age of three or four I was apparently fascinated with the sound and sight of the local pipe band, the Vale of Atholl. At that time it was mainly a parade band and didn't compete, but the pipe major, Alan Cameron, retired and a young local lad, Ian Duncan, took over. Ian is the eldest son of the above mentioned Jock Duncan, one of the finest traditional bothy ballad singers of the north-east, whose work had taken him to the Hydro schemes of Perthshire some years before. Ian knew that if the band was to survive then it needed new blood coming through, and so Alan agreed to become the teacher to the next generation. I jumped at the chance to get involved, and began learning the chanter at the age of six along with several others, including Ian's younger brother, Gordon Duncan, who went on to become one of the finest traditional musicians this nation has ever produced.

We all worked hard at our piping and drumming, viewing it very much as a serious musical commitment and not just a spectacle to serve the tourist industry, and success came fairly quickly as we moved up through the grading system, taking our place as one of the world's top five pipe bands within seven or eight years. The pipe band system is actually one of Scotland's great musical training grounds, run entirely on a voluntary basis, and encouraging thousands of young people across the country and well beyond to develop advanced musical knowledge and skills. Its highly international following and participation makes it a very fine contributor to 'positive globalisation', and I have seen a lot of places in the world I would never have had the chance to visit if it wasn't for piping. The band was also my introduction to folk music, for LPs and cassette tapes of the likes of Silly Wizard, The Tannahill Weavers, The Bothy Band and Planxty were passed around and played

on the bus trips wherever we went.

It was perhaps inevitable, then, that on taking up a place at the University of Edinburgh in 1984 I should be drawn to the School of Scottish Studies. I vaguely knew of it as a place which collected and taught about folk culture, although I had little idea what that actually meant in academic terms, but discovered that they had just begun to offer a degree in 'Scottish Ethnology' and so decided that this was the course for me. Most of the great scholars who have been associated with the department were still there, and I found myself listening with fascination to the likes of Hamish Henderson, Alan Bruford, Donald-Archie MacDonald, John MacInnes, Ian Fraser, John MacQueen, Peter Cooke, Margaret Bennett, Margaret MacKay and Morag MacLeod, all hugely knowledgeable and inspiring in their sheer zest for their subject. Together they taught me what culture and tradition is all about, how to capture it on tape, how to nurture the relationships that allow us to do that, and how to make the links between its constituent parts. I realised for the first time, for instance, that piping was not an art which was set apart, but that it linked in so many ways to other branches of the traditional tree. I learned, too, that there is nothing parochial or small-minded in studying one's own culture, for these were all people who looked outwards, linking with the traditional arts of other peoples and nations, seeking out common links, searching for a mutual understanding. I was hooked, and so stayed on after graduation to secure my PhD, and was then lucky enough to be appointed to the staff in 1994.

It was in those undergraduate years that my piping took me on a different path, away from the pipe band movement towards the folk scene. Playing in sessions around the city, I got to know many musicians who were very welcoming and it was wonderful to hear the kinds of songs and tunes I'd been listening to for years ringing out round a table in Sandy Bells, the Green Tree and the Tron Bar. Peter Boond and Davy Steele of Ceolbeg were regulars, and invited me to join the band when my pal Gordon Duncan, who had been with them for three years, left to join the Tannahill Weavers. I already had some experience in that line, as in 1986 some mates and I started a ceilidh band, we all admired Scotland's greatest modernist poet, but were particularly taken with his quaffed 'Barnet'. I'm happy to say that 25 years and a thousand dances later, Hugh MacDiarmid's Haircut is still going strong!

These Ceolbeg days were my main grounding in the performance of tradition, the manifestation of the theories and ideas I was being exposed to within its academic study. There is much work involved in the translation of folk culture from the page to the ears and I came to enjoy the challenges of that process greatly. I still do. Touring widely overseas was a real education too, especially playing at festivals where we got to meet fellow musicians from many parts of the world, sharing songs and tunes and discovering the connections between our respective traditions as well as the idiosyncrasies of each. At that time I also enjoyed a couple of years with a newly founded eight piece band, Clan Alba, working with some of the best traditional musicians in the land who I had listened to as a boy, Dick Gaughan chief amongst them. Making the decision to leave in order to pursue my academic career was very hard indeed, but since then I've been lucky to get the chance to work with a wider range of fine musicians on a number of projects, particularly with the harp player, Wendy Stewart, and immersing myself too in the bellows pipes revival which has been ongoing since the 1980s. And since 2002, presenting the weekly BBC Radio Scotland programme *Pipeline*, has provided another luxury in getting the chance to delve deeply back into my Highland piping roots.

The thoughts which lie behind this book have emerged from the meshing of all of these experiences. It is about the activity of voicing cultural tradition, and so it is about sound more than vision, ears more than eyes. Therein lies a central problem, of course, for how can we capture that on the page? When the singer and songmaker Nancy Nicolson sent me the lyrics of some of her songs while I was gathering material for this project, she reminded me that 'words are only half a song: there is a vast range of mood contained in these and it needs the tune to set that'. Nancy is absolutely right, of course, and it is for that reason that wherever possible I'll point you towards the places that you can hear the voicings for yourself.

It will not have escaped your notice that my tone tends towards the celebratory. Yes, I do believe our cultural tradition in Scotland deserves to be celebrated. That is not to say that there isn't stuff out there that should probably be left on the banks of this carrying stream, and so that is exactly what I have done with it! But there is plenty that flows on, confidently, proudly and productively. Let's head off there now and explore.

CHAPTER I

Understanding Tradition

Accept, to begin, that tradition is the creation
of the future out of the past.[1]

AS THE AMERICAN FOLKLORIST Dorothy Noyes points out, there is 'a tradition of talking about tradition'.[2] Scholars in various fields which deal with the relationship between the past and the present are fascinated with this rather slippery idea, this label for things that seem to flow through time but which we cannot quite define.

Most of us understand that tradition began somewhere in the past, that it covers a fairly wide range of cultural forms, and we tend to think we recognise it when we meet it. Perhaps its origins are unknown, 'lost in the mists of time', as we might say. Perhaps some of it is very old indeed, although we realise everything must start somewhere, and that 'new' traditions must therefore be possible. Indeed, since the phrase 'the invention of tradition' became common from the early 1980s, following publication of a hard-hitting book of that name,[3] we might actually be rather suspicious of tradition, questioning its 'authenticity' and wondering whether the whole thing is just a modern creation masquerading as something much older.

Some of us might view tradition in a positive light, considering it to be part of our 'heritage' and 'identity', and therefore a welcome companion as we move through our lives. Others may see it as old-fashioned, irrelevant and a hindrance to our attempts to develop and grow as individuals and as a society, being quite happy to see it disappear altogether. And some of us may well be torn between the two. The author Neil Gunn was one such:

> At the mere mention of the word 'tradition' some of us grow impatient, feeling that we have had too much of the stuff, that the world at the moment is all too literally and painfully sick of its effects, and that until we sweep its encumbering mess into limbo we shall have no new brave

world.... There is something invigorating and hopeful in a clean sweep and a fresh start.[4]

'The world at the moment' is the phrase which gives us a clue as to the source of his feelings, for he was writing these words in 1940, in a war-torn world where people were sick of many things, and in which tradition and ideas about the purity of 'folk' culture were being used as a destructive and evil force. Within a paragraph or two, however, Gunn moves to a more positive view of the kind we might expect from the man who gave us *The Silver Darlings* and *Highland River*, both novels dripping with tradition:

> Fortunately, the study of tradition is not an unrelieved study of evil. On the contrary, it is largely the study of our greatest good. Only inside his own tradition can a man realise his greatest potentiality; just as, quite literally, he can find words for his profoundest emotion only in his own native speech or language. Tradition would thus, on all counts, appear to be a very important thing indeed...

Tradition, then, can be a cause for good and for bad. It can also mean different things to different people at different times, and it is very easy to get bogged down in its myriad meanings. A close look at all its uses and interpretations can easily leave us even more confused than ever, but fortunately some scholars have done an excellent job in pulling all the sources together for us already.

In an impressively wide yet succinct survey of the varying meanings people have bestowed upon tradition, spanning centuries and many cultures, Dorothy Noyes distils it down to three broad concepts. First of all, tradition can be seen as a form of communication, whereby ideas, information, philosophies and creativity are transmitted through time and diffused through space, linking generations and peoples. It is a manifestation of the way its holders think and feel and believe, and is a window upon their philosophy of life or their preferred way of being. Embedded into it are all manner of clues as to their thoughts on such things as morality, humanity, relationships, family – the whole spectrum of life's concerns. It has to be organised, however, and so tends to be codified into certain recognised forms as opposed to a random selection of bits and pieces. This gives us stories, songs, customs, beliefs, rites, ways of acting and ways of doing.

The means through which such tradition is communicated can be adapted to the society it finds itself in at any given time: for most of

our human history it has been orally transmitted – voiced – but when literacy comes to the masses it finds its way onto the page too. We can now add the screen to this list, for in this concept of tradition it can happily coexist with modernity. There has probably never been as much tradition circulating, therefore, as there is in the digital and internet age, as this understanding of tradition is not set up in opposition to modern society, but remains part of it.

The second conceptualisation of tradition is as 'temporal ideology' in which it does become the opposite of modernity. This view suggests that tradition inevitably erodes through time, and that it is indeed inconsistent with technological advancement. Because it erodes and is therefore doomed to disappear, it must be rescued, preserved and understood, and the further back in time we look, the 'purer' and more 'authentic' is its form.

For some, it must be preserved in an active way, kept alive through use and celebration: stories must be told, songs sung, customs acted out. For others – in the 19th century they were generally labelled evolutionists – tradition had to be collected and documented but in practice allowed to die. For them it was an interesting barometer of human development, a layer in the cultural archaeology of mankind, rather than a valuable commodity in its own right, and as long as we noted it and took samples, that was all that mattered. Both views encompass 'temporal ideology', then, but in practice, these ideologies are clearly very different.

The final category of attitudes Noyes calls 'tradition as commodity'. In this one, tradition belongs to someone, be it a group, region or nation. When we say that tradition is 'part of our heritage' then we are recognising it as something that belongs to us. The problems begin, of course, when deciding who is included in 'us', and who is not. It can be used, therefore, to define membership of groups in both an inclusive and exclusive way, and so it is in this form that tradition is most likely to become politicised. And as a commodity it can also be bought and sold, packaged in particular ways, and used as an economic good just like any other, for example in the industry we call heritage. Or, indeed, it can be quietly adhered to, gently celebrated, and benignly cherished.

When we dig below the surface, then, tradition becomes a rather complex issue, although it is important to realise that Noyes' three categories are not mutually exclusive. Any given tradition does not necessarily exist in only one of these, but may well span all three. The

model is to do with degrees of emphasis rather than creating rigid boundaries, and relates as much to how people study, perceive and use tradition as it does to the nature of tradition itself.

Nonetheless, the model is a very useful one and there are plenty of examples from Scotland which fit very well into it, happily placing themselves under one, two or all three of Noyes' headings.

Intangible Cultural Heritage

As I mentioned in the Introduction, one of the key concepts surrounding 'tradition' which has emerged within the international agenda in recent years appears to span all three categories, although its roots lie in a frame of mind which sits most squarely in the third. This is the idea of 'Intangible Cultural Heritage', or ICH. The 'intangible' qualification is a rather strange choice of descriptor, given that the kind of heritage it relates to is real enough; the criteria were originally devised by UNESCO in a way which would differentiate it from that organisation's long accepted conceptualisation of heritage, referring exclusively to physical things. These might have belonged to the category of 'natural heritage' – landscape, flora and fauna – or to 'cultural heritage' – things which humans built, such as standing stones, monuments, buildings and artefacts. This was encapsulated in the World Heritage Convention, formalised in 1972, which encouraged all those participating nations to ensure the proper protection of their cultural and natural heritage, and invited them to nominate the best examples of their own for inclusion on the world heritage list.

In Scotland we have embraced this invitation enthusiastically, leading to world heritage status for five sites: Edinburgh Old and New Towns, the Heart of Neolithic Orkney, New Lanark and the Antonine Wall, with St Kilda taking pride of place in that it is one of very few places in the world to have double status, being recognised both for its cultural and natural value. Other sites which have been considered for future nomination include the Forth Rail Bridge, the Iron Age remains of Shetland, and the Caithness and Sutherland Flow Country. There are currently 936 sites listed across the world, most of them (725) given recognition under the 'cultural' banner, 183 as 'natural' heritage and 28 with dual status.[5] That does make St Kilda a very special place indeed.

Having world recognition like this is a major boon for a nation's cultural confidence and in many cases, Scotland included, for the positive impact it brings to tourism. However, some nations, or indeed peoples within and across nations, felt from the outset that the exclusive consideration given to physical sites within the world heritage framework was unfair, and that it only told part of the story of what heritage really is: the cultural inheritance which is passed on through each generation, and while this can certainly be physical, often it flows in other ways, shaped by mouths and ears rather than by hands. Thus, it is 'intangible' – spoken, sung, heard, acted – rather than physically built.

Some nations complained and the result was the foundation in 2003 of the Convention for the Safeguarding of Intangible Cultural Heritage, providing a framework for official international recognition of 'tradition':

> The 'intangible cultural heritage' means the practices, representations, expressions, knowledge, skills – as well as the instruments, objects, artefacts and cultural spaces associated therewith – that communities, groups and, in some cases, individuals recognise as part of their cultural heritage. This intangible cultural heritage, transmitted from generation to generation, is constantly recreated by communities and groups in response to their environment, their interaction with nature and their history, and provides them with a sense of identity and continuity, thus promoting respect for cultural diversity and human creativity. For the purposes of this Convention, consideration will be given solely to such intangible cultural heritage as is compatible with existing international human rights instruments, as well as with the requirements of mutual respect among communities, groups and individuals, and of sustainable development.[6]

To help us get our heads around what that all means, we are given some examples: oral traditions and expressions, including language as a vehicle of the intangible cultural heritage; performing arts; social practices, rituals and festive events; knowledge and practices concerning nature and the universe; traditional craftsmanship.

At present, 142 states have signed up to this convention, and 267 specific forms of ICH have made it onto the official list, around 10 per cent of which are considered to be in need of urgent safeguarding.[7] It would be useful at this stage to provide some examples of what forms of ICH from Scotland have been considered worthy of such recognition,

but we can't. The UK has not signed up to this treaty, considering it a low priority, and so our official contribution to the world's heritage must remain firmly tangible, for the time being at least. The Scottish Government is keen, certainly, but as we do not have nation state status within the eyes of UNESCO, its hands are tied. ICH is, therefore, in part a political issue, although not one which excites a great deal of public concern, understandably, given the more immediate problems we are faced with at present.

That said, we certainly don't have a monopoly on the politicisation of ICH, for the concept has had a strong political flavour from the very start. It is a story closely bound up with issues of cultural domination, imperialism, power imbalances and all the usual ingredients of international relations and diplomacy. However, there is a very specific incident which is often said to have been the catalyst which brought the whole ICH agenda to the fore, and it happened just around the same time that the tangible version of the World Heritage Convention was being set up in the early 1970s.

I promised a story about hammers, nails, sparrows and snails. If you know your Simon and Garfunkel lyrics, you'll already have made the connection to 'El Condor Pasa', featured on their *Bridge Over Troubled Waters* album of 1970, a massive hit in dozens of countries, with sales of over 25 million worldwide, making it one of the biggest selling albums of all time. The track is given a South American feel on the album by the Peruvian band, Los Incas, 'El Condor Pasa' having started life as an Andean traditional folk melody. Picked up, arranged and given lyrics by the Peruvian singer and scholar Daniel Robles in 1913, Simon and Garfunkel heard it being performed by Los Incas in Paris, and Paul Simon then composed his own English words.

This kind of evolution of a song is not all that unusual, especially for a duo who can be seen as belonging essentially to the American folk revival, but the album's unprecedented success, and the huge amount of money it generated, raised valid questions within the nations of the Andes. None of the profits were finding their way back there, and from the South American perspective, this seemed like a blatant appropriation of indigenous culture for corporate and personal foreign gain. Protests came in various forms, but one of the most hard-hitting, yet constructive, came in a letter from the Bolivian Minister of Foreign Affairs and Religion to the Director General of UNESCO in 1973.

Having surveyed the international legal instruments for the protection of cultural heritage, he explained, he had discovered that only 'tangible objects' were safeguarded, while 'forms of expression such as music and dance' were not. This was a major problem, since these were 'at present undergoing the most intensive clandestine commercialisation and export, in a process of commercially oriented transculturation destructive of traditional cultures'.

His letter was not just one of complaint; he had worked out some solutions, including that some form of protocol be established under the auspices of UNESCO which would give protection rights to member states over their 'cultural expressions of collective or anonymous origin', and that a committee be established to adjudicate in those cases where more than one state claimed ownership. He suggested that a convention be set up 'to regulate the aspects of folklore preservation, promotion and diffusion' along with an international register of 'folkloristic cultural property'. Thirty years later he got his wish, or something very close to it, with the establishing of the ICH charter.

As the Icelandic academic Valdimar Hafstein has shown, however, the Bolivian government's intervention was somewhat ironic, given that it took the form of a military dictatorship under General Hugo Banzer, which itself had a somewhat fractious relationship with the indigenous peoples of the Andes. The Aymara and Quechua groups, in particular, were subjected to questionable treatment, their lands confiscated, and their cultural expressions appropriated as a national symbol of Bolivia.[8] The Condor itself, which in Robles' version of the song stood as a symbol of resistance, was converted to the exact opposite: in Hafstein's words, 'a symbol of unity enforced at gunpoint'. Simon and Garfunkel were unwittingly getting tied up with a very messy political situation, in a clear example of 'tradition as commodity'.

Nonetheless, this appears to have been one of the key catalysts behind the eventual emergence of ICH as a concept to be taken seriously on a global scale. What it also highlights is the difficulty in determining just what exactly ICH actually is, to whom it belongs, to what extent it can or should be protected, and how to deal with the fact that a good deal of tradition transcends national boundaries. To its credit, UNESCO has recognised these issues and has tried to deal with at least some of them. It accepts that unlike material heritage, the intangible version is not necessarily to be found in one particular place, and

certainly not always within one single nation or state. It also leaves the decisions regarding precisely what should count as ICH to those to whom it belongs, although given the 'Condor' example, this is not straightforward either.

The international list is growing quickly, and makes fascinating reading. Treated as a kind of encyclopaedia of indigenous cultural riches, it is well worth a browse through from time to time, and I would love to see its use embedded in our education system. Scotland's 'Curriculum for Excellence' is well set up for this kind of thing: geography, history, music, modern studies, literature – all of these could well be enriched through exposure to the world's ICH; even if some might dismiss this as tokenism, as a small step towards positive globalisation, I think it would be a worthwhile start.

Although the UK has not signed up to the ICH convention, some embryonic work has been started in Scotland to move forward with the identification of just exactly what might constitute examples of our ICH. Under the leadership of Edinburgh Napier University a list has been started, and the nationally funded body Museums Galleries Scotland is committed to developing the concept within its own remit.[9] These are welcome developments, although given the potential riches of Scotland's many and varied traditions, it is a very large task, and there is much work to be done. What we must remember, however, is that people and institutions have been collecting and studying ICH in Scotland for decades – even centuries – and as a nation we are very well advanced in understanding what it means and what its value is. It is just that it has been done under different names: two of the key ones are 'folklore' and 'ethnology'.

Studying Tradition

Within much of Europe, the term which tends to be used for the formal study of cultural tradition is ethnology. In the modern understanding of the word, it covers a broad church and includes all that comes under the banner of ICH as well as material culture and the processes of cultural development through time. Folklore tends to be treated as one component of ethnology, along with its sparring partner 'folklife', which evolved mainly within the museum sector in Scandinavia a

century ago and tends to focus more on tangible, material culture, and the social organisation of small-scale societies. The ethnologist's motto is 'dig where you stand', concentrating on the culture of 'home', unlike social or cultural anthropology which is viewed more as the study of 'other' cultures. Ethnology has been more interested in the past than the present, although strands within the discipline are moving towards the study of modernity also. In general, however, ethnology has occupied a place at the intersection of anthropology and history, very often concerning itself with the relationship between the past and the present. How we relate to the past, how we make sense of it and how it is used within our current lives are all the stuff of ethnology. Things that arrive into our present from the past are therefore of particular interest – tradition, heritage, folklore, music – the creative traditions which lie at the heart of this book.

An undergraduate honours degree in Scottish Ethnology has been offered at the University of Edinburgh since 1987, emerging from the riches of the archival collections of the University's School of Scottish Studies, founded in 1951 to collect, preserve, research and publish materials relating to the cultural traditions of the nation. The model

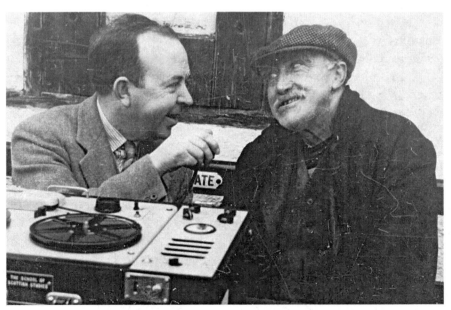

Fieldwork in action: Calum Maclean interviews Charlie Douglas
(School of Scottish Studies)

was closely based on that of the Irish Folklore Commission, established in 1935, which in turn had been greatly influenced by a pioneering approach to collection and archiving set up in Uppsala University in Sweden. All three of these institutions belong to what has been termed the 'nationalist' phase of development of the discipline of ethnology, although 'nation-centred' might be a safer term to use as not all that took place in northern Europe through that period was nationalist in the overtly political sense.

I shall return to this part of the story a little later, but there was much that took place before that. If we are to look for the roots of the disciplines that study tradition, a reasonable place to begin is within the antiquarian movement of the 18th century. Based at first mainly in England, antiquarianism was the collection and study of 'antiquities', understood as being mostly the physical or material culture remains of the past. To Francis Grose, a key figure in this movement who edited a publication called *The Antiquarian Repertory* between 1775 and 1784, antiquities comprised the 'physical remains and scenes and memorials' of the great and the good. These 'memorials' included ancient monuments, statues, coins and manuscripts, and also 'customs'. However, because Grose and his peers were only really interested in the higher social orders and the institutions which they led, the 'customs' they collected and studied tended to be those of the legal and ecclesiastical professions only. His six-volume opus *The Antiquities of England and Wales*, published between 1772 and 1787, is testament to that but made interesting reading to a highly educated audience who were fascinated by the history of their own kind.

Although there was little interest in 'the folk' within the context of 'antiquities', Grose was intrigued by the linguistic aspects of the culture of the lower classes but seems to have viewed this as a branch of study in its own right. *A Classical Dictionary of the Vulgar Tongue*, published in 1775, represents the first fruits of his work on local dialect; two years later he published a follow-up volume which expanded his coverage into proverbs and superstitions. This branch of his study is small in relation to his antiquities focus, but nonetheless in Francis Grose the UK had a scholar who in many ways pre-empted the work of UNESCO two hundred years later in his division of 'heritage' into its tangible and intangible forms.

Grose also made a key contribution to Scotland's understanding

of its antiquarian past through his companion volumes to the English and Welsh materials, *The Antiquities of Scotland*. His research for this involved several trips north, during one of which he made an extended stay with Robert Riddle, laird of Friar's Carse in Dumfriesshire. It was through this connection that Grose became a friend and drinking buddy of Robert Burns, who suggested that he should include Alloway Kirk within his publication. The bard sent him some local stories about the ruined building, which he later worked up into the poem he himself considered his finest, 'Tam O'Shanter.'[10]

Despite the fact that Grose saw fit to deal with his Scottish material separately from that of England and Wales, we should not take this as a sign that he saw any great differences between the nations or that he considered them as harbouring vastly differing traditions. His approach, like that of most of his contemporaries, was that these were regional, not national, studies. Despite his friendship with Burns, he saw nothing especially 'Scottish' about what he found north of the border. This was true also for another important figure in this period, John Brand. A clergyman from Washington in County Durham, Brand's main contribution to the study of tradition was his 1777 volume, *Observations on the Popular Antiquities of Great Britain*, much of which was based on an earlier collection of material from 1725 put together by a Newcastle curate called Henry Bourne. Brand's idea of antiquities included aural or oral remains as well as material culture, and so was less compartmentalised than that of Grose. Nonetheless, his emphasis on religious materials and his continued preoccupation with the elite rather than the masses place him firmly within the antiquarian movement, even although aspects of his work inspired the next generation whose gaze began to focus firmly on 'the folk'.

The term 'folklore' was coined by William John Thoms, writing under the pseudonym of Ambrose Merton in the London-based literary magazine *The Athenaeum*, in 1846. Thoms was a fellow of the Society of Antiquaries but by now the conceptual barriers against studying the culture of the masses had been broken down, to the extent that he felt a new name was needed for their interests. His plea took the form of a letter to the editor, in which he reiterated the importance of collecting as much cultural tradition as possible. He began:

> Your pages have so often given evidence of the interest which you take in what we in England designate as Popular Antiquities, or Popular

Literature (though by-the-bye it is more a Lore than a Literature, and would be most aptly described by a good Saxon compound, Folk-Lore, – the Lore of the People) – that I am not without hopes of enlisting your aid in garnering the few ears which are remaining, scattered over that field from which our forefathers might have gathered a goodly crop.[11]

Two things had to be done: find out how much of this 'goodly crop' had been lost, and how much might yet be rescued. *The Athenaeum* was the perfect vehicle to achieve this, he argued, as 'how many readers would be glad to show their gratitude for the novelties which you, from week to week, communicate to them, by forwarding to you some record of old Time – some recollection of a now neglected custom – some fading legend, local tradition, or fragmentary ballad!' The idea was well received, and such was the response that to move things forward Thoms founded a new publication platform, *Notes and Queries*, (which still carries on today) proposing a design for the study of folklore which he defined as the 'manners, customs and observances of olden times'. 'Collecting', then, was the way forward, but unlike those of the previous few generations his emphasis was on the 'intangible' tradition of ordinary people rather than material culture of the great and the good.

By now, men like Thoms had an impressive model to follow in their desire to collect; they only had to look to mainland Europe to see what could be achieved. The blueprint had been set out earlier in the 19th century by Jacob and Wilhelm Grimm, whose *Kinder und Hausmärchen* (Children's and Household Tales), first published in 1812, had been based on reworked versions of traditional tales collected from 'the people' (in reality, mainly from the educated German middle classes, to which the brothers themselves belonged). These folktales, they argued, were the results of generations of communal development emerging from the Indo-European language groups and were crucial to an understanding of the place of Germanic culture within the wider inheritance of which it was a part. Their ideas were later challenged and often dismissed, but their work and methods were highly influential throughout Europe and beyond. A later work of Jacob Grimm, *Deutsche Mythologie*, published in 1835, was very much on William Thoms' mind when writing his famous letter. He considered this collection to be 'a mass of minute facts, many of which, when separately considered, appear trifling and insignificant, but when taken in connection with the

system into which his master-mind has woven them, assume a value that he who first recorded them never dreamed of attributing to them'. The term 'folklore' spread rapidly following publication of Thoms' letter, and within a generation folklore societies had been established in several countries, bringing a much greater degree of rigour and professionalism to the study of tradition. The term 'folkloristics' later emerged as the name of the discipline which studies folklore, and in several Western nations, including the USA, that remains the preferred label down to the present day.

Meanwhile, another word was coming to the fore to cover similar themes as folklore. 'Ethnology' is usually understood to have been first used in print by the magnificently named Swiss scholar Alexandre-André-César de Chavannes, in a book of 1787 which traced human development through its various stages from primitive man to 'civilisation',[12] although the Slovak, Adam Franz Kollár, may have got there two or three years earlier. Either way, the term emerged originally from the antiquarian period but in its long life story since then it has taken on quite a variety of different meanings. At its widest it has referred to the comparative study of different cultures, and for the physicist Andre-Marie Ampère (he of the electrical amps), writing in the 1830s, it was the science that studies 'the places occupied by nations, and the races from which they originated, their surviving monuments, their progress or decadence, their religion and their language'.[13] You cannot get much wider than that!

By the 20th century its meaning had been narrowed and refined, being generally viewed as a close synonym of folklore, but including the study of material culture and the social relationships of ordinary people. The 1930s witnessed something of a semantic battle between supporters of each term. The two leading European figures within the field at that time were the Swede, Sigurd Erixon, who championed the cause of ethnology, and the French scholar, Georges Henri Rivière, who preferred the term folklore. The debates were not solely about labels: lying behind these preferred positions were subtle variations in the methodologies and priorities of the respective camps. Erixon was no great fan of oral tradition, for instance, preferring to concentrate on material culture and social organisation, while for some others, orality and the folktale were foremost in their minds. Again, that tangible/intangible dichotomy was to the fore, although by the second half of

the 20th century things had settled down somewhat in favour of a general adoption of the term 'European Ethnology'. Nonetheless, the words 'folklore and ethnology' are still often seen together: my own conceptualisation is that they should be viewed as non-identical twins within a family of disciplines that study the culture of humanity.

Scotland and Oral Tradition

It may seem as if we are drifting away from Scotland, but it is important to appreciate that what was going on here through that whole period was very much part of that wider European scene. Scottish thinkers fed plenty of their thoughts into these international debates and developments, at times leading the way, for there was very little that was inward looking or parochial about intellectual endeavour in Scotland in the 18th century. This was especially true in the collecting, study and publishing of oral tradition, one of the central pillars of ethnology. If Thoms was greatly inspired by the Grimms, they in turn had their own sources of influence, as indeed had some of the other great Germanic scholars of humanity and culture such as Goethe and Herder. For all three of them, and for a long list of political leaders, writers, composers and artists, that thread of influence leads directly back to Scotland, and in particular to a Gaelic-speaking schoolmaster from Ruthven, near Kingussie in Badenoch, James Macpherson.

If his contemporary, Robert Burns, has come down to us as a national hero, Macpherson has suffered quite the opposite fate, having been vilified for generations as a fraud, trickster, cheat and liar. In what now seems a precursor to the modern tabloid tactic of raising individuals to great heights of public adoration only to bring them crashing down later, Macpherson was subjected to extreme highs and lows of cultural repute over two hundred years ago, and his name continues to split scholarly opinion to this day. What is not disputed is that his work inspired such diverse figures as Napoleon, Jefferson, Coleridge, Wordsworth, Yeats, Beethoven, Brahms and Mendelssohn, and he became a true international bestselling writer within months of his first major publication. He fed what transpired to be an insatiable appetite in this early period of romanticism for ancient epic poetry, and for proof that in European terms the north had its own version

of Homer, its own hero warriors, its own tales of romance, adventure and morality, all played out in the forested hills and glens of the ancient Celtic past. In fact, it did, but not quite in the polished form that they appeared in the work of James Macpherson.

What Macpherson did, greatly encouraged by various Lowland scholars of the Scottish Enlightenment, especially John Hume and Hugh Blair, was to use his knowledge of the oral tradition of the Highlands and the Gaelic language which conveyed it to supply this huge demand. In 1760, he anonymously published *Fragments of Ancient Poetry, Collected in the Highlands of Scotland, and Translated from the Gaelic or Erse Language*, a work which became an instant international hit. Macpherson's master stroke, and the one which later led to such condemnation, was to claim that these fragments of prose-poems were composed by a single ancient Scottish bard called Ossian. Following this striking success, he put pen to paper again in similar vein in 1761, this time with *Fingal* and followed this up two years later with *Temora*. A two-volumed edition of all of this material, *The Works of Ossian, Son of Fingal*, followed in 1765.

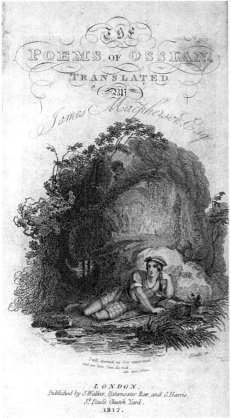

An early 19th century edition of MacPherson's *Poems of Ossian*

While these books were met with widespread admiration, some of his intellectual contemporaries were not convinced. Dr Samuel Johnston was one, and in keeping with his forthright approach to everything he did, said and wrote, especially about Scotland, he wasn't shy in condemning Macpherson and his work. The good doctor could not accept that oral tradition was capable of sustaining complex narratives over so many centuries, and so demanded

manuscript-based proof that Macpherson had not made the entire thing up. As none was provided, he concluded exactly that, and so began a long tradition, continuing down to the present day, of what James Porter has called 'Macpherson-baiting',[14] carried on by a line of condemners each concluding that this schoolmaster from Badenoch was nothing but a fraud. This has been the keystone of the 'invention of tradition' school of thinking, led by the historian Hugh Trevor-Roper (Lord Dacre), which began to see similar levels of fraudulent falsification almost everywhere they looked. This attitude stands in opposition to the other extreme, the 'wha's like us?' mentality which sees everything in Scotland's culture as glorious and ancient. As you probably suspect, the truth is hard to unravel, and almost certainly lies somewhere in between.

For those who have taken the time and trouble to look at the whole Ossian business in some detail and with a clear head, Macpherson emerges from history with a rather less dramatic reputation. Their analysis is considered and deep as they try to unravel his motivations and methods and attempt to reconcile his publications with the wider world of Gaelic poetry and oral narrative from which they were derived. Their conclusions are generally very similar to those of an enquiry which was conducted in Macpherson's own lifetime, that the published works of Ossian were based on oral and manuscript traditions, common to Scotland and Ireland, which were woven into a new and polished narrative to suit the modern tastes of the 18th century. As such, his approach was not at all dissimilar to other arrangers and sellers of tradition who followed in his wake, but whose reputations remain largely intact: Robert Burns, Walter Scott and the Grimm brothers chief amongst them. It was not so much the methods as the claims which were the problem, but in his research, fieldwork excursions and his ability to make the ancient past a valuable resource to be used in the present, his influence was, and remains, immense.[15]

Turning to Walter Scott, there is little that has not yet been said about his contribution, for good and for bad, to Scottish cultural creativity and the construction of a particular version of the nation's past. What we must not overlook is just how much his work owes to his lifelong fascination for folk narrative and the oral traditions of Scotland which so intrigued him from a very young age. It saturated his writing in almost all of its forms and can be seen to heavily flavour his

thinking in his more private reflections too. A prolific correspondent, his letters reveal much about the inner workings of his mind, and the ubiquity of folklore as his mental scenery. His first substantial work was the three-volume collection of songs, *Minstrelsy of the Scottish Border*, published by James Ballantyne in Kelso in 1802–03. The ballad tradition had fascinated Scott since childhood, and as well as building up a large personal collection of chapbooks, he owned collections such as Alan Ramsay's *Tea-Table Miscellany* published in Edinburgh in 1775, Bishop Percy's *Reliques of Ancient English Poetry* from London a decade earlier and of course the works of Robert Burns. The *Minstrelsy* contains many of the better-known Scottish ballads and in common with many of his fellow Scottish collectors, before and since, relied heavily on both written texts and oral recitations. His sometimes heavy-handed and overly creative style of ballad editing has been criticised by some, perhaps mindful of the problems created in this respect by Macpherson a generation before, but largely speaking Scott has been forgiven as his practice was usually to collate rather than invent.

He was fully aware of the ongoing debates regarding collection scholarship and growing international interest in what would later be termed folklore. He often alluded to the work of John Brand and corresponded with several key European students of tradition including Jacob Grimm in 1814 and 1815. He reflects on his own debt to folk narrative and the oral tradition in several works, including his *Introductions and Notes and Illustrations to the Novels, Tales, and Romances of the Author of Waverley* of 1833, and also in the earlier *Letters on Demonology and Witchcraft, Addressed to JG Lockhart, Esq*. One historian of tradition labels the latter 'the first full-scale treatise in English on what before long would be called folklore' noting that it 'took a place beside Brand's *Popular Antiquities* as an immediate authority and reference in matters supernatural and archaic.'[16]

Another Scott who stands tall in European attempts to collect and make sense of tradition is John Francis Campbell of Islay. Again, there was wider European influence in his motivation, for he had been particularly impressed by a book published in Edinburgh in 1859 by his friend George Dasent, entitled *Popular Tales from the Norse*. This was an English translation of a Norwegian collection put together by a pair of scholars by name of Asbjørnsen and Moe, both of whom had in turn been greatly inspired by the Grimms. Campbell was of the landed

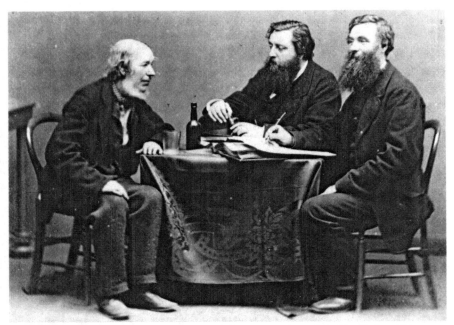

John Francis Campbell recording a tale in Islay, 1870, with Lachlan MacNeil and Hector Maclean (School of Scottish Studies)

classes as opposed to 'the folk' (although the family had by this time sold their Islay estate to pay debts), but the stories reminded him of Gaelic tales he knew as a boy, most of them told to him by his 'nurse' as he called his father's piper, also called John Campbell. He immediately set about collecting these tales which he knew to be still current in the Gaelic-speaking west, and employed several helpers, all literate in Gaelic themselves, to help with the process. In this pre-mechanised period, of course, all the tales had to be taken down by hand as the tellers recited them, an extremely labour-intensive process, in a form of fieldwork which had been followed a century earlier by James Macpherson. Scholarship had moved on by then, however, and great care was taken to record the exact words used by the storytellers themselves, and even although Campbell's rather literal English translations in the four published volumes which resulted from the project make for rather awkward reading, his methods set a new standard in European folklore scholarship. He also inspired a new generation of collectors here in Scotland, amongst them, another high-ranking member of the aristocracy, the youngest daughter of the Duke of Atholl.

School of Scottish Studies Colleagues, Alan Bruford and Hamish Henderson
(Ian MacKenzie, School of Scottish Studies)

Lady Evelyn Stewart Murray was a fascinating and gifted woman who refused to play by the rules of the high society into which she was born, and suffered greatly as a result. Her father, John, the seventh Duke, was a great supporter of the Gaelic language, speaking it fluently himself, and insisting that the staff on his extensive estates all be Gaelic speakers too. He saw to it that it be taught in the local schools, and held a Gaelic competition each year in Blair Castle for local children. Initially he was delighted that his daughter shared his interest in all things Celtic, but later became greatly concerned that it seemed to be growing into an obsession, as she studied all day and late into the night, and her health appeared to be suffering as a result. She showed no interest at all in the social niceties of her class, infuriating her mother, Duchess Louisa, who shared nothing of her husband's cultural leanings, and was mainly interested in introducing Evelyn to the London social scene in order to find her a suitable husband. Her quiet but feisty daughter was having none of that nonsense.

Lady Evelyn had access to all the scholarly works she desired, including Campbell's *Popular Tales of the West Highlands*, and she de-

cided that she would carry out a similar exercise on her father's estates and those of neighbouring Breadalbane. This frail young woman began visiting the homes of the estate workers and others she was told had plenty of stories, and like Campbell and his team, wrote them down in Gaelic with the utmost care. By the end of the year she had filled many notebooks, building a remarkable collection of 241 tales and songs, all in rich Perthshire Gaelic. Her timing could not have been better, for over 80 per cent of the population on the Atholl estates still spoke the Perthshire dialect of the language: within two generations, there were none.

Her legacy to our knowledge and understanding of local Perthshire culture of that time, including a dialect which is now extinct, is immeasurable. Yet the price Lady Evelyn paid to achieve this was heavy indeed, for her commitment to the cause translated for her parents into an obsession that to them proved she was ill of mind as well as of body, and they decided that she should be sent overseas for a spell to recuperate. Late in 1891, aged 23, she left Blair Castle for Switzerland. She never saw her beloved Atholl again, returning only in 1940, to be buried there. Her exile was self-imposed, harbouring a lifelong grudge that her parents should banish her, as she viewed it, and spent her life on the continent and later in Wimbledon. Her attention moved from Gaelic folklore to fine lace embroidery, her collection of pieces eventually finding their way back to Blair Castle where they are still on display, experts recognising her as one of the finest such artists of her generation.

She clearly remained proud of her collection of Atholl tales, for towards the end of her life she requested that the manuscripts be lodged with the Professor of Celtic at the University of Edinburgh, James Carmichael Watson. His grandfather, Alexander Carmichael, was himself a prolific collector of Gaelic folk culture, and had written to Evelyn in her youth to encourage her in her collecting work. And the university in the capital had been the source of other help for her in those early years, especially from one of Carmichael Watson's predecessors as Professor of Celtic, Donald MacKinnon, who corresponded with her a good deal, setting her grammar exercises to help her get fully to grips with the Gaelic language. Evelyn's expressed wish was that her tales be published within a year of her death, and the professor took possession of them in 1939, the year before she died. But the war

intervened before he was able to make good her wishes, and tragically, he was drowned in action in 1942. They were later gifted by the family to the School of Scottish Studies at that same institution, and were kept there for safe-keeping and consultation, but by this stage, the invention of audio recording equipment allowed such material to be captured in the spoken, not written, word, and so for a time, the importance of manuscript collections began to fade into the background as the archive shelves were filled with actual voices.

In the mid-1980s when I arrived at the School as an undergraduate, Alan Bruford suggested that, as an Atholl laddie myself, I should take a look at these notebooks and investigate the folk culture of my home area. I had studied Gaelic at school, but was far from fluent, and the Perthshire dialect made life even harder, so I have to admit to relying a good deal on translations of a selection of them which had been undertaken some years earlier by the poet, Sorley MacLean. What I found just fascinated me. We were learning in class of the complexities of oral narrative theory – tale type indices, different genres of oral culture, the ideas of evolutionists, structuralists, psychoanalysts – yet here was a body of real stories which had been told by real people in real places from my own backyard. Suddenly, it all made sense.

Voices on the Shelves. Tapes in Storage in the School of Scottish Studies
(School of Scottish Studies)

I found myself reading of the fairy people (both good and bad), of local witches, of the heroes of clan warfare, of strongmen and tricksters, of spirits and ghosts – in short, here was a window into the creative mindset of the people of Atholl a century before. It had the same kind of impact on me as James Macpherson's Ossian adventures had on his audience over two hundred years earlier, invoking a delightful wonderment. And these were not tales that were only known to a few 'tradition bearer' storytellers who remembered them on behalf of the whole community: she collected from well over one hundred local men and women, proving that such tales were still firmly embedded in the popular culture of the entire area.

The tales reveal what we might term the 'imagined landscape' of Atholl. Many of their tellers were intimately familiar with the physical landscape of north Perthshire, but Lady Evelyn has captured for us something of their mental scenery. Yes, stories were told as entertainment, as one way of passing the time, yet they meant so much more besides. Some were didactic, part of a child's education, warning the young of certain places where unknown dangers may lurk; others point towards a subtle morality or ethics; some bring an explanation of past events, or a way of accounting for life's tragedies and mysteries. And all of them bring a sense of place, of local belonging, of a grounding and identity which was firmly planted in Atholl.

Magnificent editing, research and translation work by two dedicated scholars over a sustained period has at last brought us these tales in a volume which they deserve. Local Atholl historian Sylvia Robertson and linguist and scholar Tony Dilworth were determined to grant Lady Evelyn her dying wish, and – even although it took a little longer than she had hoped (70 years longer!) – her tales were published by the Gaelic Text Society in 2009.[17] For the launch of the book at Blair Castle, I had the honour of composing and playing a tune to mark the occasion, a companion piece for the wedding march which had been written for her sister, Lady Dorothea, over a century earlier. Dorothea was herself a collector, but her particular interest was music manuscripts, a pastime deemed to be rather more in keeping with her station in life, and therefore uncontroversial in the eyes of her parents. Her tune had been written by the then piper major of the Atholl Highlanders, Aenas Rose (who also happened to be one of Evelyn's informants), and a very fine 6/8 march it is, well-known in the piping world and a standard

of its genre. My composition aimed to sit alongside it in rhythm and melody, a sister tune for a shunned sister, if you like. It was a humbling experience to play it for her, under the gaze of her portrait, in the library of the castle where she spent so much time all those years ago.

The aforementioned Alexander Carmichael from Lismore, who had written so encouragingly to Lady Evelyn, was himself one of the most prolific collectors of tradition ever to grace the nation, although his methods brought something of a return to the controversy surrounding James Macpherson all those years before. Having contributed to Campbell's *Popular Tales of the West Highlands*, Carmichael began his own folklore collecting in Islay in 1860. As an exciseman by profession, he found himself posted to various parts of the Western Isles, including Skye and South Uist, where he was able to fuel his growing obsession with oral tradition, collecting in his notebooks a massive body of material that is only now being studied in the depth of detail it deserves.[18] However, his job was not exactly conducive to earning the complete trust of the people from whom he collected, and in fact he became the subject of local folklore himself, as tales emerged of local worthies who got one over on him as he searched for illicit stills amongst the crofts and peat bogs of the communities within his jurisdiction.

In terms of publication, the main fruits of his labours appeared in 1900 – *Carmina Gadelica*, a 'sumptuous' two-volume collection comprising a corpus of Hebridean charms, hymns, prayers, blessings, stories, cures, customs and songs. I was introduced to this in my late teens, in the same year as Lady Evelyn's collection was first shown to me, and together they revealed the overlapping, yet distinct worldviews of these two parts of the *Gaidhealteachd*. A generation before, Neil Gunn had been similarly touched:

> Turning up the pages of *Carmina Gadelica* to check a reference, I found myself some half-hour later lost in the account of what used to happen out in Uist on the eve of St Michael. It is a truly remarkable account of a festival by the common folk, given a whole meaning and cohesion by what we would call superstition. The very air seems full of magic. And the whole is steeped in a profound happiness and goodness... On St Michael's night a great ball is held in every townland. Gifts are exchanged between young men and women. Song and dance, mirth and merriment 'are continued all night, many curious scenes being enacted, and many curious dances being performed, some of them in character'.

Altogether there is a suggestion of eager life, a wonder upon things, a freshness in the eye, a vivid delight.[19]

Carmichael belonged to a movement, often labelled 'the Celtic Twilight', which emerged in Scotland and Ireland in the closing years of the 19th century. Writers such as Lady Gregory, WB Yeats and Sean O'Casey in Ireland and collectors and arrangers such as Marjory Kennedy Fraser and John Lorne Campbell in Scotland moved the study of tradition firmly into its 'nation-centred' phase, culminating in a crop of official institutions set up in the mid-20th century, aimed at professionalising, consolidating and modernising all of these collecting activities. The Irish Folklore Commission, followed by the Welsh Folk Museum, the School of Scottish Studies and the Ulster Folk Museum marked a definite move away from all-British approach of the 18th-century antiquarians and the 19th-century folklorists. Linked to this was an increasing awareness of the importance of the study of language and dialect, returning full circle in some respects to the outlook of the likes of Francis Grose. In Scotland this gave us major projects such as the Scots and Gaelic Linguistic Surveys of Scotland, the Scottish National Dictionary, the Dictionary of the Older Scottish Tongue and the Institute for Historical Dialectology, mostly based within

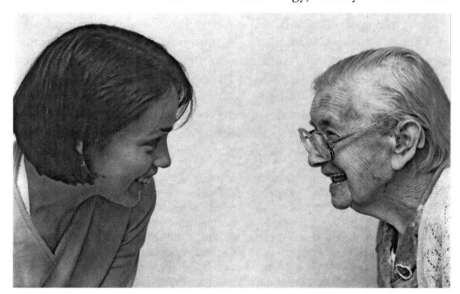

Katherine Campbell of the School of Scottish Studies with Lizzie Angus, aged 106, a pupil of the collector Gavin Greig (Ian Mackenzie, School of Scottish Studies)

theUniversity of Edinburgh.

I cannot move past this brief overview of collecting in Scotland without pausing to reflect on the legacy of two prodigious gatherers of songs, both words and tunes, who worked away in the north-east for decades in the late 19th and early 20th centuries. The schoolmaster Gavin Greig and the Reverend James Duncan collected over 3,000 songs which have helped to supply subsequent generations of performers with a rich seam of material, and continues to do so. As is often the way, the corpus had to wait for a later generation before the money and energy was found to publish these in full, but the series is now complete and fills eight volumes under the general editorship of Pat Shuldam-Shaw and Emily Lyle, with significant editorial input from a team which includes scholars and performers such as Adam McNaughtan, Andy Hunter and Katherine Campbell.[20]

Several of that team are connected with the School of Scottish Studies, my own daily place of study and then work for the last 28 years, and since its foundation in 1951 it has become the key institution for the collecting, archiving and study of folk culture in Scotland. Our main task there now is to teach and to disseminate the 'voices on the shelves' while ensuring their ongoing protection,. Stewarding a collection which now amounts to some 15,000 hours of recordings, filling over 900 linear metres of shelving, is a major task. A significant step forward has been taken with the digitisation of the fieldwork recordings, which has allowed a proportion of them to be made available on the internet. The project, 'Tobar an Dualchais' in Gaelic, and 'Kist o Riches' in Scots was funded by the Heritage Lottery Fund with significant support from a wide range of other organisations, and was a joint project with the BBC and the National Trust for Scotland who provided material from Gaelic radio and the Campbell of Canna collection respectively.[21] Those voices on the shelves can now emerge from computer speakers anywhere in the world, and the audience is a truly international one. There is still much work to be done, however, both in completing this Herculean task and in following it up with projects which help these users to engage with the material in ways which enhances their understanding of its meaning and worth. As the institution moves into the next 60 years of its journey, that will be one of the central tasks for ethnologists and folklorists in the digital age.

I began this chapter with the thinking of two modern-day folklorists,

Dorothy Noyes and Henry Glassie, whose bold statement defining tradition as 'the creation of the future out of the past' serves as its epigraph. Glassie is a beautiful writer and a perceptive observer of people. Thoughtful and thought-provoking in equal measure, for me he is the one figure who has managed to bring all the strands of the study of tradition together in a synthesis which gets to the heart of what it really means to individuals and the communities to which they belong. His method has been not so much to collect, but to immerse himself in the communities he is interested in. He gets to know them and they get to know him, and out of that relationship emerges a wisdom and understanding that makes him compulsory reading for any student of tradition.

One theme which emerges strongly in Glassie's work is the importance of tradition to an understanding of the past, and he is apt to complain that historians do not take nearly enough notice of it. 'Change' is their business, for history as a discipline is the telling of a story, 'an artful assembly of materials from the past'. It necessarily leaves out more than it puts in about the past – it would be an impossible task not to – and so what tends to be left out is all the stuff that does not change, or only very slowly:

> Overtly, histories are accounts of the past. Their authors, acceding to the demands of narration, customarily seek change, the transformations by which they can get their story told... Historians need tradition. For one thing, it would wean them from their obsession with rupture, free them from the need to segment time into trim periods, and enable them to face the massive fact of continuity.[22]

And yet, as Glassie is quick to point out, tradition and change are not always opposing forces, for tradition is only the opposite of one kind of change, 'that in which disruption is so complete that the new cannot be read as an innovative adaptation of the old'. In all other forms of change, tradition can and does play a part, for it develops incrementally on that which has gone before. 'Most of that which makes up life is neglected in history,' he argues, 'because it cannot be gracefully assimilated into hearty narratives of violent change.' Tradition is part of history, then, and it is also part of 'culture'. It is 'culture's dynamic, as the process by which culture exists, and it emerges as the swing term between culture and history'.

This fascination was especially honed for Glassie during the time he spent in a small community in Upper Lough Erne, County Fermanagh,

Northern Ireland, in the early 1970s. *Passing the Time in Ballymenone* is the two-inch thick result of that, a doorstopper of a book which takes us with him on his journey to the heart of the place and to the heart of its people. Anthropological 'participant observer' accounts of 'the natives' by a well-meaning foreign scholar can make for painful reading, but not this one. Glassie knows the traps and the dangers, and steers clear of them. Let me give you a flavour:

> As a young professional I had published a paper that conformed to academic norms and dutifully cleared a patch of intellectual new ground, but it offended the man I wrote about and lost me a friend. Friends are worth more than books, but writing is my way to discover what I think. Unable to retreat from analytic writing, I turned from people to study their shadows on things, their projections in earth. Artifacts became my company.[23]

Starting out as a scholar of material culture – folklife – he was also trained in folklore, and so he found himself moving quickly from shadows to sounds:

> The shape of Ballymenone's concept of sound can be imagined as a terraced sequence leading upward from silence to music and from separation to social accord. Silence, talk, chat, crack, story, poetry, song, music: with each step, entertainment increases, sound becomes more beautiful, and the intention of the creator of sound becomes more clearly to please the listener. Individual creations and whole events feel as though they shift from plateau to plateau along a flight of steps that lift people simultaneously toward aesthetic perfection and social union. Central and crucial to this rising sequence is the story.[24]

That is it. Tradition is a story, learned from the past, told in the present, looking to the future.

CHAPTER 2

Music and Custom at Home

THE DOMESTIC HOMES OF the people of Scotland have served as the stage for a great deal of 'performance' of tradition down through the centuries. We shape our lives through the spaces we inhabit as the heart of our daily existence, and it is in the home that our material and creative cultures merge into one. It is a prime laboratory for the ethnologist, for it is here that we act out a substantial part of our lives, here that we learn directly from our elders, here that our ways are passed on down through the generations. Despite changing technologies, it is here, too, that Henry Glassie's 'massive fact of continuity' holds most true, where the micro-details of daily routines are to be found and where the intimacy of life is most pronounced.

There have been very few households within Scotland, whatever their positioning in respect of time, place or social hierarchy, which have not been enriched with music. Custom is perhaps a less obvious vehicle for understanding tradition, but it has been one of the primary shapers of the manner in which we have organised ourselves and marked key events in our lives as individuals and as communities. Custom is the manifestation of belief and even beyond the organised and codified belief of religion there has been a huge amount of it around. It lies at the core of a great deal of our ICH and so deserves our attention here. But first of all, let's take a listen to the domestic soundtrack of the Scottish home.

Those householders who could afford to often paid for the provision of music, while the majority made do with their own efforts, or those of their more talented neighbours and visitors. In the pre-industrial age, Highland chieftains supported their pipers, bards and harpers, the daughters of Edinburgh socialites learned spinet, virginal and lute from French and Italian masters, while the 69 individual musicians being paid by the court of King James IV on New Year's Day in 1506 testify to the importance placed on the spectacular household consumption

of the musical arts by the ruling elite.[1] And if the folklore surrounding that particular sovereign's son and heir is to be taken literally, James v's clandestine 'gaberlunzie' wanderings around the Scottish countryside would have opened his ears to the diverse musical riches to be found within the homes of his subjects across the length and breadth of the nation.[2] This diversity remained a constant in the centuries to come: infants being dandled to the gentle sounds (but sometimes brutal lyrics) of a Gaelic lullaby; wool being spun to a rhythmic tale of heroic deed or bloody treachery; pious offerings of metrical psalms or 'Solitary Thoughts' in praise of The Almighty; a ribald parlour gathering, delighting in the erotic tales of what one collector termed 'the secret songs of silence'.[3]

The twin processes of industrialisation and urbanisation may have reshaped the domestic settings within which such music was played and listened to, but the rural exodus towards townhouse, tenement and miners' row did nothing to silence the music of the people. By the mid-19th century, accordion, melodeon and mouth organ had joined the fiddle and trump (jew's or jaw's harp) on the list of the most popular working-class instruments, while the new concentration of such large numbers of children within the limited urban space encouraged a massive creative surge of rhymes, clapping songs and other ditties which enlivened the kitchen as well as the stairwell, street and playground.

The Big Hoose

Professional musicians in Scotland – as elsewhere – have often relied upon the patronage of the social elite in order to earn a livelihood, and so the households of the aristocracy have for long acted as the setting of much music-making and appreciation. The cultural life of the Highland chief's household, certainly up until the 18th century, was rich indeed

> with filidh, bard, clarsair, piper, fool, all part of a considerable retinue of intensively trained and highly skilled people... an evening's entertainment recounting the deeds of the chieftain and his ancestors could have been of epic proportions.[4]

Such luxury was unjustifiable in the harsh social and economic climate of the post-Culloden era, and so clan chiefs could no longer bask in the panegyric eulogising of their personal song-poets. But the

romantic aesthetic of the new age at least encouraged many lairds, both above and below the Highland divide, to continue (or begin) to sponsor a household piper. Lord and Lady Breadalbane were able to call on as many as nine pipers and in 1842, at Taymouth, Perthshire, Queen Victoria was very taken with the 'princely and romantic' scene their presence helped to create.[5] While having such a number of pipers attached to one household was exceptional, many early 19th century lairds remained keen to support at least one piper.

Those who did not offer permanent employment to musicians were content to pay for their services as and when required. The Mar account book for the late 17th century records one-off payments to 'a blind singer at dinner', 'a Highland singing woman', 'Blind Wat the Piper' and 'ane woman harper'. During the same period, John Foulis of Ravelston near Edinburgh made regular payments to a range of musicians, especially fiddlers, pipers and drummers, while his daughters were taught to play both the virginal and the viol by one Monsieur De Voe. The household accounts book of Lady Grisell Hume, wife of a 17th-century Borders laird of middle rank, reveals that money was spent on domestic music in three main ways: to pay music teachers for her children, to buy, repair and maintain instruments, and to pay performers (in this case, harpers, fiddlers and singers) for entertaining the household.

The drawing rooms and parlours of the upper and middle ranks of Scottish society were not only the setting for the playing of much music and song, but also a catalyst for their creation. John Clerk of Penicuik, for one, made a significant, if under-celebrated, contribution to the European classical tradition of his day in the form of a series of five cantatas of outstanding quality. Clerk's contemporaries, William McGibbon and James Oswald, both products of an east coast middle-class upbringing, also made a lasting impression on the musical output of the the 18th century.

In the Victorian era, the drawing rooms of the wealthy played host to a new thirst for romantic Scots song, much of it composed or arranged by some of the women who frequented them. Lady Carolina Nairne, Joanna Baillie, Lady Alicia Scott and Lady Anne Barnard were all finally revealed as songsmiths of note in the middle decades of the 19th century, earlier sensibilities having demanded that as women, they publish their work anonymously. The themes of their songs – many of which achieved great popularity both north and south of the border –

pre-empted those of the kailyard school of novelists of the following generation:

> They are 'morally healthy' in advocating contentment with one's lot; they abound in pictures of domestic peace and comfort; and they show joy in the beauties of nature.[6]

This musical view from the drawing room window was of a romantic, heroic, and egalitarian nation, proud of its recent Jacobite past, and yet safe in the stability of the unionist present. A distorted view it may have been, but it was durable and influential, eventually breaking free of the private home and making its way straight to the very public platform of the music hall stage.

Functional Music

Music was not always performed within the home for entertainment alone, but was often employed in a more overtly functional role. Whether used to accompany dancing, or to pass the time while carrying out some laborious task, to set up a working rhythm or to soothe or rock an infant, the voice in particular could be pressed into action for any number of practical uses. These uses were widespread throughout Scotland, but it is within the Gaelic-speaking areas of the country that the strongest survivals of functional songs are to be found. These too found their way onto the concert music hall stage through the collecting of the likes of Marjorie Kennedy-Fraser in the early 20th century.

In the Preface to his *Highland Vocal Airs* collection of 1781, Patrick MacDonald testifies to the frequent use of songs, particularly by women, when going about their daily and seasonal tasks in and around the home

> and they are sung by the women, not only at their diversions but also during almost every kind of work where more than one person is employed, as milking the cows, and watching the folds, fulling of cloth, grinding of grain with the quern or hand-mill, hay-making, and cutting down corn.[7]

Of all the labour tasks associated with song accompaniment, the fulling of cloth is perhaps the one that has achieved almost symbolic status in relation to the collective memory of the musical and social

past of the *Gaidhealteachd*. Within the Lowlands, the fulling process was mechanised and centralised in mills by the 18th century, and if there ever was a Lowland parallel to the Gaelic waulking songs it does not appear to have survived. But in the Outer Hebrides in particular, this form of work song still existed, attached to its original function, well into the 20th century, for waulkings continued to be practised as a communal task by women in their homes until the 1940s.

The waulking songs were sung at a tempo and rhythm that were closely integrated with each stage of the fulling process. To begin with, when the cloth was wet and heavy, both work and songs were slow, but as the cloth began to lose its moisture, the pace quickened and the song tempo increased accordingly. Margaret Fay Shaw provides a succinct account of the process:

> The ends of a length of newly woven cloth are sewn together to make it a circle, and the cloth is then placed on a long trestle table and soaked with hot urine. An even number of women sit at the table, say twelve with six a side, and the cloth is passed around sunwise, to the left, with a kneeding motion. They reach to the right and clutch the cloth, draw in, pass to the left, push out and free the hands to grasp again to the right. One, two, three, four, slowly the rhythm emerges.[8]

As the evening wore on, the waulking tended to develop into a highly charged social gathering, very much the domain of the womenfolk only, at which stories, gossip and leg-pulling would be the order of the day. Indeed, much of this was integrated into the improvised lyrics of the rhythmical songs themselves. As such, the waulking tradition provides an excellent example of the manner in which music, material culture and social organisation can combine to create a central element of the culture of many Scottish homes.

The functional uses of music and song within the home stretched well beyond the rhythmical accompaniment of physical labour. The soporific effects of the lyrical human voice, for example, have probably been recognised since the earliest development of civilisation, and both the Gaelic and Scots traditions abound with cradle songs and lullabies. Indeed, it was not only the young whose slumber could benefit from 'sleep music': in the late 19th century, the widow of the Reverend George Munro of South Uist employed a local woman primarily to sing her to sleep at night.[9]

Music was also a common element in the domestic celebration of ritual practices associated with both religious and secular custom and belief. Pious musical offerings have rarely been confined to the formal buildings of worship, for instance, as gloriously revealed to one visitor who heard 'a mile of singing' as he walked the length of a Lewis crofting township one Sabbath evening in the 1880s. 'The singing at family worship,' he noted, 'was so general and continuous that it seemed unbroken from one end of the township to the other'.[10] Rites of passage within the human life cycle provided plenty of opportunities for musical celebration or commemoration within the household. In Shetland, a fiddler was a central figure within several stages of a wedding celebration: the official contract was sealed in the bride's home several days before the main event by dancing to the sound of the fiddle; the fiddler would play at the bachelor's party the night before the wedding, and when the bride was ceremonially bedded, he would provide a musical backdrop there too.

The importance of music in the construction and celebration of cultural or ethnic identities is widely recognised, and it is of little surprise that functional household music in a multitude of forms is a basic ingredient in the complex web of ethnicity that stretches across modern Scotland.

Perhaps one brief example can make the point: for David Daiches, growing up in a respected Jewish family in early 20th century Edinburgh, music helped to define his 'two worlds':

> round the candle-lit table, Lionel and I wearing little green skull-caps and my father his accustomed black one, we talked in a politer accent than the one we employed in the streets and discussed quite other matters. And as we sang the familiar shir ha-ma'aloth at the beginning of the post-prandial grace, to the plangent minor melody that my father had learned from his father, the Meadows and Marchmont and Arthur's Seat and Blackford Hill were forgotten and we were back in a world which stretched unbroken back through the Middle Ages to ancient Palestine.[11]

Community

While music in some form or other must surely have been a feature of virtually every Scottish home, most communities, past and present, would have a selection of houses which might act as the focal point for

musical gatherings. Willie Scott, a fine traditional singer and lifelong shepherd, recalls the frequency of communal gatherings of this kind in the Borders in the early 20th century:

> There was a party in one house one night and a party in another house the next night. An they sort o'gathert together. There wasn't a hill cottage but there was a fiddle or two hangin in, ye know. There was always a song or a fiddle to play a tune and there was dancing, a sing-song, just a sort o ceilidh, as they were called in the north o' Scotland. We had some great nights.[12]

The role of music as a catalyst in the processes of social integration amongst members of dispersed communities should not be underestimated and has for long been a common feature of life throughout rural Scotland. In Shetland, talk was of going 'in aboot da nyht' to share stories and fiddle tunes, while in Gaelic-speaking areas it was the ceilidh house that performed this vital role. Music and song were also ubiquitous in the bothies and chaulmers which, from the early 19th until the mid 20th centuries, acted as home to the unmarried male farm servant population of Lowland Scotland. Physically spartan they may have been, but these communal homes nurtured one of the most dynamic and expressive folk cultures of recent times. The so-called bothy ballads, composed in an earthy Scots vernacular, deal with the issues that were of most interest to those whose world was the 'ferm toun'. Love and sex are themes which lie at the heart of many of them, some leaving little to the imagination, while others take the form of good-humoured but heartfelt protest songs which highlight dissatisfaction with working conditions or tyrannical employers.

While these farm servants' dwellings became most closely associated with the singing of the bothy ballads, musical instruments were by no means in short supply there too. Fiddles seem to have been the favoured instrument, although by the second half of the 19th century, the melodeon began to be widely adopted. Imported in great numbers from Germany from the 1860s,[13] the marketing of these instruments was aimed at the domestic, amateur player, advertisements in the popular press suggesting that no household should be without one as a means of encouraging 'innocent and mirthful recreation in the family'. The message must have worked, for by the turn of the 20th century the melodeon could be heard in homes throughout Lowland Scotland, although it was by no means uncommon north of the Highland divide.

Its compact form, versatility and relatively low volume also made it a popular choice of instrument amongst the tenement dwellers of Scotland's towns and cities.

Practice, Performance and Transmission

Until the second half of the 20th century, a longstanding scholarly preoccupation with text rather than context – with songs rather than singing, tunes rather than playing – resulted in the development of a wealth of theories on structure, form and variation within the creative arts, but a paucity of ideas concerning practice or performance. Recent studies of a more ethnographic nature, however, have gone some way towards redressing this imbalance and serve to underline the importance of the domestic home as the hub of the onward transmission, through both time and space, of received traditions of whatever form. 'Strong tradition-bearers', the driving force of any artistic tradition, according to one scholar, are distinguished from their more passive counterparts by displaying heightened levels of five traits: engagement, retentiveness, acquisitiveness, critical consciousness and showmanship.[14] They learn, perfect and transmit their styles and repertoires within a variety of contexts, but the home remains central to these processes, especially as they often become the preferred setting for the kind of communal gatherings outlined above. For a 20th century *bard baile*, (township song poet) like Iain MacNeacail of Skye, the muse may have come while 'walking the road', but it was the ceilidh house that provided the setting for the performance and transmission of his creations, as his biographer recognises:

> The role of the *taighean céilidh* in transmitting rural Highland culture cannot be over-emphasised... [I]t was by far the most usual (and natural) environment for oral entertainment traditions, providing endless information about the community, whether through songs, sayings, stories and legends of the past, or news and gossip of the present. From his earliest days, Iain was a keen participant and it was there that he first began to take an interest in songs.[15]

Many of the 'strongest' tradition-bearers of all were to be found amongst the travellers or cairds of central and north-east Scotland, for whom home was frequently a tent or caravan. The folk revival of the

1950s and 1960s elevated several members of this marginalised community into national stars, but for generations before this belated fame took hold, their songs and stories were taught and learned within the home, on the road and around the camp fire. For some, such intimate gatherings provided a relaxed, informal environment within which to teach and learn, but others viewed the passing on of the tradition as worthy of a more formalised approach, although still situated within the domestic sphere. The acknowledged queen of traditional singers, Jeannie Robertson, belonged to the latter category, as her nephew, Stanley Robertson, recalls:

> If I was asking her for a ballad – asking her to teach me – she was very, very strict, very very hard. 'All right, laddie, I'll learn you this song, but I want you to sing it right, sing it proper, an' sing it real.'[16]

Music Appreciation in the Home

As some musical theorists point out, music cannot be defined in terms of the production of the sound alone, but must take note of the role both of the listener and of the listening environment.

Music in the Home, Forest Glen, Dalry, Galloway, 1985
(Ian MacKenzie, School of Scottish Studies)

James Parakilis illustrates the point:

> Classical music is no longer itself when it is used as a background music. It becomes like 'easy-listening' popular music, valued more for its geniality than for its genius. But the change that comes over it is a change in the listening, not in the notes.[17]

The 20th-century revolution in audio technology has initiated a 'change in the listening', greatly altering the dominant patterns of musical consumption and appreciation within most Scottish homes. While live music-making carries on regardless, the ubiquity of recorded music within most households today – often different forms playing within several rooms simultaneously – has served to significantly redefine the role of the listener. Music has thus become less of an event, and more part of the space – aural wallpaper perhaps:

> music becomes a form of architecture... The sound becomes a presence, and as that presence it becomes an essential part of the building's infrastructure.[18]

Jonathan Sterne is here referring to the use of background music within the very public space of American shopping malls, but his findings can be applied to the changing soundscape of domestic space also. And yet, the same technology that may encourage an architectural role for music can also facilitate a very direct and highly personalised relationship between music and the individual. Headphones and portable playback devices enable the listener to engage repeatedly and in minute detail with a musical passage in a way that would be virtually impossible in a 'live' or even communal setting. Any suggestion that widespread adoption of advanced audio technologies within the home has necessarily 'dumbed down' music appreciation must therefore be treated very cautiously.

The birth of the British Broadcasting Company in 1922 (from 1927 the British Broadcasting Corporation), introduced a revolution which was to bring music into the home in a whole new way, and open up a brand new chapter in the story of music appreciation. From the outset, it was music rather than speech which dominated the radio airwaves: in 1926, for instance, music made up four hours and forty minutes of the seven hours of daily output. Opera, classical symphonies, chamber music and 'light' or 'dance' music were the most common broadcast genres, most of this music being played 'live' within the studio: there was very little reliance on gramophone records in pre-war British broadcasting.[19]

Indigenous Scottish music was not well represented on the airwaves in the early years of the BBC, but it was by no means absent altogether. The first bagpipe to be heard on the radio, for instance, was that of Willie Ross, who played 'The Lament for James MacDonald of the Isles' in March 1927 as the finale to a programme consisting largely of a lecture on the pibroch tradition presented by Seton Gordon.[20] Through the 1940s and '50s, series such as *Country Magazine, As I Roved Out* and *Ewan MacColl's Radio Ballads* provided a broadcast platform for the kind of traditional music and song that was still being played 'live' within many Scottish homes. But it was the 'foreign' sounds that were coming into these homes that were having the greatest impact on listening tastes. Blues, jazz, country and western and rock and roll provided a very different aural backdrop to the post-war domestic life of the Scottish people from that which had gone before. In time, of course, this directly influenced the patterns of music making as well as appreciation within subsequent generations of the Scottish population. It is interesting to note that it was the rural centres of Scotland, rather than the larger towns and cities, which witnessed the earliest popularity of rock music. This lends support to the claim that broadcasting and the gramophone were highly influential in the dissemination of such new musical styles, for the opportunities to hear this music played live were limited within the rural sphere. Nonetheless, some local entrepreneurs, such as Albert Bonici, were successful in their attempts to lure the top acts to the Scottish rural periphery: The Beatles played Bonici's club in Elgin in 1963.[21]

Custom

While music has been a key ingredient in the forging of buildings into 'homes', so too has been the way we have organised ourselves within them. In the everyday goings-on of the Scottish home, each space was allotted its function. In the grand houses of the well-to-do, this demarcation would tend to be at the level of specific rooms for specific purposes – dining, sleeping, receiving guests – while in the more modest dwellings inhabited by the majority of the population, the one or two rooms that usually comprised the home were by necessity multifunctional. And yet, these spaces retained a significance that went far

beyond mere utility, for various internal parts of the building were imbued with meanings that were treated with reverence by the householders. The hearth, for instance, was a symbol of great importance as the beating heart of the home, while doors and windows, as points of entry and exit, represented boundaries that had to be treated with caution during certain key periods and events. At particular points in the annual cycle, and at times of great significance in the lives of families and individuals, the home became the setting for rites and customs that represent the manifestations of a complex set of beliefs and cosmological blueprints that might be dismissed by some as 'superstition' but which nonetheless retain a potent legacy right down to the present.

Life Cycle

In Scotland, as indeed appears to be the case universally, various stages of the human life cycle are considered to be of particular significance and are therefore marked in special ways. Some of these are based on biology – birth, puberty, death – but others, such as coming-of-age ceremonies and betrothals have more social or cultural roots. Termed 'rites of passage' by Arnold van Gennep in 1909, these life cycle markers attract ritual celebration and behaviour that feeds into the traditional custom and belief patterns of local communities throughout the nation. The specific places within which this activity took place were highly significant, for movement through physical space was often used as a symbol of the metaphorical 'passage' of the individual from one life stage to the next. Some such events required the participation of the wider community and as such were held in public space, while others were acted out within the confines of the private home.

Basing his analysis on a wide range of cultures, van Gennep concludes that each ritualised rite of passage within the human life cycle has three distinct phases: separation, transition (also known as liminality) and incorporation (or aggregation). Rites of separation mark the period in which the individual is removed from the normal social order, and this is followed by a period of transition in which he or she is considered to be in a state of liminality, isolated from the former social role, but not yet integrated into the new one. The final passage involves rites of incorporation through which the initiate is accepted into the new

status. Lynn Holden succinctly captures the essence of the liminality phenomenon:

> Each transition in the life cycle involves a period during which the initiate has no distinct status and is in a state of danger as well as being dangerous to others. The danger is alleviated by ritual abstentions and taboos, often involving segregation from the community and dietary restrictions.[22]

Birth

The creation of new life is of course a time for celebration and rejoicing, and is of such fundamental concern to all societies that it is of little surprise that pregnancy, childbirth and the first weeks of life tend to be demarcated particularly vividly in many cultures. So it is, and was, in Scotland, where both religious and secular belief systems have thrown up a great many rites and customs associated with this primary rite of passage. While the clinical procedures of pre- and post-natal care are nowadays the domain of formally trained professionals – as well as the birth itself – the spiritual associations of pregnancy and childbirth continue to display strong elements of traditional belief, most often articulated simply as 'superstition'. These may be predictive (of the baby's sex, stature, health, complexion, etc.) or protective, aimed at counteracting the evils of otherwordly creatures, diabolic powers or even the jealous gaze of an unfriendly neighbour. Indeed, they may even be ritualised offers of practical advice, based on the collective experiences of generations of mothers and their carers. Here, though, I shall highlight a selection of those rites and practices that centred specifically upon the home.

The confinement of the expectant mother was an important marker of the beginning of the birth process and can be said to represent Van Gennep's separation stage. An important part of this separation was the removal of the men from the scene, and preferably from the house altogether. The comment made by Alice Hick of Leith that 'the men would be out of the house – we rarely saw the husbands' is a scene that many will recognise, although this is one tradition that does now seem to have been consigned to the past.[23] 'She's for the neuk' was a common saying in Orkney, a reference to the 'neuk beds' that were often built into the stone wall of the Orkney homes, and once bedded, it was

considered important to ensure that no harm befell the mother-to-be while in her confinement. This was a time in which she was vulnerable to the goings-on of the otherworld, and so various protection rites were carried out, with the Bible and some form of metal object being among the more common items involved:

> it used to be quite common among women, at the time of their confinement to stick a darning needle in their bed, and place a bible beneath the bolster, and this was thought to keep the fairies away.[24]

The fairies were considered a potent threat during the whole birthing process, the risk lying in their legendary liking for human milk. The protection of the new mother, and her milk in particular, was paramount, therefore, and this was reflected in the large number of rites and practices that relate to lactation:

> Neither could a woman giving suck seat herself on the edge of the bed of the lying-in woman, from the belief that such an action stopped the flow of milk of the lying-in woman.[25]

If this taboo was ignored, and the new mother later found difficulty with feeding, an elaborate procedure was invoked involving the clandestine 'borrowing' of the offending woman's child which was passed under and over the apron to encourage the flow of milk. Such talk of fairy hosts and secret rites may appear strange to us today, but it is surely easy to understand the preoccupation with the potential loss of milk of a nursing mother. Without the back up of modern formula alternatives, a mother's milk was the life-giving force for the newborn, and without it, the child's survival would be unlikely.

During the labour and birth, and indeed for the days following, both mother and child were seen to be in a state of liminality, again a most dangerous period, with the mother not yet 'churched' nor the child baptised. Certain precautions could however be taken in the meantime, with both mother and child being 'sained'. Regional traditions varied on the exact form of this protection rite, although in the north-east in the late 19th century the procedure went as follows:

> A fir-candle was lighted and carried three times round the bed, if it was in a position to allow of this being done, and if this could not be done, it was whirled three times round their heads; a Bible and bread and cheese, or a Bible and a biscuit, were placed under the pillow, and the words were repeated, 'may the Almichty debar a' ill fae this umman,

an be aboot ir, an bless ir and ir bairn'. When the biscuit or the bread and cheese had served their purpose, they were distributed among the unmarried friends and acquaintances, to be placed under their pillows to evoke dreams.[26]

The final part of Walter Gregor's description hints at another important signature of the celebration of rites of passage: the close involvement of other members of the community, and not just the family concerned. The home, in this respect, while obviously affording a degree of privacy, was also a centre of community gathering. There were, however, strict conventions regarding the concept of 'visiting', none more so than in relation to another major life marker – marriage.

Marriage

As he approaches the marital home for the first time since the wedding ceremony, the modern-day groom is probably aware of the tradition that suggests he should carry his bride 'over the threshold'. Should he rise to the challenge, then he is embracing a general concept that appears to be of great antiquity, and that lies at the heart of many of the rites and customs associated with marriage in Scotland, for he is negotiating a conceptualised boundary. During the whole marriage process – conceived of as a journey rather than a single event – those involved had to pass through various stages of ritualised behaviour, each representing a change in their status. The metaphorical boundaries marking the beginning and end of each phase were usually represented by physical boundaries, some relating to public space, and others to the home. The threshold of the marital home is just one example and can be said to represent the boundary between these public and private spheres. Neill Martin has closely examined marriage ritual in relation to Scotland and he explains the point thus:

> The tripartite structure of separation, transition and incorporation which characterises the marriage ritual indicates a symbolic conception of the change in the central figures' social position, a step-by-step movement towards the public acknowledgement of new status, identities and responsibilities. This symbolic movement is linked with actual spatial passage...[27]

This 'spatial passage' was often accompanied by ritual dialogue and the

Scottish tradition in this respect was just one localised manifestation of a very widespread international phenomenon, elements of it being found in Ireland, Wales, Brittany, Germany, Austria, Norway, France, Russia and Japan. The homes of both the bride and the groom each became significant spaces during this marriage journey, and specific physical features within these homes also took on special associations.

The 'betrothal' usually took place in the bride's home, and in Highland society normally involved two stages, the rèiteach beag or còrdadh (small betrothal) at which the permission of the girl's father was first sought, and the *rèiteach mór* (big betrothal), a more formalised cere-monial occasion attended by close relatives and friends of both parties. The suitor would often be accompanied by a matchmaker, usually a strong, healthy local male who had the wit and verbal skill to conduct his duties properly. These duties included taking part in an allegorical dialogue with the girl's father in which permission was sought for the marriage to take place. To make the request in overt terms would be dangerous, as in the event of a negative response there would be

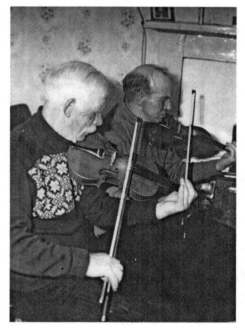

House fiddle session: Willy Henderson and Bobbie Jamieson, Gloup, Yell, Shetland, 1970
(Peter Cooke, School of Scottish Studies)

no way for the father to couch the refusal in a gentle and polite manner. The use of allegory got round this problem, for as Martin explains, 'one of the functions of this device is to provide a method of refusal which would preserve the dignity of the suitor, regardless of the outcome.' The usual practice was to refer to the girl in metaphorical terms:

When the company has had a dram out of the bottle, tea follows, after which the friend contrives to introduce the subject of their visit, in the best form possible. If he is a man of wit, or eloquence, he has the advantage in the use of these gifts, in discharging his delicate task. Here is an example of the

business part, of what is reported to have been said on such occasion:– After a few suitable words by way of introduction, the friend went on thus:– 'We have been building a house, and have got it all ready for the roofing, but we find we are short of the leg of a couple, to match another we have already got. We know you have got such a thing to spare, and as we are wishful to have the best that can be had, and being assured of the good quality of those you have got beside you, we have come to request the favour from you. If you can see your way to oblige us, you will contribute greatly to our house and to our happiness'.[28]

The specific metaphor employed could vary, although often it related to the occupation of the girl's father, e.g. a lamb for a crofter, a boat for a fisherman, etc. Where the father was keen to add to the verbal drama he may well have taken the metaphor further: he might explain, for instance, that the boat 'has never yet been sailed in'!

The space within the home in which this ritual drama was acted out was significant, with the hearth and the table together providing a key focus for the action. Both are associated with the basic components of hospitality – warmth and food – but there is strong evidence to suggest that these focal points of the home took on more subtle meanings during the acting out of customs such as the *rèiteach*. According to one South Uist account, the representatives of the prospective bride and groom were spatially divided into two camps, their respective positions leaving no room for doubt that it was the girl's family that was in the position of power within this relationship:

> The hosts' 'solemn decorum' is the first indication that this is no ordinary visit, but a clearly-structured ritual event. The spatial separation of the two 'camps' is clearly delineated; the girl's family are gathered round the fire, physically aligning themselves with their representative who occupies the 'superior' end of the table. The table is a 'male' space which becomes the 'duelling-ground', and the visitors are conducted by their hosts to their 'inferior' place at the end of the table furthest away from the hearth.[29]

Another place of great metaphorical significance within the home, particularly in relation to marriage, is of course the bed. Consummation was an essential part of the marriage journey, but the exact stage of the process at which it took place could vary. In Shetland, the betrothal was centred around the 'speiring night'; 'the couple were expected to sleep together that night as a seal of the contract, but not to have intercourse again until after the wedding.' With the 'bedding' of the bride

taking place in front of many witnesses, we can see the inversion of normal social order when the private sphere of the bedroom is brought fully into the public domain. This might be done in the company of a large gathering of friends and family, and in Shetland was even accompanied by music from a fiddler. John Irvine provided the music on many such occasions:

> The bride was put to bed, and the whole lasses, the whole women went into the bride's hoose and they put her to bed. And there was no man allowed in there at all – unless the fiddler – and I was always it so... I had to step up and play the fiddle... There were no room to dance you see, the hoose was aa full as she could ha'd you see, there were 50 or 60 lasses'd be within. Then after they got her in, aa the men cam in wi the bridegroom.[30]

There are many other examples of the importance of particular spaces within the home in relation to marriage, but this rite of passage does in fact share a good deal of common ground with the final journey in the life cycle, and it is to this that we now turn.

Death

> There was no privacy, no play space, no work space, no place to get out of the tensions of family life, to think, relax or sulk. There was not even space to die.[31]

Christopher Smout here paints a most striking picture of the problems associated with overcrowding in many of Scotland's urban areas, particularly in the 'single end' tenement flats comprising only one room. For those living in two-roomed houses, the 'good' room (the 'ben' end in rural dwellings) at least provided the chance to define the use of the limited space more specifically. Indeed this demarcation was adhered to almost religiously, the kitchen accommodating most of the everyday activities such as cooking, cleaning and sleeping, leaving the second room relatively free for special activities. It was to the good room that an expectant mother might retreat for her confinement, and there that friends and family might gather to bring in the new year. And until the 20th-century specialisation of commercial undertaking took hold, it was there too, that the bereaved family would lay out its dead; it was this 'liminal' space that was denied the single-end family. Referring to

the high level of infant mortality in 19th-century Glasgow, one Medical Officer of Health commented:

> Their little bodies are laid on a table or on a dresser so as to be somewhat out of the way of their brothers and sisters, who play and sleep and eat in their ghastly company.[32]

And yet, lack of space would certainly not stand in the way of the plethora of rites and actions that had to be undertaken within the household immediately following the death. Well into living memory, in rural and urban communities alike, families knew exactly what was expected of them, this knowledge being based entirely on unwritten tradition. As with marriage, space, liminality and boundary seem to lie at the heart of much of this activity. Doors and windows were opened as soon as the death occurred, 'to give the departing spirit full and free egress, lest the evil spirits might intercept in its heavenward flight'.[33] Clocks were stopped – a clear sign that the household was now entering a liminal time zone between the occurrence of the death and the final incorporation into the afterlife following the funeral. Mirrors were covered or removed, perhaps to avoid confusing the departing spirit or, as some adherents to the tradition suggest, to prevent the family from seeing the face of the deceased appear in the mirror. Blinds or curtains were drawn as a signal that the normal order of life had been upset, although this might also serve to communicate the death to the members of the wider community who would then draw their own curtains in turn.

This involvement of the wider community is essential, for it serves to reinforce the sense of belonging that membership of any community demands. Indeed, it is manifested in several ways in relation to a death. After the body was laid out or 'straiked' (stretched) on a board or table and dressed in the 'deid claes', usually by the local howdie wife, the room in which the body lay became public space as relatives, friends and neighbours came in to pay their respects. For the two or three nights before the funeral was held, neighbours might also take turns to sit with the body to 'watch' it – essentially to protect it from evil spirits. In many instances, this took the form of a lykewake, a communal gathering held in the room in which the corpse lay, and at which much food and drink was taken:

> the great attraction of the old-style lykewakes was the hospitality

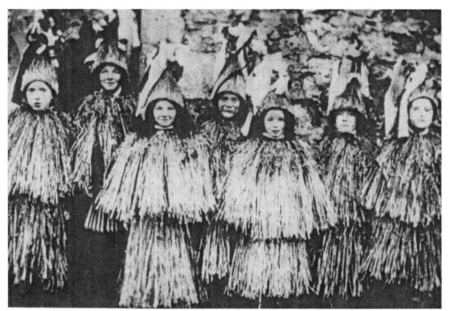

Guisers, Fetlar, Shetland (School of Scottish Studies)

shown at them, all part of 'decent burial', and no one minded how long the interval between death and burial might be. There was sure to be a plentiful supply of tea, beer and bread, with perhaps cheese, while new pipes and tobacco as well as snuff were provided for the men.[34]

Representatives of the community would also attend the 'kisting' – the placing of the body into the box or coffin ready for removal from the house for the funeral service and the burial. And just as arrival into the world was marked in particular ways within the home, and the first entry into the home following marriage, so too was the final exit from the house, another boundary that had to be crossed on life's journey. The body was removed feet-first, so that it could not see the way back into the house, while there was also a long-standing tradition in parts of rural Scotland that the corpse should not be removed through the doorway at all, leading to some very complex extractions through smoke holes, windows or even through temporary breaks in the wall especially pulled down for this specific purpose.[35] In more recent memory, the use of windows for extracting the coffin was most often associated with suicides.

It is clear, then, that there are common links between all of these main life cycle rites of passage – birth, marriage and death – in that in

each case different elements within the home take on special significance. Particular spaces are clearly 'set apart', underlining the liminality that is a central feature of these journeys from one status form to the next. These themes are by no means peculiar to lifecycle events, however, for they also appear in activities and beliefs associated with seasonal custom.

Calendar Customs

The Scottish home has for long been the site for the concentration of rituals and customs aimed at marking the passing from one phase of the year into the next. This may relate to the seasons, to religious observance, to important events in the economic production cycle such as harvest, or indeed to a host of other contexts and purposes. What scholars normally refer to as the four quarters of the old celtic year have, however, provided the foundation stone for much of the custom associated with calendar celebrations within the Scottish home. *Samhain*, 1 November, and B*ealtain* (Beltane), 1 May, are said to have marked the beginning of winter and summer respectively, while two other divisions occurred in between, Lunasdal (or Lammas) on 1 August and Imbolc or St Bride's Day on 1 February (the latter having become closely bound up with Candlemas on 2 February). In Gaelic tradition the night is considered to belong to the following day rather than the one that has just gone, and so the 'eve' of some of these markers attract celebration too: *Samhain* festivities have been replaced with those associated with Halloween on 30 September, for example.

Other dates brought yet more cause for domestic celebration. Yule or Christmas was marked enthusiastically in certain areas, especially those regions where Episcopalian or Catholic adherence predominated, yet was virtually ignored by large sectors of the rest of the population who preferred to wait for New Year before breaking from the normal routines of daily life. Here, of course, is another example of the emphasis being placed on the 'eve', Hogmanay attracting more popular interest in Scotland than New Year's Day itself. The term Hogmanay may derive from the medieval French *aguillanneuf*, a word used to refer either to New Year itself or to a New Year's gift, although an alternative suggestion is that it relates to 'hugman' bread given to beggars at the end of Yule. The earliest use of the word within a Scottish context dates

to the beginning of the 17th century.

The manner in which events such as these were marked (and still are, in many cases) varied through time and space, but certain common traits can certainly be identified. As with life cycle rituals, movement from one calendar period to another involves a transition of status, introducing a state of liminality that can be exploited for good and for bad. It is a time for foretelling the future, for disguising identity, for undertaking role reversals, for commemorating that which has gone and embracing that which has yet to come. People come together to perform rites aimed at celebration, purification, protection and charity. Some of these practices are communal and public, others personal and confined to the family and the private home, while the concept of 'visiting' unites the two.

The following sections provide a brief taster of a selection of these traditions as they pertained to life within the Scottish home.

Protection

The use of fire and water and the employment of verbal sayings, chants or songs are among the most common methods of offering protection to the householders at these special times of year. Fire was of course to be found in the hearth, the 'beating heart' of the home, and so it was the hearth that acted as the focus of much of the ritualised goings-on relating to the calendar. For those who could afford the necessary fuel, it was normal practice to keep the fire alive in the hearth at all times as it was considered bad luck to let the flame go out. Thus, the fire was 'smoored' or smothered at night, the embers being covered with a large peat or log, ready to be coaxed back into full life the next morning. Keeping the fire alive was of particular importance through the transition from one period to another, and so on Hogmanay in particular great care was taken to 'rest' the fire correctly:

> On Hogmanay the fire was 'ristit' by the 'gudeman'. The sign of the cross was made on the peat that was put among the burning ashes. The peat was then covered up by the ashes, and after the whole was smoothed, the sign of the cross was made over the whole. No woman was allowed to take a hand in this work, though it was her province to do this work at all other times.[36]

This passage captures several elements that are commonly found in relation to such liminal periods: the use of fire, the grafting of Christian symbolism onto older pagan beliefs, and the gender role reversals are all common signatures of the Scottish tradition. In some areas, the smothering of the hearth flame was accompanied by the recitation of a blessing. Alexander Carmichael included several of these in *Carmina Gadelica*. One, simply entitled 'Smooring the Fire' is not untypical:

> The sacred Three
> To Save,
> To shield,
> To surround,
> The hearth,
> The house,
> The household,
> This eve,
> This night,
> Oh! this eve,
> This night,
> And every night,
> Each single night.
> Amen.[37]

While many of the practices associated with the marking of calendar customs took place within the domestic sphere, individual households did not exist in isolation and were linked to the wider community in various ways. One symbolic act that served such a purpose was closely associated with Beltane. To celebrate the beginning of summer, a large community fire was built (*tein eigin* in Gaelic), often on a prominent hillock, and cattle were driven past this as a ritual purification to protect them for the coming year. It was also a chance for the community members to re-assert their common sense of belonging, for all the household hearths were extinguished and relit anew from the communal source, rendering them 'people of one fire'. The symbolism was powerful and could be used as a social sanction as well as a sign of common identity:

> In Rannoch the *tein eigin* was produced within living memory. My father, who died at the age of 82, remembered taking part as a boy in the production of *tein eigin* in a distant glen on the borders of

Inverness and Perth shire. It was then the custom for each family in the district to receive a brand from the sacred fire to kindle the domestic hearth. But those who were in arrears of rent, had failed to pay their just debts, had been guilty of theft or mean-ness, or were known to have committed certain offences against good morals were deprived of the privilege.[38]

The links between households might also be strengthened at other times through various forms of visiting, often formalised through certain rituals, and a task commonly bestowed upon the young men of a community. Guising belongs in this category (the word simply means disguising), and while certainly associated with Halloween, as at present, it was New Year that attracted the most enthusiastic sartorial frolics. In the Highlands, bands of youths, some dressed in animal skins, would roam from house to house welcoming in the new year, and offering the householders protection from evil spirits for the months ahead. This protection was achieved through a combination of fire-based rituals and chants and was offered in return for food and drink.[39]

Ritual Hospitality

It would be misleading to imply that guising was aimed solely at offering protection to the householders, however, for often no protective rites were present, the emphasis being placed instead on the request for charity. Groups of young men would wander from house to house requesting meal, cheese and other foodstuffs that would then be offered to those in need within the local community. 'Thigging' as this was called, was often accompanied by the singing of a song requesting alms:

> Rise up gueedwife, and dinna be sweer,
> B'soothan, b'soothan.
> An deal yir chirity t' the peer,
> An awa b' mony a toon.

The dramatic tendency which was often integrated within these guising traditions reached its high point in the mummers' plays, common in many parts of England in the 18th and 19th century and surviving in Scotland as 'the Galoshins'. This folk play, based on a death and resurrection motif, was widely known in Lowland Scotland

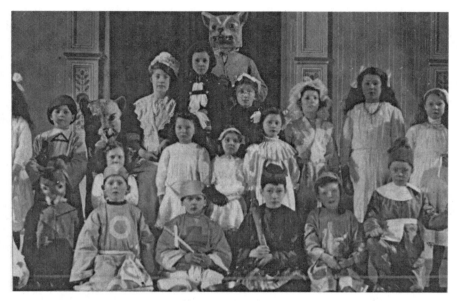

Galoshins Play, Dumfries, 1915
(Photographer 'Heugham', School of Scottish Studies)

and the Borders through the 19th century, and survived in pockets into the second half of the 20th century. One early account from Abbotsford captures its essence:

> Yesterday being Hogmanay there was a constant succession of Guisards – i.e. boys dressed up in fantastic caps, with their shirts over their jackets, and with wooden swords in their hands. These players acted a sort of scene before us, of which the hero was one Goloshin, who gets killed in a 'battle for love', but is presently brought to life again by a doctor of the party. As may be imagined, the taste of our host is to keep up these old ceremonies. Thus, in the morning, yesterday, I observed crowds of boys and girls coming to the back door, where each one got a penny and an oaten cake. No less than 70 pennies were thus distributed – and very happy the little bodies looked with their well-filled bags.[40]

While the houses of the landed gentry were no doubt viewed as a lucrative source of revenue by the guisers, the performance of the play might take place in any household. Given that their presence was seen to encourage fertility and prosperity, coupled with the widespread belief that it was bad luck to let the lads leave empty-handed, they could usually be sure of a reward of some kind wherever they went.

Summing Up

Cultural creativity has always been present in our homes. Here I've just sketched out a few examples based on two forms of tradition – music and custom. Both saturated the lives of every generation, at all levels of society, in town and countryside, north and south. They have brought us meaning, sometimes on a functional level but often running deep into our sense of self. They are part of the way we have tried to make sense of our world, and indeed of other, unknown, worlds. And when taken out of the home, onto the public stage – 'performed' – they take on new meanings, new life, new significance. They have helped to fuel the creative minds that lie at the heart of 'the traditional arts'. So let's now leave the home and head out into that world.

CHAPTER 3

Voicing Place

SCOTLAND IS A NATION of many parts. We have a tendency to set these up in opposing pairs – urban versus rural, east versus west, Highland versus Lowland, old versus new, heart versus head – but in reality the picture is much more complex than that. While there is no doubt that 'national' identity is a very strong component in people's lives, there remains a key part of our being which sits at the level of the local. As a nation we sometimes forget that – especially at times where 'nationhood' takes centre stage as it did for a decade or so in the lead-up to the devolution referendum in the 1990s, and again now within the context of the independence debate. What it means to be Scottish, or living in Scotland, tends to take precedence in these debates over what it means to be from or even just *in* any one of its constituent parts. There is a strong balancing force to this, however, for we don't have to search far to find some powerful voicings of place.

For me that has been one of the defining features of our greatest creative minds here in Scotland: that ability to voice what we all feel about the spaces we inhabit, the places we breathe in and wander in and which our very presence helps to shape. And it is also at its finest when there is a willingness to link the local with the global. Neil Gunn was a master of such reflection, taking us there and beyond – wherever his there happened to be. I urge you to seek out some of his musings on place, many of them gathered in the collection of his essays brought together in *Landscape and Light*. Some of his titles point us towards the places themselves – 'Caithness and Sutherland', 'East to Buchan', 'My Bit of Britain' – others to things which went on there – 'One Fisher Went Sailing', 'The French Smack', 'The First Salmon'. From there we are guided towards the questions that the marriage of place and happenings throw out at us – a search for meanings. Six such essays, 'On Backgrounds', 'On Tradition', 'On Belief', 'On Looking

at Things', 'On Magic', 'On Destruction' still see him grounded in his homeland, but from there it is on outwards to the places beyond, and to his fascination with the philosophies of the East which resulted in a long flirtation with Zen Buddhism. 'The Heron's Legs', 'Highland Space', 'Light', 'Remember Yourself', 'The Miraculous': each reveal a mindscape which flies eastwards and back again, planting itself back in its native soil somehow altered and reshaped. Its greatest reflowering, in Gunn's case, is in his 'spiritual autobiography', *The Atom of Delight*, published in 1956 and released into a literary world which by then had gone somewhat cold on such perceived personal escapism.

What gives Gunn's place-writing its ability to speak so powerfully is its grounding in the lived lives of those who had gone before him. It is not the describing of the places, rather the accounting of their meaning for those who peopled them. And that meaning is not always positive, not always something which can be tholed. He opens one of his Zen-infused essays:

> There is the story of the man who after the last war (he had done most of his fighting in the desert) came back to his home, a croft between mountains, and stood the austere scenery for three days and nights, and then beat it. The mountains had got on top of him, the silence, the loneliness. I was told the story at the point where he was passing through Inverness on his way south. Apparently he had no definite destination. He was a piper, too.[1]

That final 'too' is intriguing: perhaps as a piper we might assume he 'belonged' on a croft between mountains, (although few of us actually do) but perhaps his war had changed everything. For Gunn, it doesn't take a war to change it all, just a going-away. It was this, he tells us, which sent his new-found hero, Jung, 'to foreign places and other culture patterns, so that he might look back at the one he had left. When this is done, astonishing things can happen.'

Two Pipers

That combination of words – piper, mountains, culture patterns, astonishing things – leads me directly to one young man who brought them all together in a far too short yet inspirational life, and who shared Gunn's gift of seeing and hearing the pathways from the local to the global. I first met Martyn Bennett when I was studying at the School of

Martyn Bennett (© BJ Stewart)

Scottish Studies where his mother, Margaret, was one of several equally inspirational lecturers. Martyn must have been around his mid-teens at that time, I was five years older, and we shared some tunes on the pipes together at the department's regular ceilidhs. He was a confident young lad, eager to learn, full of energy and questions and music. He was already a highly accomplished piper, pretty useful on the whistle too, and by all accounts already able to handle a violin, piano and guitar each to a very high standard. I can't claim to have known Martyn well, but we bumped into each other from time to time as the years wore on, enjoying a good blether and the odd tune or two, especially once we both discovered the newly revived Scottish smallpipes which made life easier when it came to having a casual jam. But I did watch this young lad from the sidelines, fascinated by the journey he was taking, from the Edinburgh City Music School at Broughton High, to a classical training at the Royal Scottish Academy of Music and Drama, to the mysteries of the hi-tech recording studio, and from there, on out to the world. It was a world which embraced him, lauded him, challenged him and which deeply mourned him when it lost him to cancer at the age of 33 in 2005.

At the outset I wasn't sure to which chapter Martin belonged, but

having revisited a lot of his work, and my own memories of him, it became obvious to me that the one word which sums it up for me is 'place'. Martyn planted his two feet in a place, felt the grit, looked outwards from there and listened. He was the most spiritual musician I ever knew I think, not in that trite, new-age manner but in a genuinely rooted and thinking and feeling way which grounds him in many soils and makes his music genuine and deep. His places were many: Newfoundland, where life began, including time spent in the Cordroy valley where Highland settlers had left their linguistic legacy through the continuation of spoken Gaelic and where his father, Ian, played fiddle to him constantly; Kingussie, where he learned his first instrument, the great Highland bagpipe, from a fine player and teacher, David Taylor; cities – both Edinburgh and Glasgow – his main introduction to classical violin and piano, but also his discovery of urban beats which for him was not a great leap at all:

> I think for a classically trained composer, the dance world is such an attractive place as it encapsulates the same musical ethos. It is principally about sound and scale, tension and release, power and detail – much like the orchestral canvas perhaps. It is no wonder that many of us end up composing using technology.[2]

The islands of Scotland also had a strong pull for him. Skye, especially the Cuillins, which feature so strongly in his music and its naming. Mull, where he settled with his wife, Kirsten, herself a very fine musician and fellow RSAMD graduate, and from where he fought his later battles with cancer and also produced some of his finest work. Glenlyon, in Highland Perthshire, which inspired a song-cyle and entire album. Martyn worshipped hills and mountains, which he urged us all to discover:

> I hope when you listen or dance to these tunes you get a sense of your own roots. If you push back the pressure of Urban development for a second you might remember where you came from. Go climb a mountain and see.[3]

And yet other places captured his imagination too, far off places, sometimes going there physically, other times, like Neil Gunn, allowing them to come to him. One of his great musical heroes was Omar Faruk Tekbilek, a Turkish woodwind and lute virtuoso, and like Martyn, a child prodigy and a deeply spiritual man:

Omar Faruk's music is rooted in tradition, but has been influenced by contemporary sounds. He views his approach as cosmic and his commitment to music runs deep. The four corners of his creativity emanates mysticism, folklore, romance, and imagination. Like Omar Faruk himself, his music symbolises diversity-in-unity.[4]

In fact, that is not a bad summing up of Martyn's music too – rooted, yet global.

Martyn's eponymous first solo album, released in 1996, forced people like me to sit up and take note of musical words and worlds I had barely ever heard of, never mind understood. I don't know if it was those five years between us that did it, or if I was just too square and set in my ways, but I certainly missed out on the 'summer of love' of which he speaks in remembering 1994, and the dj sets in Edinburgh night spots with names like Squid, Sativa and Slam. Martyn heard something in that scene which spoke to him, a freshness and excitement which on the surface may have seemed at the other end of the musical spectrum from the traditional material he knew so well, but which in his ears and imagination sprang from the same source.

Of course, grafting traditional tunes onto contemporary genres of music was nothing new: crossovers with classical, rock, jazz and pop styles had been on the go for quite some time by then, with varying degrees of success, and it was inevitable that experiments involving the beats of the club scene would emerge at some point. Having worked with Martin Swan on his *Mouth Music* project, a major step in that electronic direction, it was perhaps inevitable that Martyn would head off down that road most enthusiastically. His first album was a notice of intent, a gentle invitation to step inside and feel the club scene from the safety of the couch. I recall accepting the invitation with a healthy scepticism, not at all convinced that the recipe would work for me, but willing to lend an ear all the same. But I loved it. There was nothing frivolous there, no trendy gimmicks, no sense of being in the presence of machines devoid of human soul. This was deep-rooted, complex art, driving yet melodic, meaningful yet peppered with humour.

It was also music firmly grounded in place. The key melodic voices were Highland pipes, Scottish smallpipes, fiddle and whistles, giving the tunes an unmistakably Scottish accent with some borrowings from Ireland. Some of the tunes I knew and played myself, 'The Swallow-tailed Coat' and 'Farewell to Erin', but there was a heavy sprinkling

Martyn Bennett (© BJ Stewart)

of Martyn's own compositions in there too. What impresses me most was just how much is going on in these tracks. On each listening there is more to discover in the layers of sound and intriguing sonic vignettes. It is dance music, certainly, but listening music too, the first stirrings of a 'brave new music' as Hamish Henderson was later to call Martyn's work.

A sense of place also underpins his follow-up albums. *Bothy Culture* developed the dance beats structure a good deal further, again bringing in words and terms which were new to me at the time: drum and bass I could understand, but trippy, breakbeat and hip brought us folkies a whole new language and culture that amused and intrigued in equal measure. Yet these are just words: what I discovered when hitting the play button was more sonic adventure that teased and challenged and delighted. Again I thought of Neil Gunn when I first heard this mix of the 'foreign' and the local inviting us to contemplate at once the difference and universality of creative human culture. 'The Tongues of Kali' might well take us some way to the east, yet what is Gaelic *puirt a beul* – mouth music – if not singing in tongues? Or for that matter *canntaireachd*, the system of vocal sounds used to teach and transmit pipe music down through the generations and centuries? And that rooting of the album in the Gaelic tradition is cemented by inviting Sorley MacLean to voice the English translation of his seminal poem, 'Hallaig'. The poem speaks of the desolation of his native Raasay following The Clearances, and is rich in the imagery of birch wood, slender rowans, and the ghosts of the people who once walked amongst them. As the scholar John MacInnes has remarked, the poem is

> an utterly new statement which is emotionally subtle and powerful, unsentimental, and wholly Gaelic. Through his genius, both the Gaelic sense of landscape, idealised in terms of society, and the Romantic sense of communion with Nature, merge in a single vision, a unified sensibility.[5]

How, then, is that mood of reflection, of sorrow, of regret, of anger, to be captured in an underpinning soundtrack? A bagpipe lament? A wretched, anguished vocal outpouring? No, the feel is actually one of gentle optimism, of an almost jaunty expectation that all is not lost. Indeed it is not, for as Sorley had declared, 'the dead men have been seen alive'. That deep-seated Highland belief that we each leave our indelible mark on the landscape as we pass through this life is there in this music as it is in the poem itself. It is a potent pairing.

That sense of just passing through must have been a constant companion to Martyn as he worked on his later projects, the sharp awareness of his own mortality no doubt finely tuned as he came to terms with his cancer. Following the release of *Hardland*, the live gigs took off even more forcefully, although he recognised that this was perhaps a step too far towards modernity for some of his followers. *Glenlyon*, a collaboration featuring the vocals of his mother, Margaret, brought him back to a gentler, more contemplative mood, closer once more to the thin soils and bare rock of this most emotive of Perthshire glens, where the songs and tales of generations seem to reverberate all around. It's a place I know well, just a couple of glens away from my own, where my mate Andy Shearer lived, where I recorded the voices of some of the locals, and the only place I've ever hunted. When the hinds were shot, we dragged them down to the back of the big house at Chesthill, in my case with a strange mixture of guilt and pride.

The album speaks to me for that, and many other reasons, but I know it speaks to others equally powerfully. The songs here are all in Gaelic: no native speakers of Perthshire Gaelic exist now, but their songs still do, and between them Martyn and Margaret spin them into a song cycle which is blended with the soundscape of the glen itself:

> It is my hope that this recording conveys an authentic look into those old ways without the use of nostalgia or overbearing anthropology. Many of the sounds that are specific to these songs may have geological implications as well as seasonal ones and I spent several weeks making field recordings of elements such as wind, water, agricultural and maritime machinery, birds, and even insects (listen for the bee!). These are the sounds that pertain to a song's ambience or inner meaning. In many ways my interpretation of these songs returns to the very first track – Gaelic song sung by my great-great-grandfather, Peter Stewart, who never saw an orchestra, but, as far as I'm concerned was surrounded by one in his daily life – birds, horses, harness, ploughs, and the grind of everyday work.

'Authentic' and 'nostalgia': two keywords there for any of us who deal in tradition. The first is seen as a positive, the second is usually shunned. We have to be careful with both, though, for their meanings can be slippery. Authentic to what? And what is wrong with a wee touch of longing for the past? Actually, nothing at all if it doesn't take over, but often it does, and that becomes a problem, blinding us to reality. The one thing to avoid with a search for authenticity is to conceive of it as an odyssey back in time until we somehow arrive at a golden age of tradition, a time when that tradition was true or whole, perfectly formed, before time itself had eroded it down to a mere stump. That can happen, but it rarely does, and the idea fails to give any credit at all to the concept of change. I do think we fall into that trap a lot when talking of the past, but it is not what Martyn means here. For authenticity is really about understanding, about empathy, about *getting it*. It is about seeing and hearing from the inside, taking the time and trouble to get in there, either directly if it is still there and breathing, or through the memories and experiences and voices of those who lived it if it is not.

For me, Martyn's creative journey reached its greatest heights of art and authenticity with his final album, *Grit*. By this time he was too ill to play any of his instruments himself, and it is a masterpiece

Lizzie Higgins, One of the voices on Martyn Bennett's *Grit*
(Ian MacKenzie, School of Scottish Studies)

of creativity, bringing archived voices and technological manipulation together into an outstanding tribute to the marriage of tradition and modernity. To take an iconic voice like that of Sheila Stewart and elongate it electronically with a driving techno soundscape underneath seems about as far away from the 'authenticity' of the berry fields of Blair as we could possibly imagine. Yet in fact it is a highly moving tribute to the voices, personalities, cultures and lifestyles of all those who have felt tradition most keenly, most tangibly, most wholly. In *Grit,* Martyn has voiced his understanding of their place and his, and that is a very fine thing indeed.

I headed this section, 'Two Pipers'. The other one who has left an immense legacy, bringing a potent mix of tradition and innovation, is Gordon Duncan. Like Martyn, Gordon emerged out of a family background that was steeped in music and the culture of the folk, and it is a sad coincidence that we lost them both in the same year. Born in 1964, a native of Pitlochry, Gordon died tragically, by his own hand, at the age of 41, but the musical legacy he has left us is immeasurable. Gordon was two years above me at school in Pitlochry and we both started piping around the same time, but it became clear, even as a ten-year-old, that he was destined for the top of the tree. He learned at a prodigious rate, developing a clean, precise and fluent fingering style that was later to become the envy of the piping world, but with it, a feel and flair and imagination that set him apart from other technically gifted players.

As a teenager, Gordon followed the expected path of competitive playing, winning most of the contests he ever entered: the rest of us were playing for second place. But the strict rules of competition were always going to be tethers for him and he strained at that leash, desperate to explore new paths. And that is what he did, not just exploring them, but creating them, for where Gordon ventured others followed. He welcomed that, and was generous in the time he gave those who sought him out, but insisted that as musicians they would have to learn the basics thoroughly before they could or should take to the new roads. That was true, too, of other players who were blazing new trails along with Gordon, Fred Morrison and Allan MacDonald in particular, both of them saturated in piping tradition as well. Therein lies the authenticity, the reverence for the generations of players before them who had collectively arrived at the advanced knowledge and

finely honed techniques that made this most bestial and unpredictable of instruments actually work. That is the crucial point, for like Martyn, Gordon *understood*. In fact he understood deeply, and listened to the great players of former generations with conviction and admiration. One of his heroes was John D Burgess, himself a child protégé in the 1940s, having won two of the top honours in piping, the Argyllshire Gathering and Northern Meeting gold medals, by the age of 17. To us as boys in the 1970s, Burgess was the 'King of Pipers' and I well recall Gordon's father, Jock, taking us to hear him play a recital in the Weem Hotel, Aberfeldy. We must have been in our early teens at the time and we were just blown away with the man and his music. In later life Gordon often referred back to that night, recalling the flair and presence of the man. In fact, he mentioned it the very last time I saw him. To Gordon he was a hero, and it is a sad irony that we lost John as well in 2005, a year that saw the passing of these three giants of Scottish expressive culture.

Gordon's death puts his achievements into sharper focus, and a few years on, the world of piping now seeks to celebrate rather than mourn. And there is plenty to celebrate: he has left us at least one hundred tunes, many of them now staples of solo players, pipe bands, folk bands and musicians well beyond the piping community. As a composer his name belongs alongside those icons of piping from generations past, GS MacLennan, Donald MacLeod and John MacColl amongst them. Each of them brought a particular stamp, an individual flavour, to their composing, a quality shared by Gordon whose tunes seem to seek out a melodic thread of a kind that simply never occurred to other writers, and when we only have nine notes to work with, that is no easy task. And if his tunes were unique, his own performances followed the same path. Already by his late teens he had developed a style of playing which brought energy, drive and a touch of wildness, to a musical integrity which came from that deep understanding of the roots of the tradition. We talk of music being in the blood, and that was certainly the case with the Duncan family. His father hailed from the farming folk of Buchan in the north-east of Scotland, and was himself steeped in the earthy folk song tradition of the area. He is regarded as one of the finest exponents of the bothy ballad tradition, a status recognised by his induction into the Scottish Traditional Music Hall of Fame in 2007. Gordon himself was given the same honour posthumously and his brother, Pipe Major

Ian Duncan, completed a remarkable and unique family record, having been inducted in 2011.

Gordon had a few run-ins with what might be termed the piping establishment, especially as represented by Seumas McNeill, then Principal of the College of Piping in Glasgow. A highly committed stalwart of competition-style solo piping, Seumas had very strong opinions on what was good and what was bad within the art form, and was never shy in voicing them. He did so, dramatically and publicly, on the BBC airwaves following the final of a knockout contest in 1993 featuring Gordon and his namesake, Gordon Walker. Both played highly charged, explosively fast-fingered sets, although with some more gentle and laid back contributions too. When awarding the prizes, Seumas lambasted them both, saying if he had known piping was coming to this, he'd have taken up another instrument instead. Gordon's response was not immediate, but came in the tongue-in-cheek title of his debut album a short time after, *Just For Seumas!* Yet I've never felt that this should be taken as a sign that Gordon was conducting some kind of one-man struggle against the conservative establishment of piping. I don't believe that was his intention, for Gordon saw himself as a part of that tradition, he just had very different ideas from them as to how it should be allowed to develop and grow. He never lost sight of the legacy of the older generations, but like Martyn, he felt that strong desire to move it forward in his own way. People, after all, had been doing that for generations: if they had not, we would still be playing the music of the ancient past on hollowed-out tubes with the rudest of reeds.

And also like Martyn, there is a multi-layered sense of both place and time in Gordon's music. That comes from his home soils of Perthshire, certainly, as well as the Western Isles and his father's north-east roots, and it comes also from his travels to the places which embraced him and his music most enthusiastically. Ireland was a big pull for him, and he spent some time there at an early age learning to play whistle their way. There was more than a hint of Irish influence in his compositions and his style of playing, and other Celtic nations were very much on his radar. From the first time he visited the Lorient Festival in Brittany in 1980, he was hooked on their distinctive tradition of dance-centred piping, and the Bretons welcomed him as one of their own from the start. (That may have been helped by his unusual antics: I'll never

A National Treasure: Gordon Duncan (Greentrax Recordings)

forget the look of amazement on a sea of faces as a Harley Davidson roared past with Gordon playing reels from the precarious comfort of the pillion passenger seat!) It was on that trip that most of us first heard the wonders of the Galician gaita, a high pitched bagpipe which was going through a major revival in the north of Spain, and which sounded foreign yet familiar at the same time. Gordon was impressed with that indigenous tradition, and we were intrigued that their tunes, especially those which sounded like our own 6/8 time jigs, sat so easily under our Highland fingers. Perhaps too much is made of the whole Celtic brotherhood idea, that we all share one underlying culture, but there is no doubt that our various bagpipe-centred traditions do seem to feel right at home when they are swapped between us. Take a listen to Gordon's final album, *Thunderstruck*, and be transported between Scotland, Ireland, Brittany and Galicia, and you may well be persuaded.

All those who knew Gordon or who have been familiar with his music will have their own feelings as to what his main legacy to Scotland's culture will be. His tunes will feature for most, as will his recordings, mainly released by his close friend and another towering figure in the story of the nation's musical culture, Ian Green of Greentrax Recordings. Yet for me, as someone who grew up with Gordon, learned beside him as a boy and watched him take his music to the world, his greatest legacy will be the knowledge that this quiet, unassuming, lad from my home town could finish his day's work then sit on a stool and produce the most wonderful music I have ever heard in my life. If we can legitimately call this genius – and personally I think we can – it lay in that ability to pick up his pipes and transport us to another place entirely. A rare gift, yet one he willingly shared with us, any time, anywhere.

Gordon, like Martyn, has left our cultural landscape a lot richer than he found it, and I have no doubt whatsoever that if someone sits down to write a new history of Scotland's music a century from now, both of them will be given their place as creative protagonists. Their gift was to have both the ambition and ability to stand inside their tradition and look outwards. They understood that a healthy, vibrant tradition cannot rely solely on faithful replication of what has gone before. There has to be innovation as well as emulation. They were very different characters and they followed correspondingly different paths in the way they found and displayed that innovation. Martyn

was a livewire and seemed at home in any company, surrounding himself with other musicians and 'tradition bearers' and investigating all sources and sounds and styles that he found on his journey. As such his music is about synthesis, about the bringing together of disparate and even seemingly incongruous forms, distilling them down to their common essence, adding in a generous helping of his own imagination, and re-presenting the whole to give us 'brave new music'. Gordon, on the other hand, never appeared to take life too seriously and there are many tales of his antics in the piping folklore canon. I can vouch for the fact that unlike most legends, they are all true! Playing a set of reels on top of the mast of the Rothesay ferry is one that springs to mind, and perhaps his most infamous jape, going through the baggage security X-ray machine at John F Kennedy airport, lying flat out and playing the chanter! Yet Gordon was actually a reserved, almost shy lad, and his music, though flamboyant in its way, was not about creating layered soundscapes. His focus was on tunes, on finding new combinations of melodic lines and motifs within the very limited scales of the bagpipes. For the generations of players coming through behind him, he has changed the way we think about the music of that instrument and its relationship to the international community of traditional music making. As the reaction to his passing showed, that gave him hero status in many countries. Perhaps he found that too hard to cope with, I just don't know.

The Prestonpans Bard

This chapter is in danger of becoming something of a roll call of those who have left us far too early, for another man who speaks to a strong sense of place in his composing, this time with words, is the late Davy Steele. Davy's song writing continued to be greatly inspired by the people, places and industries of his native East Lothian right up until his death from a brain tumour in 2001, aged 52. Drifter fishing, coal mining, salt panning, arable farming, family war experiences, folklore; his lyrics were firmly rooted in the local, yet universal in outlook. Often dealing with the tension between continuity and change, or tradition and modernity, the songs of Davy Steele are a fine example of the positive contributions made to our performance-based folk culture of

Clan Alba, 1993, from left: Gary West, Mary Macmaster, Brian McNeill, Davy Steele, Patsy Seddon and Dick Gaughan – the other members were Mike Travis and Davie Tulloch
(Patsy Seddon Collection)

modern times. I had the good fortune to play in several different bands and projects with Davy over the years, especially Ceolbeg and Clan Alba, and I was proud to call him a good friend. He taught me a lot about music and performing and life, and his death hit me hard I have to say, but a decade on it feels good to be able to take another look at his work. Of those who played with him and knew him well, I'm by no means alone in my admiration for the man. Here's Dick Gaughan:

> Everything Davy ever wrote, sang or played, he did with total conviction, honesty and enthusiasm. He wouldn't have known how to start faking even if he'd wanted to... He had a passionate love of Scotland and all the strands of our culture, a deep pride in being working class, and an implacable hatred of injustice, all of which informed his singing and songwriting. In all the years I knew him I cannot remember a single occasion when Davy wasn't ready to launch into song at any moment, regardless of the circumstances. He sang the way most people breathe.

Davy was fiercely proud that he was a miner's boy from Prestonpans, a fact which gave him a political and personal empathy with the working man which underpinned his writing and his thinking throughout his life. His songs are stories, highly narrative in style, and more often than not composed in the first person from the point of view of the central

character. That might be a family member – his father or an uncle – a worthy from local folklore or an imagined fisherman, salt panner, farm worker or soldier. He composed around three dozen songs in total, covering politics, war, work, family, locality and love. At school, when he admitted that he was dabbling in a bit of composing, his music teacher encouraged him to write about things he knew, the life that was around him, or which was recent enough to still be retained in the communal memory of the local people. His home town was well placed for that, for Prestonpans had been a bustling centre of small-scale industry, boasting a busy harbour in Morison's Haven, two coal pits, saltworks, a pottery, brewery and wire mill. Just inland were the fertile plains of East Lothian, the richest agricultural lands in Scotland, home to many hundreds of farm labourers and providing the coastal townsfolk with a little extra income at harvest time. There was no shortage of things to do, jobs to seek and stories to be told.

One of Davy's best known and most covered songs deals with the decline of herring fishing out of Morison's Haven. Herring, Neil Gunn's 'silver darlings', had been a staple of Scotland's east coast fishing industry for generations. Herring fishing normally used drifter nets cast from Fifies, the preferred style of boat of the lower parts of Scotland's east coast (while further north they tended to use scaffies). Herring migrated around the British coastline on a fairly predictable seasonal cycle, and made rich pickings for those prepared to brave the ferocities of the North Sea to harvest them. It was a way of life captured beautifully in song by Ewan MacColl in 'The Shoals of Herring', composed in celebration of the good times. Davy Steele's response, 'Fareweel to the Haven', marks the decline, which by his time was more or less complete. Sung in the voice of the last of a long family line of herring fishers, it begins with a clear statement of fact – he'd had enough:

> I'm leavin the fishin, the life I have known,
> The battles wi nature that nobody's won:
> The fish stocks are dwindlin, and the shoals hard tae find,
> I'm leaving the fishing. I've made up my mind.

It wasn't an easy decision, though, for this was a man who had followed the herring all his days, and he was acutely aware that with his leaving,

a tradition lasting generations was ending. It was hard to take, for

> My faither worked drifters, and my grandfaither tae;
> My brother's a skipper on the Elena Mae:
> And I worked at the fishin, just as soon as I could,
> So leaving's no easy – the sea's in ma blood.

And in the final verse we learn he has a job lined up which 'they say' is a good one, although he doesn't sound entirely convinced. Is that bold declaration of intent from verse one becoming a little less assured?

> I'll work in the wire mill, it's a good job they say;
> I'll start and I'll finish the same time every day.
> The money is constant and my wife she seems pleased,
> Ah but I'll miss the fishin, and I'll miss the sea.

A final singing of the chorus underlines his intent, and off he goes, stoically facing a future away from the sea:

> Fareweel tae the Haven, my hert it is sad.
> The drifters I'm leaving, tae work on the land.

I'm reminded of Nancy Nicholson's insistence that words are only half a song, and that is certainly the case here, for Davy's simple, plaintive melody does set the mood in a way that black ink alone on the page never can. It was first recorded on Ceolbeg's *Not the Bunnyhop*, while a number of artists, including The McCalmans covered it, and it is their version which features on the tribute album to Davy released on the tenth anniversary of his passing, *Steele the Show*.[6]

'Fareweel to the Haven' is a song of change. Like several of Davy's compositions, it documents change, laments change, yet ultimately accepts it as a necessary part of life. From the first few times I heard it and performed it with him, just shortly after studying Scotland's history as an undergraduate, I've thought of the song as something of a metaphor for thousands of our forebears who made that same life-changing transition from open-air vocation to the mass-production line. It is not a song of protest, simply a reflection of shifting times. But Davy was certainly capable of protesting, and did so in several of his works.

One of them was written in support of the sit-in, or rather 'work-in' at the Caterpillar heavy machinery plant in Uddingston, Lanarkshire in 1987. Despite it being profitable, the American owners decided to close it, as they were attempting to downsize their workforce back home and to invest in China, and felt it politically expedient, from their own domestic point of view at least, to be seen to sacrifice some of their overseas operations first. The news was broken to the workforce on the morning of 14 January, and within hours the unions had organised the occupation of the plant which lasted for almost four months. Public sympathy was high, and a host of singers, comedians and celebrities turned up regularly to provide some light relief and entertainment. Davy was one of them, and received a hero's welcome when he sang them a song he had written for them:

And we're no gonnae leave here, no withoot a fight,
For if we are the working class then working is oor right.
And if they think that they can pick us up and drop us when they want,
This time we are determined to show them that they can't.

One of the issues that raised the anger levels well beyond those usually associated with such closures was the fact that the vice president of the company had promised £62 million of investment in the plant only weeks earlier, leading John Smith, in opposition at the time, to complain to parliament:

Does the Minister believe for one moment that an assessment of worldwide capacity changed so dramatically in a matter of weeks? Does he not appreciate that the Caterpillar company has deceived the Government, the unions, the work force and the local management in a wholly calculating and ruthless manner? Surely it is not tolerable for a multinational company to abandon the interests of a work force and community which has given 30 years' service to that company.[7]

Davy made the same point in song:

And they said that they were sorry and their plans were all revoked,
And their promise o expansion it seems was just a joke,
They smiled and slapped us on the back and said 'It's quitting time'
But when the factory gates were shut, we were still inside.

And they'll call us reds and anarchists saying we're outside the law,
But it's them that sold the taxpayers' money and we pay tax and a,
And we're no here oot o preference, nor for political gain,
We're here to show some Scottish pride against American shame.

Ultimately, that battle was lost and the plant had closed by the end of
the year. Yet in commemorating the 25th anniversary of the action in
2012, those involved looked back with pride at the manner in which
the fight had been taken to the owners, following the pattern of work-
in tactics developed by Jimmy Reid in the Clyde shipyards of the 1970s.
Academics have seen the Caterpillar action as a key event in modern
industrial relations,[8] and Davy was quietly proud to have contributed
in his own way.

Other protest songs followed: 'The High and Mighty' was aimed
at the instigators and supporters of the poll tax, 'Seeds to the Wind'
reflected back on the Clearances, while in 'See the People Run' his
gaze was aimed outwards to injustices on the world stage. Tiananmen
Square, Soweto, the fate of Martin Luther King, all peaceful popular
protests: to Davy they were Caterpillar writ large. The difference, of
course, is the violence with which these protests were quelled:

In an eastern land on a national square,
A crowd was gathering, they came from everywhere.
Theirs was a peaceful way, this was plain to see,
But it was a time of change, this was a nation's plea.
But that disappeared when the soldiers came,
See the people run, see the people run.
And their pleas were stopped by a soldier's gun,
See the people run, see the people run.

And on a summer's morn, a bright and early dawn,
Through an African haze, came the sound of a rhythmic throng,
Theirs was a cry of hope as they went marching on,
This was a time of change, this was a freedom song.
But that disappears, when the soldiers come,
See the people run, see the people run
And their songs were stopped, by the soldier's gun.
See the people run, see the people run.

In a southern state, where hate filled the air,
One American's words, resounded everywhere.
He'd been to a mountain top, oh a better world he'd seen,
This was a time of change, this was a people's dream.
But that disappeared with the soldier's gun,
See the people run, see the people run.
And their dreams were stopped, by a soldier's gun.
See the people run, see the people run.

Then the soldier stopped, for it was suddenly clear
That this was his own kind, running away in fear.
And he realised right there and then,
He was just being used, by those faceless men.
And he closed his eyes, and the anger came,
See the people run, see the people run.
And he cried out loud 'O what have I done?'
See the people run, see the people run.

And he dropped his head and he dropped his gun,
See the people run, see the people run.
See the people run, see the people run.

This form of overt protest, with singer as third-person narrator, was not Davy's preferred style of communicating his distress at corporate or state injustice and there are only a few of his songs that deal directly with issues on that level and scale. He was most comfortable using local events to make the big points, partly, I suspect, as this allowed him to write the way he spoke, using his own voice and local Lothian dialect. Like most of his generation, Davy's natural speech was a mixture of standard English and local Scots. I recall having a debate with him when we were preparing some of the lyrics for album sleeve notes, discussing whether it was better to get the dictionary out and make sure everything was fully translated into 'correct' Scots, as opposed to the hybrid forms he tended to actually sing. He came down firmly on the side of the latter. Sometimes he might sing 'after' while on other occasions it was 'efter'; 'heart' and 'hert' were interchangeable (as in the chorus of 'Fareweel to the Haven' above), as were 'our' and 'oor', 'my' and 'ma' and so on. What that did, for me at least, is ground his songs realistically and naturally in the locality and culture from which they emerged, and they

The Bard of Prestonpans, Davy Steele
(Patsy Seddon Collection)

are the richer for it.

As a boy who grew up on the miners' row of Summerlee, that industry was especially close to his heart, and unlike the life of the sea which was that bit more removed, the 'collier's way' was immediate and real. That was to become the title for one of his more localised protests, this time composed in the voice of one of the Monktonhall miners of Midlothian.

Set in the early 1990s when a workers' cooperative had re-opened this deepest of Scotland's pits following its mothballing in 1989, the song conveys the mixed feelings, doubts and fears that this ray of hope engendered for the hundreds of men involved:

> They've tellt me I can work again, go back doon the mine,
> But efter lyin off three years, I'm no sae shair I can.
> For I've forgot the taste o coal, I never thought I could,
> For a miner's life runs deeper still, the dust runs through ma blood.
>
> I've missed the boys, I've missed the noise,
> I've missed the collier's way:
> But I never missed the black, black coal
> I dug day efter day.

Davy himself explains this one:

> Monktonhall Colliery in Midlothian was the last pit my father worked in. It was closed down by British Coal and the Government as being uneconomical. The miners decided to pool their redundancy money, and with outside financial help, plus backing by the same Government, they bought the pit and eventually started producing coal. This whole process took something like three and a half years, between the closing and

reopening of the pit. The first order the miners received was for 185,000 tonnes from British Coal. That angered me enough to write this song.

But for all the politicising and the reticence there was an excitement to going back too:

> I'm no afraid o graftin hard, it's like I cannae wait,
> Pit on again ma lamp and hat and stand at the cage's gate;
> And hear again the lads a talking, hear their jokes as well,
> Hear the engine's high pitched whine, that drops us doon tae Hell.

Although Davy himself headed for the army at 16, choosing not to follow his forebears down the pit, for his father, that hell-bound whine of the cage was experienced on a daily basis for most of his working life. And while the blackened-faced miner is an icon of Scotland's industrial past, few of them as individuals ever have their story told.

To have it told in song, was, I know, very special to Jimmy Steele:

> When I was a young man of seventeen years
> I went doon the pit as a belt boy;
> To keep the coal clean I shed sweat and some tears,
> And I did just what I was tellt, boys.
>
> *Chorus*
> Coal mining, coal mining,
> ma life's been coal mining.
>
> Maist o the miners I worked wi were grand,
> But some they treated me rough boys;
> And some were born wi a pick in their hand,
> I found out the real meaning of tough, boys.

The song then takes us through the narrative of his life: his marriage to his sweetheart, 'The Rose of Summerlee', raising their family in Prestonpans until Hitler changed everything. As a reserved occupation, miners weren't obliged to join up, and as he reminds us, 'I could have stayed doon the pit like some lads', but he was determined to do his bit and joined the Seaforth Highlanders, seeing action in France and being one of the few members of the 51st Highland Division to make it onto

a boat from the beaches of St Valery. And afterwards, it was back to the old life once more:

> James Steele I was christened, auld Jimmy I'm cried,
> I've worked as long as I can boys;
> I've never made money how e'er hard I tried,
> For I'm just an ordinary man, boys.

> Coal mining, coal mining,
> ma life's been coal mining.

A the Airts

'The Ballad of Jimmy Steele' is a highly personalised tribute to a loved and respected father, yet it surely breaks free from the personal realm into something of much wider meaning. It captures a time and place which saw enormous change, spanning a good part of the twentieth century and a fundamental reshaping of the world. It looks at that world from below, quite literally, and lays out for us in stark reality that paradox which was lived by many thousands of Jimmy Steeles. It is the paradox of a life acted out in the local community, proud to have a trade and dealing with the daily realities of earning a wage and supporting a family, and then suddenly being hurtled into the front line of violent world conflict, with guns instead of picks in hand. And afterwards, after the beaches of St Valery and the reshaping of history, returning to the old life again to be 'just an ordinary man'.

The philosophy of starting with the local, moving towards the national, and aiming, from there, for the global, is encapsulated in 'Jimmy Steele' as it is in any number of other works which tend to be 'filed under folk'. I've chosen to focus on East Lothian here, but there are songsmiths and storytellers from all parts of the country whose work can speak to us in similar ways. Adam McNaughtan, for example, paints both realist and witty verbal canvasses of Glasgow life in songs like 'The Jeely Piece Song' (one of the first songs I remember learning as a boy myself) and 'The Glasgow That I Used to Know':

> Oh where is the Glasgow where Ah used tae stay?
> The white wally closes done up wi pipe clay,

Where you knew every neighbour frae first floor tae third
And to keep your door locked was considered absurd,
Well do you know the folk staying next door tae you?
Oh where are the weans who once played in the street?
Wi jorries, a peerie, or a gird wi a cleek,
Can they still cadge a hudgie or dreep aff a dyke?
Or is writing on walls noo the one thing they like?
Can they tell Chickie Mellie frae Hunch, Cuddy, Hunch?

There is a gentle, humour-laden search for his home city's past here, although by the end of the song he recognises that it takes more than cosmetic changes to take the soul out of a place, for 'if you scrape the veneer aff, are these things still there?' As he has made clear in the sleeve notes, the answer to him is a firm 'yes'.

Adam's work is greatly informed by tradition, for he has spent a significant amount of time researching the creative song cultures of generations past. Having spent most of his career as a teacher of English in secondary schools in and around Glasgow, he knows the nuances of the city's street culture and language too, and the combination makes for a delightful set of voicings of his place. He voluntarily catalogued a major collection of printed folksong in the Mitchell Library, a task which provided him with a deep and refined knowledge and understanding of the creative voice of his forebears, especially of the broadside ballads composed within the 'Poet's Box' shops which existed in Glasgow, Edinburgh and Dundee up until the mid-20th century. These provided songwriting services for the locals, their imaginative employees composing and printing single sheet songs about all manner of tales and happenings and they were hugely popular: around 3,000 have survived in Glasgow alone.[9]

Adam's songs reflect that tradition, and as with the best of his fellow revival writers, there is a careful balance of the local and the global in many of them. The marvellous retelling of Hamlet in the patter of the Glasgow streets is the best known of them, but the tragedies he marks are not only those of Shakespeare. In a football-dominated city, sport can be a handy vehicle for taking a moral stance, and while protest is not perhaps a central theme in his writing, he has certainly been moved on occasion to speak out. One such was the occasion of the Scottish national football team's preparations for the world cup in Argentina in 1978.

The previous year they visited South America on tour, and played Chile in the same Santiago stadium where just four years earlier Pinochet's troops had imprisoned, tortured and massacred supporters of the elected leader, Salvador Allende. Among those killed was the leader of the New Chillean song movement, Victor Jara. In 1977 the Scottish Football Association came under significant pressure to take a moral stand and to refuse to allow the national team to play in that same stadium, but the campaign, led by the MP and folk collector Norman Buchan, ultimately failed. Adam protested in the best way he could, in song:

> September the eleventh,
> In Nineteen seventy-three,
> Scores of people perished
> In a vile machine-gun spree.
> Santiago stadium
> Became a place to kill,
> But a Scottish football team
> Will grace it with their skill.
> And there's blood upon the grass,
> And there's blood upon the grass.
>
> Will you go there, Alan Rough?
> Will you play there, Tom Forsyth?
> Where so many folk met early
> The Grim Reaper with his scythe.
> These people weren't terrorists,
> They weren't Party hacks;
> But some were maybe goalkeepers
> And some were centre backs,
> And there's blood upon the grass,
> And there's blood upon the grass.
>
> Victor Jara played guitar
> As he was led into the ground,
> Then they broke all of his fingers
> So his strings no more could sound.
> Still he kept on singing
> Songs of freedom, songs of peace,
> And though they gunned him down

His message doesn't cease.
And there's blood upon the grass,
And there's blood upon the grass.

Will you go there, Archie Gemmill?
Will you play there, Andy Gray?
Will it trouble you to hear the voice
Of Victor Jara say
Somos cinquo mille –
We are five thousand in this place.
And Scottish football helps to hide
The Junta's dark disgrace.
And there's blood upon the grass,
And there's blood upon the grass.

Do you stand upon the terracing
At Ibrox or Parkhead?
Do you cheer the Saints in black and white
The Dons in flaming red?
All those who died in Chile
Were people of your kind.
Let's tell the football bosses
That it's time they changed their mind,
Before there's blood upon their hands.[10]

Other places of course have their bards too: Dougie MacLean puts my native Perthshire firmly on the world map, as does Jim Malcolm, Michael Marra brings the stories of Dundee alive while John Watt and Matt Armour do the same for Fife. Steve Byrne follows one of his heroes, Jim Reid, in highlighting the local creativity of Angus, between them setting to music the poetry of both Violet Jacob and Marion Angus. Brian McNeill casts his net widely around Scotland, likewise Karine Polwart, Robin Laing and Archie Fisher. These are all major writers whose work demands closer attention than I have space for here, and that of course is by no means an exhaustive list. Rod Paterson too, although known more for his wonderfully rich voicing of songs than his writing of them, has nonetheless given us some gems. Is there a finer lyrical depiction of the two faces of our capital city than 'The Auld Toon Shuffle'?:[11]

Edinburgh toon has a fine distinction,
Edinburgh toon gets a nice abuse,
Everybody knows when the East wind up and blows,
Edinburgh toon's reduced
To two conditions, that could be described
As the Auld Toon shuffle and the New Town stride.

So cast a canny eye on the Soothside swagger,
Don't be taken in by the New Town taste;
Edinburgh toon wears a wig above a goon,
Baith above a bib and brace.
But don't mistake it, for Jekyll and Hyde
It's the Auld Toon shuffle and the New Town stride.

Because the Auld Toon shuffle and the New Town stride
They walk round hand in hand,
But when the Auld Toon ruffles up the New Town's pride
That's when the shit hits the fan!

Check the office clerk in his two piece pinstripe
Lounging round the Mound like a cat in heat.
In the public eye, wi nae buttons on his fly,
He's the Prince o Princes Street:
If you find him funny, oh jokin aside
He's the Auld Toon shuffle and the New Town stride.

And see the slinky legs by the sixties' Bentley,
Safe beneath the tweeds of a Jenners' bride;
Who never had a voice, never knew she had a choice,
She never got to play outside.
Aye, they're ugly sisters, poverty and pride,
They're the Auld Toon shuffle and the New Town stride.

Because the Auld Toon shuffle and the New Town stride
They walk round hand in hand,
But when the Auld Toon ruffles up the New Town's pride
That's when the shit hits the face of the fan!

Old man in the road with a white stick tapping,
Leaning in the wind at the Cowgate head;

Through the funny smell he thinks that he can tell
Sweeter airs are over head.
But it's an uphill struggle however you ride
From the Auld Toon shuffle tae the New Town stride.
Cos you're one or the other, wherever you bide –
You're the Auld Toon shuffle or the New Town stride.

I've just scratched the surface of some of the ways our creative minds of recent times have been voicing place here in Scotland. But I hope the scratch at least goes deep enough to make the point that within the traditional sphere, not everything is articulated at the level of the nation. Locality is absolutely central, and may be one reason why folk artists are sometimes mistakingly thought to be parochial in outlook, a charge which is often aimed at cultural production more widely here. And while I see little wrong with being 'of the parish', the writer's gaze seldom stops at its boundaries, but looks out from there, grounded in that place, yet thinking and singing well beyond.

CHAPTER 4

Voicing War

THERE ARE FEW WRITERS within the folk tradition who tackle the theme of religion in their composing, but Dick Gaughan faces it full on in several of his songs. In 'Childhood's End' we have one of the few outright declarations of atheism in the entire folksong canon, as he imagines the day the last old soldier has been laid to rest, 'a lingering relic of the older way'.[1] The new way is one where soldiers are redundant, where we are able to resolve our conflicts peaceably, and where despite our 'vanity' and our 'stumbling' we can at last call war a thing of the past. And as we bury him, we bury our childhood with him, for we have come of age and left the daft days of playground squabbles gratefully behind us. There is no pomp and ceremony with the burial: no drums, no flags, no gun salute, no Last Post, for these are the very symbols of war, and should be buried with him. But there is reflection:

> And a silent prayer was said by those who have something to pray to
> While the rest of us joined hands and softly sang,
> And asked forgiveness from the dead for millennia of killing
> For we knew now where the blame lay.

This is not a denial of the right for prayer, the right to ask for divine help in supporting our coming of age and the mourning of our violent childhood, but for the singer himself there is no expectation of supernatural intervention: we must take the full responsibility on ourselves. And we do it together, hands joined, asking forgiveness from all those who have died at the hands of other humans over thousands of years, 'for we knew now where the blame lay'. It lay with us.

I had the good fortune to perform 'Childhood's End' several times with Dick in Clan Alba, and I well recall long discussions about the arrangement and delivery of it within the setting of an eight-piece band. It is a complex song in terms of mood – mournful, reflective,

guilt-ridden, and yet cathartic, optimistic, hopeful. We went for light instrumentation but big voices – all eight of us in four part harmony on the refrain, mirroring those gathered around the grave who 'softly sang':

> Childhood's End, was long in coming
> But come it must, for all our fear:
> For all our vanity, for all our stumbling
> Childhood's End, is drawing near.

I found the singing of it a powerful and deeply reflexive experience every time. It is a big statement of a song, offering up a moral code for all humanity within the framework of what we might call a 'Godless morality' (a phrase borrowed from former Bishop of Edinburgh, Richard Holloway).

Gaughan continues his explorations of the idea in another composition penned five years later, in 1996.[2] 'Son of Man' expands the philosophy laid out in the earlier song, accepting that there are those who will always find comfort in Christ, although noting with regret that for others the cross is a heavy one to bear. His mood is altogether less patient, however, with the proselytising of those who seek to use it as a weapon:

> I've met some good and decent folk
> Who bore the symbol of the cross,
> And others who were bent and crushed
> Beneath it like some ancient curse.
> And many more who waved it like
> A blinding spotlight in the eyes
> Of those they wished to influence,
> Exploit, and mesmerise.

And the writer engages in a spot of gentle proselytising himself in the concluding verse, inviting us to contemplate his own conceptualisation of where the truth might lie. It is a call, perhaps, to those who we left praying at the graveside of the last old soldier to join the rest of us in our gentle singing, for 'salvation lies within ourselves' and to find it we 'should maybe cast a glance inside'.

Gaughan's anger at the use of the cross as a tool of exploitation had

Dick Gaughan
(Dick Gaughan Collection)

emerged in his work over a decade earlier. Adding his own voice to the growing impatience with the anti-apartheid South African regime, 'Amandla'³ was his 1985 salute to the *Umkhonto We Sizwe*, Spear of the Nation, the armed wing of the African National Congress. Serving as a counterbalance to the later utopian vision of 'Childhood's End', this was an anger-soaked war cry for

The white god of Mammon won't listen to Africa,
Sends no Messiahs to set the world right;
If there's a god, he's not in Johannesburg,
Prayers haven't worked – what's left but to fight?

Patience had run out, and it was time to counter that weapon which had stood at the heart of colonial power since the 'pale strangers, wide-eyed with wonder' first emerged from the sea, causing the folk of Africa to reflect on what on earth had happened:

Clutching their cross like the spear of a warrior
Into our country, bible in hand;
But while we were praying, strange things were happening,
We got the bible, and they got the land.

Following the ANC's victory, Gaughan rededicated the song to the memory of Joe Slovo, the Lithuanian-born Jew whose family moved to South Africa when he was still a child, and who eventually emerged as one of the leaders of *Umkhonto We Sizwe*. The author of *No Middle Road* which argued for the overthrowing of the Apartheid regime and a protagonist in the 1992 negotiations which eventually brought it to

an end, Slovo played a key role in South African politics throughout the anti-Apartheid struggle, spending a good part of his life in exile as a result. His wife, the activist Ruth First, had been assassinated by the regime they were fighting against in 1982, while Slovo died of cancer in 1995. Having become a 'Jewish atheist' in the sense that he rejected the doctrines and beliefs of his family's religion while remaining comfortable with its *cultural* forms, his was also a 'godless morality'. It was by pure chance that I came across a discussion of him in Richard Holloway's marvellous book of that same name. Or rather, it is a discussion of Gillian Slovo, his middle daughter who in 1997 penned a painfully candid biography of her parents, *Every Secret Thing: My Family, My Country*.[4] Its pain lies in her own lost childhood, as she struggles with the bile of resentment she can't help but feel for her parents at the memory of the constant separation she suffered from them as they followed the cause. Holloway's empathetic enthusiasm for the book made me seek it out immediately, and I found it to be a work which captures great depths in a particular, yet universal search for a childhood's end.

The cross appears in another song within Gaughan's repertoire. Iain MacDonald's 'Seven Good Soldiers' sketches a starkly graphic reminder of the realities of the battlefield, the pleasant weather and rolling countryside unable to mask the horrors of what went on there:

> An autumn evening of gold and blue
> And the air all around is still:
> Seven bright stars they lie beneath
> Seven white crosses on a hill.
>
> 'Please don't grieve Mary my dear
> Our mission it will soon end'
> The squaddie's letter it lay by his side
> As the bullets they blew him to hell.

There's no hiding from it, no dressing it up. No neat white crosses can camouflage the broken bodies of real men. Any attempt to do so, to play down the reality, is a source of intense anger to Gaughan, as witnessed in a brief note amongst the 'ramblings' on his website:

On the television and radio, I keep hearing euphemisms like 'collateral damage' and 'friendly fire' and suchlike abominations. Let's stick to

using the correct term – 'dead human beings'. I don't care whether
they're Iraqui, Kurdish, Australian, British or American; I make no
distinction on the grounds of race or nationality. Dead human beings
are dead human beings and no number of mealie-mouthed ways of
avoiding saying it changes that reality.[5]

Two Poets and a Piper

Reading Gaughan's words on the stark reality of war and death, I'm
transported back to my own childhood's end, to Breadalbane Academy,
to my higher Gaelic class this time, and to a Sorley MacLean poem we
studied called '*Glac a' Bhais*' – 'Death Valley'.

> '*Na shuidhe marbh an Glaic a Bhàis*
> *fo Dhruim Ruidhìseit*
> *gille òg 's na logan sìos m'a ghruaidh*
> '*s a thuar grìsionn.*

> Sitting dead, in Death Valley
> below Ruweisat Ridge
> a boy with his forelock down about his cheek
> and his face slate grey.[6]

It was not so much the colour of the boy's face which stuck with me –
I rather expected the dead to look grey – but I certainly didn't expect
them to be *sitting*. With that word Sorley had hooked me in his very
first line (the sign of a great poet I suppose), and drew me in for more.
Only then did I glance back at the short prose introduction to the poem:
'Some Nazi or other has said that the Fuhrer had restored to German
manhood the 'right and joy of dying in battle'. I was grateful for that
steer as I read on, struggling with the Gaelic but getting the picture
nonetheless. He was sitting there 'with flies about grey corpses / on a
dun sand / dirty yellow and full of the rubbish / and fragments of battle'.
Was he one of those who abused the Jews and the Communists? Or one
'of the greater / band of those / led, from the beginning of generations /
unwilling to the trial / and mad delirium of every war / for the sake of
rulers?' We shall never know, but there was precious little sign of the
joy of a noble death:

Ge b'e a dheòin-san no a chàs,
a neoichiontas no mhìorun,
cha do nochd e toileachadh 'na bhàs
fo Dhruim Ruidhìseit.

Whatever his desire or mishap,
his innocence or malignity,
he showed no pleasure in his death
below Ruweisat Ridge.

Some years later, in 1996, I got the chance to offer a little return tribute to Sorley for the way that poem – and others – touched me in my teens, when I was asked to pipe at a celebration of his 85th birthday in the Assembly Rooms in Edinburgh. Sadly, it became a commemoration of his whole life, not just his birthday, as he died just days before it took place. I was asked to play a lament, and had recently finished composing one following the death of a schoolmate who drowned in the Tay at Aberfeldy, Johnny MacDonald from Pitlochry. His elder brother, Donald, had also died a few years earlier aged 20, one of many victims

Sorley MacLean
(School of Scottish Studies)

of the A9, and so it was composed for them both, or rather, for their family. They lived in an idyllic stone cottage on the golf course overlooking the town, so I named the tune after their home, Drumchorry.[7] As a family of good West Highland stock – they had moved down from Achnasheen some years earlier – I didn't think they'd mind if it was shared just that once with one of Scotland's greatest ever poetic voices, and so for one night only it became the 'Lament for Sorley'. As I played it, a little nervous at the live broadcast recording equipment and the sea of faces in front of me – the faces of the great and

Gary playing Scottish Smallpipes, 2003
(Greentrax Recordings)

the good of Scottish art and culture – Sorley, Johnny, Donald and the sitting, grey-faced, dead boy were all very much in mind.

Hamish Henderson was there that night, and we had a good blether about Sorley, and piping, and our common Perthshire links. I'd been a student of Hamish's for four years in the School of Scottish Studies during the previous decade, and had been greatly inspired by his teaching, and by his tales of people and places and world events he had witnessed at first hand. His style was not one that would sit well in the clinical context of today's higher education institutions, which demand detailed lecture outlines, highly structured planning and preordained learning outcomes. Hamish's approach was delightfully shambolic; often at the start of a class he'd ask us where he'd got up to yesterday, then merrily launch into a theme he'd already covered the week before. Then within five minutes he was off somewhere else entirely, recounting a song he'd picked up while interrogating one of his German POWs, delighting in the comradeship of the Italian Partisans, or describing the moment he heard the pipes and drums of the 153 Brigade march into the square in Linguaglossa playing 'Farewell to the Creeks', its swinging, 6/8 rhythms conjuring up a lasting phrase for him: Farewell, ye banks o Sicily...'

I was delighted, a few years later, to discover a fieldwork recording

in the School's Archives of Hamish chatting to the composer of the original tune. Pipe Major James Robertson (1886–1961) was born at Scotsmill of Boyne, near Banff, although his family moved to Coatbridge when he was seven years old. He was taught to play the pipes by Willie Sutherland of Clarkston, and joined the 1st Battalion Gordon Highlanders in 1905, serving with the regiment until 1926. Captured at the Battle of Mons in August 1914, he became a prisoner of war and it was during that period that he composed some of his most famous tunes. On leaving the army, he was employed as janitor at Banff Academy until his retiral in 1952. There was a personal link for me there, too, James Robertson having been the first teacher of Ian Duncan, my own main piping teacher and inspiration; us pipers do like to celebrate our pedigrees whenever we get the chance. I've published this conversation before, and broadcast it too, but I make no apologies for repeating myself here. I think it's a wonderful moment – the meeting of two powerful, creative forces, tunesmith and wordsmith in each other's company for the first time, a first sharing of a new creation which would soon become an icon of modern folksong:

> Hamish Henderson (HH): When did you compose 'Farewell to the Creeks', now?
>
> Pipe Major James Robertson (JR): Oh, I think I composed it about 1915.
>
> HH: Oh aye? During the war itself?
>
> JR: Yes. As a matter of fact it was composed on a piece of yellow blotting paper. I have got the original bit yet.
>
> HH: Oh, have you still got it? Whereabouts did you compose it?
>
> JR: Oh, I think it was in Germany. I was a prisoner of war at the time.
>
> HH: Oh I see, oh aye. And what were you thinking of when you made the title, 'Farewell to the Creeks'?
>
> JR: Well, I was thinking about the Creeks of Portknockie as a matter of fact. I remember my uncle stayed in an old house there, and when I was a boy I went on holiday once. And the place was called The Creeks. I saw it recently as a matter of fact. The first time for many years. And this particular locality was called the Creeks. I remember it was pretty stormy and the waves were washin hard up against this other wall outside the house. It's known in Portknockie as the Creeks, this particular part.
>
> HH: And are there wee inlets in it?

JR: Yes, yes. Well, all over the Morayshire coast, of course.

HH: Do you know, when I first heard that tune, I didn't know who had composed it, but I was sure that it related to this north-east coast, you know? It seems to me to spring just as naturally out of it as the bothy ballads spring from the soil inland, you know? I heard it played for the first time – to my remembering it anyway – when I was in Sicily, in Linguaglossa. The square of Linguaglossa. The massed pipe band of 153 Brigade played it over... Would you sing over 'Farewell to the Creeks'?

JR: Aye. [James 'diddles' all four parts of the tune.]

HH: My God! That's a fine tune.

Pipe Major Hepburn: You put words tae that, did ye?

HH: I put words to it, aye. But did I sing you over the words I put to it?

JR: No, what were the words?

HH: Och well, I composed this when the Highland Division were leaving Sicily, you know. And it was the time that the units were going out to Augusta to embark and there was the sense of leaving, you know? And I heard this – the massed pipe band of 153 Brigade play yer tune then. And so the two ideas just sort o came together in my head and I made this ballad which I sang at that time. It goes:

> The Pipie is dosey, the Pipie is fey,
> He wilna come roon for his vino the day;
> The sky oer Messina is unco an grey,
> And all the bricht chaulmers are eerie.

> An Fareweel, ye banks o Sicily,
> Fare ye weel ye valley and shaw;
> There's nae Jock will mourn the kyles o ye,
> Puir bloody bastards are weary.
> Fareweel, ye banks o Sicily,
> Fare ye weel ye valley and shaw;
> There's nae hame can smoor the wiles o ye,
> Puir bloody bastards are weary.

> Then doon the stair and line the waterside,
> Wait yer turn, the ferry's awa;
> Then doon the stair, and line the waterside,
> A the bricht chaulmers are eerie.

The Drummie is polished, the Drummie is braw,
He canna be seen for his webbin ava,
He's beezed himself up for a photo an a
Tae leave wi his Lola, his dearie.

Then fareweel ye dives o Sicily,
Fare ye weel ye shielin and ha;
We'll a mind shebeens and bothies
Where kind signorinas were cheery.
Fareweel ye dives o Sicily,
Fare ye weel ye shielin and ha;
We'll a mind shebeens and bothies,
Where Jock made a date wi his dearie.

Then tune the pipes and drub the tenor drum,
Leave yer kit this side of the wa;
Then tune the pipes and drub the tenor drum,
A the bricht chaulmers are eerie.

Well that was it, anyway.

Pipe Major Hepburn: Damn good that! Yes, very good.[8]

I've heard various debates over the years as to how that song
'should' be sung in terms of mood and tempo. Is it a song of victory,
of relief, of sadness at parting, of jovial camaraderie? In that particular
singing of it, Hamish seems to tend towards the latter, moving through
it at a fairly sprightly pace and at times there is laughter in his voice.
Certainly, when he heard it being played by the 153 Brigade pipe band,
when the words first started to form in his mind, it would have been at
a fast march pace, around 120 beats per minute in fact. At that pace it
would be almost impossible to sing, however, or at least to sing in any
meaningful way. So perhaps it belongs more within the tempo at which
a solo piper would play the tune, more nuanced, more space given to
its subtleties, stately rather than jaunty. That would seem to catch the
mood of the lyrics themselves, which move between comic images of
the polished, 'beezed' up drum major waiting to have his photo taken,
to fond memories of drunken nights with the local signorinas, to the
weariness of the soldiers and the eeriness of their now empty quarters.
But why is the pipe major so dozy and not up for his daily shot of wine?

And the drum major's photo is to give to Lola – she is 'his dearie', but is it a sad parting? Or were they both happy to leave it as a fling? Does he have someone to go home to? Although they were not of course going home, only leaving that particular island, and heading to goodness knows what on the mainland of Italy. They would become the 'D Day Dodgers' as Hamish was to ironically note in a later song of that name, many of them never making it home at all, adding instead to the count of bodies lying under white crosses. So does singing it now, in that knowledge, change its mood somewhat? Clearly it didn't change it too much for Hamish in that moment in 1952, although I did hear him sing it in more reflective mood on several occasions in later years. And for Dick Gaughan, in what for many is the 'stand out' version of the song, it is much more lament than march. His guitar arrangement is pure pibroch, the singing anything but triumphant. That, for me, is one of the great joys of folksong: once they are let loose on the world by their makers, they are free to take on a life of their own. They speak to us in so many different ways, at different times, in different contexts. There is no right and wrong to them, only mood, feel, and taste.

Back in the Desert

Thinking back to Hamish's undergraduate classes, it's now clear to me that he wasn't really a 'lecturer' at all. He was a storyteller, one who didn't necessarily know where he was going at the outset, but who always ended up going somewhere new and interesting and worthwhile, and he always took us with him. He opened my ears to what folk culture is all about, what makes it tick, how the best of it stands in its own soils boldly looking outwards, not tamely looking in.

At one of his classes, Hamish handed us all a copy of a slim book, *Elegies for the Dead in Cyrenaica*, presented with his best wishes to each of us personally. I had never heard of Cyrenaica, part of eastern Libya, and a central focus of the North African campaign in which both Hamish and Sorley played their part. Hamish's war poems, composed 'between March 1943 and December 1947 in North Africa, in Italy and in Scotland', comprise one of the key poetic texts of World War Two. As his friend the pacifist poet and writer Adrian Mitchell reminds us, Hamish 'writes about war as war', of 'life-size or death-

Hamish Henderson, Sandy Bells, 1992
(School of Scottish Studies)

size' real men – 'dead human beings' as Dick Gaughan insists. The dead from both sides are mourned here, for as a captured German officer remarked to Hamish, 'Africa changes everything. In reality we are allies and the desert is the common enemy'. It was that observation which lit the spark for the whole collection, which has at its heart two sets of fundamental relationships: men versus desert and dead versus living. Both stalls are set out early, in the 'First Elegy – End of a Campaign':[9]

> There are many dead in the brutish desert
> who lie uneasy in this landscape of half-wit
> stunted ill will. For the dead land is insatiate
> and necrophilous. The sand is blowing about still...
> There were our own, there were the others.
> Their deaths were like their lives, human and animal.
> There were no gods and precious few heroes.

If gods were nowhere to be seen for Dick Gaughan in apartheid Johannesburg, neither were they showing themselves to Hamish on the

opposite end of the continent a generation earlier. Nor were any heroes, or 'precious few' at least, for this was not a place for heroes. It was a place for surviving, or dying, and little else. 'There were no gods and precious few heroes' is one of these sorts of lines which occasionally break free of their original stanzaic home and take on a life of their own, almost as aphorism, and it has since been used as the title of a book on 20th-century Scottish history by Christopher Harvie, and a rallying, invective-laden ballad by Brian McNeill. Both employ it as metaphor for modern Scottish society, although with differing messages attached.

That in the desert it was the land that was the main enemy is not in doubt. It is brutish, stunted, insatiate, necrophilous – also razor-sharp, malevolent, bomb-thumped, impartial, hostile – we could go on. But perhaps worse than that, it was also mind-bending, its vastness and directionless form creating what the poet later called 'this odd effect of mirage and looking glass illusion' which became for him 'a symbol of our human civil war, in which the roles seem constantly to change and the objectives to shift and vary'. The conventional concept of enemy, those they were trying to kill, was an ambiguous and confusing one within this landscape, for in those struggles between man and desert and living and dead, British and German were on the *same side*. That accounts for the mood of the 'Ninth Elegy', which tells the story of the poet noticing a soldier contemplating the grave of a fallen enemy:

> His thought was like this. – Here's another 'Good Jerry'!
> Poor mucker. Just eighteen. Must be hard-up for man-power.
> Or else he volunteered, silly bastard. That's the fatal
> *the – fatal* – mistake. Never volunteer for nothing.
> I wonder how he died? Just as well it was him, though,
> and not one of our chaps... Yes, the only good Jerry,
> as they say, is your sort, chum.
> Cheerio, you poor bastard.
> Don't be late on parade when the Lord calls 'Close Order'.
> Keep waiting for the angels. Keep listening for Reveille.

Reveille won't come, of course, for as the next poem starkly reminds us, he, and thousands like him, are 'not sleeping but dead'. That brutal clarity again, a conviction to tell the truth shared with Sorley MacLean, Dick Gaughan and Iain MacDonald. I've often wondered

whether Iain found inspiration in these poems when composing 'Seven Good Soldiers', for Hamish's 'Seventh Elegy' was titled 'Seven Good Germans'. They had come to the desert with Rommel, and 'never gave a thought to a place like El Eleba'. To get to it you had to 'drive into the blue, take a bearing / and head for damn-all'.

> Still, of some few who did cross our path at El Eleba
> there are seven who bide under their standing crosses.

We are then taken through a rollcall of just who they were: the first was a lieutenant who had jotted in his notebook 'keep me steadfast'; the second was a corporal who was fed up with his comrades griping about their rations; the third 'a farm-hand in the March of Silesia' but now himself 'fresh fodder'; the fourth a lance-jack who 'had trusted in Adolf'; the fifth was a mechanic who 'had one single headache / which was, how to get back to his sweetheart'; the sixth was a Pole, 'not a bad bloke'; the seventh was a young swaddy, 'Riding cramped in a lorry / to death along the road which winds eastward to Halfaya'.

> Seven poor bastards
> dead in African deadland

Memories

There are many ways of voicing war. With Hamish and with Sorley we have creative responses from those who lived through it, art fashioned from experience. Yet that experience can be reflected and articulated outwith the codified forms of poetry and song, captured instead through memory and conversation, and that has a power to inform us and greatly move us also. This is the stuff of oral history, voicings usually captured well after the event, and so filtered through the great healer, time. But to witness such reflection taking place in front of you, on the other side of the microphone, can be a most intense experience. We see it from time to time on the television, usually a full frame shot of a brightly lit face within a background of blackness, a production of stark drama, and yet even in more mundane settings it can be dramatic enough. The example that stands centre stage in my own memory took

place in a small rural primary school which was taking part in an oral history project I was involved with, encouraging children to interview the older members of their community about their life experiences. Oral history provided a useful fit for the environmental studies element within the '5 to 14' curriculum guidelines which prevailed in Scotland at this time which included the social study of 'people in the past', 'people and place', and 'people in society'.

These children had been exploring the theme of 'war' in the weeks before our team arrived, and so during the recording sessions, which involved them interviewing local volunteers who had come into the school for the day, it was inevitable that this would come up. Sure enough, questions about gas masks, blackouts and rationing were met with enthusiastic and cheerful responses, although they hadn't seen much direct evidence of war themselves so far north, they said. That changed though when one lady was asked what she remembered about the war, and she told her story, delivered in a very matter of fact way, devoid of deliberate drama, yet with a power which silenced the classroom. She had lived in Poland, she explained, and remembered going to her bed one night when she was a child, but woke up with a commotion going on downstairs. German soldiers had come to the door, and they took her away with them, leaving her parents behind. She was lucky, though, she said, as she was taken to work on a farm, not put into one of these camps, and so she did ok. Then she remembered bombs falling, and so they hid in a cellar, only creeping out when silence came two days later. The soldiers she next saw wore different uniforms and spoke in a different language. They were American, she now knew.

By now a young woman, six years older than that child who had been taken from her bed, she was asked if she would consider going to Britain to help to nurse injured Polish soldiers, and she agreed. She was sent here to Scotland, and helped slowly bring her countrymen back to health, many of them having suffered dreadful injuries at the Battle of Monte Cassino in Italy. For them it was a long convalescence, and her work kept her there for much longer than she had anticipated. But her stay was longer still, for she married one of them and they settled there, started a family and only then managed to make contact with her mother, almost thirty years from the night she had gone to bed as normal. And there she finished her story, firmly part of that community, she said, with her daughter a teacher in that very classroom and her

grandaughter sitting there too amongst her friends. But it was a room now full of wide eyes, open mouths and tear-stained cheeks. These children must surely now have a deep seated fix on the realities of war, on the human pain of war, on its immediacy and its cost. It was the most powerful voicing of war I have ever heard.

Oral history, whether formalised in such projects or casually passed on through normal family chats, can also fuel creativity through song. Davy Steele was born three years after that war ended, but grew up hearing the stories of his father's generation. His father's tale, told in song in my 'Voicing Place' chapter, includes mention of his experience at St Valery, but he was accompanied there by his brother, Robert. They were both part of the 51st Highland Division, a Territorial Army force originally founded in 1908 comprising the kilted Scottish regiments. During the Great War they had seen action at the Battle of the Somme, and found themselves back there once more a generation later as part of the British Expeditionary Force. But while most of the other troops in the BEF were successfully evacuated at Dunkirk, the Highland Division found themselves hemmed in by Rommel's forces further along the coast. Led by General Fortune, they planned an evacuation from the town of St Valery-en-Caux, priming the Royal Navy to supply enough boats for the job. But there was fierce fighting around the town, with the 1st and 5th Gordons, 2nd and 4th Seaforths, the 4th Camerons and 1st Black Watch all struggling to hold their positions. Their problems were compounded by fog at sea, and in the event only a few boats made it. Jimmy Steele found himself on one of them, but following Fortune's inevitable surrender, Robert was taken prisoner with most of his comrades, ending the war in Stalag XX-A north of Warsaw. Davy tells *his* story in 'The Beaches of St Valery':

> It was in 1940, the last days of Spring,
> We were sent to the Maginot line;
> A fortress in France built to halt the advance,
> Of an army from a different time.
> We were soon overrun, out-thought and out-gunned
> And pushed further back every day,
> But we never believed High Command would just leave us,
> So we fought every inch of the way.

Til the 51st Highlanders found themselves back
On the banks of the Somme one more time;
It still bore the scars of that 'war to end wars'
The old soldiers' scars deep in their minds.
But we couldn't stay long for the Panzers rolled on
And the battle raged West t'wards the sea,
Then on June the 10th when sapped of all strength
I entered St Valery.

Chorus
And all I recall was the last boat leaving,
My brother on board, waving and calling to me.
And the jocks stranded there wi their hands in the air,
On the beaches of St Valery.

So I huddled all night in a hammered old house,
While the shells and the bullets rained down;
And just before dawn my hope was still strong,
For we moved to the beach from the town.
But the boat that had left on the day we arrived
Was the only one we'd ever see,
With no ammo or food, we had done all we could,
 So we surrendered at St Valery.

And when I returned at the end of the war
From the Stalag where I'd been confined,
I read of the battles the Allies had fought,
Stalingrad, Alamein and The Rhine.
Wi pride in their hearts people spoke of Dunkirk
How defeat had become victory;
But nobody mentioned The Highland Division,
They'd never heard of St Valery.

No stories, no statues for those that were killed,
No honours for those that were caught,
Just a deep sense of shame as though we were to blame
Though I knew in my heart we were not.
So I've moved to a country I've come to call home
But my homeland is far o'er the sea,
I will never return while my memories still burn
On the beaches of St Valery.

The Gallant Forty Twa

My consideration of the voicing of war so far has focused on death. That seems reasonable, given that death is the inevitable, and actual, consequence of this most inhumane of human pastimes; a glance at a newspaper proves that childhood's end has not yet come, and Gaughan's dream seems as far off as ever. Scotland as a nation has a highly ambiguous relationship with war, for while we may protest our taking part and mourn our losses, we also pride ourselves in being rather good at it. That pride is tightly bound up in the Scottish regiments and the timeless traditions, acute sense of belonging and powerful identities which lie at their heart. These identity markers are partly visual, but also aural: regimental pipe marches, tunes named after people, places or campaigns, songs of past heroes, folklore about their feats, tales of glorious deeds. Both our instrumental and song traditions in Scotland owe a great deal to our military past, a theme which has been fairly well explored elsewhere, but we're all familiar I'm sure with the upbeat mood and celebratory tones of any number of soldier songs from centuries gone. And why not celebrate victory? In fact it's essential, otherwise any possible justification for war would evaporate instantly. In war, after all, it is *not* the taking part that counts.

Creative minds in Scotland have always wrestled with the conflicting tensions of war, but the most powerfully successful attempt to do so in recent memory is surely the National Theatre of Scotland's *Black Watch*.[10] Gregory Burke's script, based on extensive interviews with former soldiers from the regiment who had served in Iraq – the research process itself being cleverly restaged within the play – vies with James Kelman's Booker-winning *How Late it Was, How Late* for its expletives per page hit-rate, but it could not have been any other way. Just as the authors discussed above insisted on being *real*, the cast of this play speak their own language in every sense.

As a Fifer himself, Burke knows how to voice the young lads of the kingdom and their Perthshire and Dundee neebors, and it's eye watering and ear-bending stuff. It is also questioning, accusing, thinking, challenging, penetrating, lump-in-your-throat and pee-yourself-laughing stuff, drawing standing ovations and glowing reviews on both sides of the Atlantic. One reviewer of the 2007 USA tour, writing in *Variety*, saw it as

both a hymn to soldiers and an indictment of the foolishness that makes their jobs necessary, shot through with odd, affecting grace notes of music and dance. And beneath it all, the low unmistakably Scottish hum that signals an inescapable call to duty.[11]

These 'affecting grace notes of music' are indeed crucial to the success of this play, Davey Anderson's score and song arrangements adding poignancy and pride in equal measure. That said, it is the *absence* of music at the start which sets the mood, for we're set up by a Sir Tom Fleming style tattoo commentary to welcome the sound of the massed pipes and drums. But as the gates open to the blast of a cannon, there is then only silence as a peelywally red-haired lad appears, looking timid and self-conscious in his civvies, and from his very first words, unmistakably a Fifer: 'A'right? Welcome tae *this* story o the Black Watch, ay.' Our minds are probably already made up, he says, that we assume he was only in the army because he couldn't do anything else, couldn't find any other work. That he's exploited by the army, and it's such a shame. But then he noticeably straightens, a new-found resolve: he could have done other things, but he *wanted* to be in the army. And when the action immediately cuts to a pub where the interviews take place we realise the pipes and drums never did materialise, as the cast gather around the pool table to a blast of 'Spitting Games' by Snow Patrol.

Yet the soldier songs which we might have expected to grace the soundtrack to *Black Watch* do appear: 'The Gallant Forty-Twa', 'Twa Recruiting Sergeants', 'The Forfar Sodjer' are all there, but they are not performed in the macho, singalong manner which is often to be heard. There is plenty of machismo in the play, but it doesn't show itself in these songs. Instead they are given space: the instrumentation is minimal, often a single piano providing the most gentle of aural backdrops, giving plenty headroom to hear the voices tell their stories. Davey Anderson is quite explicit about the need for that, being no fan of the driving guitars or plodding bass lines that he associates with these songs, for to him, it is all about the stories:

> I've always had a fascination with folk songs particularly that have gone through many different versions – the origins of the words are often obscured and have gone through different adaptations.... These traditional songs, they have a quality to them that somehow has endured... I love the songs, I love the words and I love the melodies and the stories that they tell, so I try and strip back the music that gets in

the way of that. The stuff that's kind of rabble-rousing – stuff like that annoys me, and it gets in the way of the melody of the song and the singer's connection with it.[12]

The performance of the 'Gallant Forty-Twa' within the play illustrates this philosophy very clearly. The piano arrangement does indeed have more space than notes, very much in that minimalist style reminiscent of the French composer Erik Satie, creating a mood of reflection more than celebration. One of the soldiers takes the first verse as a solo:

> Oh it's ainst I was a weaver, ma name is Wullie Broon
> It's ainst I was a weaver, wha dwelt in Maxwell toon
> But now I've joined the sodjers, and tae Perth I'm goin awa
> For tae join that Heeland regiment, the Gallant Forty-Twa

There are actually two main versions of this song within the tradition, one common in Ireland, and this one, often printed on broadsheets and frequently heard in the north-east of Scotland. It was a favourite of the well-known street singer, Jimmy MacBeath, who sung it very much as a comic song, drawing laughs from his audience at the tale of the hapless recruit who was told to keep his 'napper' down as it was so big he would give their position away.[13] Jimmy was a jovial character in any case, plying his trade as a street singer and busking around the fairs of the north-east before being 'discovered' by Hamish Henderson on one of his collecting trips in the early 1950s. Soldier songs were one of Jimmy's specialities, and he was no stranger to warfare, having found himself in the trenches of Flanders by the age of 20, not, as it happens, in the ranks of the 'forty-twa' but with his local regiment, the Gordon Highlanders.

The mood struck by Davey Anderson's arrangement is far from jovial, the contemplative effect being heightened by the choreography and lighting combination which makes it clear that this is no tale of comedy. As the soldier sings, his comrades lie motionless on the ground all around him, before rising up and joining him in unison for the rest of the song. It is powerful stuff, the power lying in its acute simplicity. The recipe is a good one, and that starkness is brought back to the soundscape later in the play in Margaret Bennett's singing of a Gaelic lament following the fatal blast which takes the life of three of the

characters. There is irony, perhaps, in the choice of song, 'A *Thearlach Òig*', 'Young Charles Stewart', a symbol of the kind of revolutionary threat which the Black Watch was formed to counter in the first place. Yet just as for Hamish Henderson in the desert, sides don't matter, for the deep, raw pain being sung of here is from an unknown woman lamenting the loss of her father and two brothers at Culloden. Drumossie Moor, Cyrenaica, Flanders, Iraq – the settings may differ but the pain of loss is the same. The recording is from her son Martyn Bennett's album *Glenlyon*,[14] – an appropriate choice given the glen's proximity to Aberfeldy where the regiment was first officially raised. But it is not the geographical niceties that make this the right choice, it is the purity of the sound, both in tone and timbre, with simple drone-style backing, punctuated with the crash of artillery. The album is presented as a song-cycle and as such deserves to be heard in its entirety, but it will survive the lending of this one track to 'the other side', to *Black Watch*, where it does its job just beautifully.

With Margaret's singing of a woman's mourning we move across from the voices of fighting soldiers to the voices of those left behind to worry or to grieve. Once again, tragically, the theme is timeless. If you search for 'The Gallant Forty-Twa' on the Kist o Riches website, you'll find another ballad of that name, but sung from a girl's point of view, lamenting the fact that her lad has gone off to join the regiment. Lucy Stewart from Fetterangus, a very fine singer from the travelling folk, recorded her version in 1959:[15]

> It's six weeks come Sunday, since ma laddie gaed awa
> And he's awa tae jine the regiment, o the gallant forty-twa
>
> I'd only one sixpence, and I broke it intae twa
> And I gied ma lad the half o't, oh before he went awa
>
> Broken hearted, I shall wander, for the loss o my true lover
> He's awa tae jine the regiment, o the gallant forty-twa.

Yes, timeless. For how many sweethearts since Lucy sang that half a century ago do these words say it all? Plenty just in the forty-twa itself – the Black Watch – but the situation and sentiment is universal.

Australian singer-songwriter Judy Small says it in another way,

capturing the incessant predictability of the waving goodbye:

> The first time it was fathers, the next time it was sons
> And in between your husbands marched away with drums and guns
> But you never thought to question, you just went on with your lives
> For all they taught you who to be, was mothers, daughters, wives.

Toys and Dugs

Another who adds her voice to the anti-war song corpus is Nancy Nicolson, brought up in Caithness and a well-known singer-songwriter around the Scottish folk scene. She brings a powerful mix of childlike humour and cutting satire to her protest songs. When performing them herself, her lilting delivery and cheery smile belies the razor-sharp message within them, their playground simplicity and directness adding further to their worth.

A primary teacher by profession she knows plenty about children's songs, and capturing that clapping or skipping feel beautifully, she takes aim:

Nancy Nicolson: 'Words are only half a song'
(Nancy Nicolson Collection)

Geordie Geordie Bush Bush,
Geordie Geordie Bush Bush,
Geordie Geordie Bush Bush,
Had a terrible toy box.
It was full of bombs and guns,
Bloody great enormous ones,
Duck, ma darlin, here it comes,
Geordie Bush's toy box.

Saddam Saddam Hussein,
Saddam Saddam Hussein,
Saddam Saddam Hussein,
Was a terrible tyrant.
Might is right, the despot said,
Wrung his people till they bled,
If they disagree, they're dead,
Saddam was a tyrant.

Geordie Geordie Bush Bush,
Geordie Geordie Bush Bush,
Geordie Geordie Bush Bush,
Saw elections coming.
What a chance, upon my soul,
Wartime leaders top the poll,
Let the tanks and missiles roll,
Gotta stay in the White House.

Tony Tony Blair Blair,
Tony Tony Blair Blair,
Tony Tony Blair Blair,
Longed to play wi the big boys.
Bambi was a little 'dear',
Now he had to make it clear,
Tony was a force to fear,
Out to play with the big boys.

Tony calling Dubya,
Tony calling Dubya,
Tony calling Dubya,
Come and see *my* toybox.
I have regiments galore,
Primed and polished for a war,
Take them, Georgie, Here they are,
Have... the British Army!

Stand to attention!
Stand to attention!
Stand to attention!
Says the sergeant major.
Now's the day and now's the hour,
See the front o battle lower,
To keep two parasites in power,
Here's your marching orders.

Kiss goodbye to Mammy,
Kiss goodbye to Mammy,
Kiss goodbye to Mammy,
Bonnie Scottish Soldier.

You will soldier far away,
You will fight in many a fray,
Ye ken the price that ye may pay,
You're the Flower of Scotland.

Ma laddie is a hero,
Ma laddie is a hero,
Ma laddie is a hero,
Oot there on the front line.
Silently I pace the floor,
Secretly ma hert is sore,
Ah dread the knock upon the door,
Laddie's on the front line.

Sumb'dy's at the door, Ma,
Sumb'dy's at the door, Ma,
Sumb'dy's at the door, Ma,
He says he's fae the Army...

And like Dick Gaughan, Nancy is also greatly angered by that most sickening of euphemisms, 'collateral damage'. 'The Crows Caa'd "Collateral"' was composed after she had been following John Simpson's regular television news reports from Pristina during the war in Kosovo. Each evening's programme began with a signature recording, 'of crows cawing and one wee bark from a dog'. As well as reporting on the main events of each day, Simpson 'also drew searing little cameos from everyday life, or death, as it happened.'

Oh the craws caa'd 'Collateral,
Collateral, collateral'
An the craws caa'd 'Collateral,
And The General's on the TV.'

Now please tell me, General, how can it be
That women and babies lie dead?
'We weren't aiming at them, they just got in the way,
They're collateral damage', he said.

And the craws caa'd 'Collateral,
Collateral, collateral'

An the craws caa'd 'Collateral
And the wee dug barked for his boy.

The boy he is gane wi his mammy and daddy,
Their haill life piled on a cairt,
He cairries his bundle o gear on his back
The heaviest burden, his hert.

And the craws caa'd 'Collateral,
Collateral, collateral'
An the craws caa'd 'Collateral
And Irene she ran for the wiuds.

She hid in the trees and she trembled wi fear,
She stood on a twig an it cracked,
Too frichtened tae answer the harsh 'Who goes there?'
And a bullet tore intae her back.

And the craws caa'd 'Collateral,
Collateral, collateral'
An the craws caa'd 'Collateral
And the big strong man he wept.

His Faither an Mither were faur ower frail
Tae traivel tae some unkan place.
They stood, prood an plain, as his bus drew awa
An the tears burnt intae his face.

And the craws caa'd 'Collateral,
Collateral, collateral'
An the craws caa'd 'Collateral
There's a bairn on the road lyin dead.

In Vietnam and Bosnia, Afghanistan
It was always the innocent bled
There's a 'Peacekeeper' standing, a gun in his han
And a bairn on the road lying dead.

And the craws caa'd 'Collateral,
Collateral, collateral'

An the craws caa'd 'Collateral
There's a bairn on the road lyin dead.

Tunes of Glory

If folksong is about changing moods, then perhaps it's time for me to do likewise, time to lift the spirits a bit, get away from all this death and farewell and mourning. That, I suppose, is what a lot of the military music which has emerged within the Scottish tradition is all about, and it has given us such a rich seam of material that in itself is worthy of celebration. The final tune we hear in *Black Watch* is 'The Black Bear', and a cheerier, more spirit-lifting pipe march it's hard to imagine. It's one of those tunes I grew up not quite knowing how to take, for it was something of a cliché, and a favourite request of drunken old men on Highland Games days – 'Hi son, gonnae gie's the Black Bear'! Yet I always thought it was a cracking tune, and I loved to play it. I still do. Tunes become hackneyed or clichéd for a reason and that reason is usually because they're wonderful melodies, even if familiarity breeds our contempt from time to time as we seek out something new and different to play. But we always come back to them. And that is true of a huge corpus of tunes which began their lives, like 'Farewell to the Creeks', among the rank and file of Scotland's regiments.

Many of the staples of pipers' repertoires arose from active service campaigns, named after battle sites, campaigns and tours of duty: 'The Battle

Pipe Major James Robertson, Banff
(School of Scottish Studies)

of Waterloo', '93rd at Modder River', 'The Heights of Dargai', 'The Highland Brigade at Magersfontein', 'The Bloody Fields of Flanders' – the list is a very long one. And modern-day war zones continue to inspire new compositions: Pipe Major James Riddle of the 2nd Battalion the Scots Guards composed 'The Crags of Tumbledown Mountain' following a particularly hard-fought battle during the Falklands Campaign, while the first Gulf War produced 'The Sands of Kuwait'. Senior officers have also done rather well out of the military composing tradition, and a quick survey of one of the standard reference lists of pipe tunes, Harry Bain's *Directory* reveals a total of 372 tunes named after commissioned officers, including 90 captains, 57 majors and 65 colonels, most of them either 2/4 or 6/8 marches.

But tunes do not just emerge out of thin air; like any cultural creation, they are informed and inspired by the wider tradition from which they spring. For many composers of pipe music, that well of tradition belongs to the *Gaidhealteachd*, but for others the music emerges from a Lowland context. Let's return to that conversation between Hamish Henderson and James Robertson in Banffshire in 1952:

> HH: I've been listening to a lot of the bothy ballads, as you know, Pipe Major, and it seems to me that a lot of them are in the pipe scale. Do you think that the piping tradition has anything to do with those bothy ballads?

> JR: Oh yes, of course... the fact they speak in one octave, you know. And a good many of the tunes... are just the one octave.

> HH: And it is the pentatonic scale – the scale of the old folk song, that is also the scale o the pipes of course. But take for example some of these tunes like the 'Barnyards o Delgaty' – 'lintin addie toorin addie' – you could play that on the pipes... And the same with these old Rhynie tunes, or the tunes associated with Rhynie, that Willie Mathieson was singing to me. 'At Rhynie I sheared ma first Hairst'. Well it seems to me that that is just the pipe scale, more or less.

> JR: Well a lot of the old tunes, you see, some of the airs, are just real pipe tunes, you know. The songs were put to them, I think. You hear a lot of these cornkisters like the 'Bonnie Country Garden'. And old things like that. 'The Muckin o Geordie's Byre'. 'The Barren Rocks of Aden', of course, all these things are played on the melodeon now. The melodeon and the fiddle. The average fiddler roon aboot the north-east, here, he didn't go in for any fancy technique, or anything. He just played the melody.

> HH: Oh, no, he just stuck wi the old melodies, that's right... Then of

course some of yer own marches I think, too, Pipe Major – the thing I like most about them, such as 'Farewell to the Creeks', for example, is that they seem to me to link up with this folk song of the north-east in some way or other that I can't quite define. But I think they share a common musical experience. They seem to me to come out of the same sort of tradition as a lot of the bothy songs. Do you think they do?

JR: Oh, well probably wer ideas are just like that. The old folk songs ideas, you see.

Pipe tunes and local song traditions go hand in hand, then, yet most of James Robertson's compositions were also filtered through the experience of war. That is true of many of the most prolific piping tunesmiths to have emerged through the 19th and first half of the 20th centuries, the heyday of light music composing, for most were military men who saw active service. The very concept of 'the march', of course, derives from the most functional of martial reasons, and as a musical genre of Scotland it arrived late, only once there were roads to actually march on! And while they have long since made the transition to 'listening' music, with a highly refined and stylised aesthetic at their heart, there is no disguising where they came from. And with the Scottish cultural diaspora having taken the highland bagpipe to every continent, and to some in huge numbers, we have here, of course, an iconic, yet musically sophisticated means of voicing Scotland.

Lands and Lyrics

Not vernal show'rs to budding flowers,
Not Autumn to the farmer,
So dear can be, as thou to me,
My fair, my lovely charmer.

THE RELATIONSHIP BETWEEN THE writer and the land has been rich, multi-layered and highly rewarding in Scottish literature and song. Often celebratory, at times tense, rarely ignored, it has stood as a foundation stone of Scottish cultural expression for much of our history, and as such has played a key role in voicing Scotland. It is, though, a complex relationship: the landscape has been friend and foe, embraced and shunned, celebrated and cursed; it has been held up as a symbol of all that is both good and bad about the manner in which we perceive our sense of person, place or nation and of the way we choose to represent ourselves to the world. Our land has been wild and natural or tamed and worked; it has been seen, smelt, heard, felt, tasted.

This multiplicity of meaning, this wholeness, has rarely been captured more eloquently than by Robert Burns in 'Now Westlin Winds' ('Song, Composed in August'), one of his very first ventures into song verse, composed, it seems, when he was a mere boy of 15. In just five stanzas – a few dozen lines – the poet runs us through the many strands of this complex and malleable relationship. As the west winds blow in, the land they meet is at first wild and unpeopled. Partridge, plover, moorcock, woodcock, heron, cushat, thrush, linnet – this place belongs to them. Yet amongst the birds, the hand of mankind is present, too, the 'waving grain' testimony to his intrusion, his success in taming nature. And yet this is no innocent idyll: very soon we are startled into recalling the warning shot sounded in the very first line of the song:

Now westlin winds, and slaughtering guns
Bring Autumn's pleasant weather.

The weather may be fine but there is murder in the air: this is, after all, 'tyrannic man's dominion', and suddenly the songs of the thrush and linnet give way to a soundscape which is altogether less bucolic:

> The sportsman's joy, the murd'ring cry,
> The flutt'ring, gory pinion!

Burns' reaction to the role of the hunter is one of distaste rather than outrage, however, and his fleeting protests soon give way to the main task in hand, romancing his girl. There is seduction potential aplenty in this landscape, as the 'cruel sway' is forgotten and the couple wander on through a scene which has once again returned to a pastoral paradise:

> But, Peggy dear, the evening's clear,
> Thick flies the skimming swallow;
> The sky is blue, the fields in view,
> All fading green and yellow;
> Come let us sway our gladsome way,
> And view the charms of Nature;
> The rustling corn, the fruited thorn,
> And ev'ry happy creature.

And when we hear his final lines (my epigraph for this chapter), again invoking the shared needs of both humankind and nature, can we think of a more simple yet powerful proclamation of love anywhere in the canon of Scottish literature? We will all have our own answers to that question, but for me, a brief engagement with 'Now Westlin Winds' serves as an apt scene-setter for a gentle meander through this theme, for in its succinct simplicity it comes close to unravelling the complex, multi-layered relationship which exists between the writer and the land within the Scottish tradition. A truly beautiful song, it's one I've often had the pleasure of hearing sung at close quarters by Dick Gaughan, who has referred to it as the best ever written. Dick finds new lines of thought in it every time he sings it, and he has the voice, passion and awareness to make these fresh connections sing out on every re-telling. At times the 'flutt'ring, gory pinion' line is spat out with seething anger, at others its delivery is more weary, perhaps resigned. What it never lacks, however, is passion. The song features on *A Handful of Earth*,

A Working Pair, Yarrowford, 1959
(School of Scottish Studies)

voted by the readers of *Folk Roots* as UK album of the 1980s – a well-deserved accolade for a fine example of an artist voicing the land, and indeed, voicing Scotland.

Back to Dunbar

Imagining the land remains a preoccupation for us in the 21st century, but it has a longstanding tradition within Scottish creative thought. The work of the 'Makars' of the fifteenth century seem a worthy place to pick up the tale. Robert Henryson (1430–1500) peppered his poetry with references to the land and soil, his fables in particular showing a concern for nature and for the changing seasons, but for man's mastery of the earth also. Witness 'The Fable of the Swallow and the Other Birds':

> Moving thusgait, great mirth I took in mind,
> Of labouraris to see the business,
> Some makand dyke, and some the pleuch can wynd,
> Some sowand seidis fast from place to place,
> The harrowis hoppand in the sowers' trace:
> It was great joy to him that luvit corn
> To see them labour baith at even and morn.[1]

While Henryson 'that luvit corn' was celebrating the work and produce of the field, his younger contemporary, William Dunbar, was at times more admiring of the finer subtleties of the domestic garden. The theme is present in two of his greatest secular poems, the dream allegory 'The Golden Targe' and the cutting satire on medieval marriage 'The Tretis of the Twa Mariit Wemen and the Wedo', both composed in the highly decorative aureate (or golden) style. The opening lines of the latter set a mood not unlike that achieved three centuries later in the lighter moments of Burns' 'Now Westlin Winds':

> Apon the midsummer evin, merriest of nichtis
> I muvit furth alane in meid as midnicht wes past,
> Besyd ane gudlie grein garth, full of gay flouris,
> Hegeit of ane huge hicht with hawthorne treis,
> Quhairon ane bird on ane bransche so birst out hir notis
> That never ane blythfullar bird was on the beuche hard.[2]

Loving corn was by no means a trait peculiar to the Lowland Makars, for the contemporaneous Gaelic bardic tradition likewise saw a good crop as a symbol of power and wellbeing. Flattering a patron for personal gain was all part of the panegyric code and culture, and the likes of Giolla Brúilingeach (probably a Galbraith of Gigha), looking to be sent a new harp from Ireland in the mid-15th century, was quick to praise the fertility of his potential patron's lands to win his favour:

> Red wheat grows on smooth plains
> Under the rule of Tomaltach, lord of Céis;
> On the white-hazelled domain of Coll's descendant
> Each ear of corn carried its full burden.
>
> Cows yield sweet milk in milking folds;
> He has fallow land most rich in grass;
> Both in its smooth demesne and its hilly land
> It is lovely country bearing a heavy crop.[3]

He got his harp.

If engagement with the land was a common thread running through literary and lyrical creativity in Scotland, there are certain periods

and movements in which such engagement became the prime focus of attention. The Scots Pastoral tradition performed such a role, with Allan Ramsay (1684–1758) leading the way with his 'pastoral drama' *The Gentle Shepherd* of 1725. Situated in Cromwellian Scotland (a period still within living memory for the older generation at the time) the play tells the tale of 'real country folk set in a realistic natural setting.'[4] Ramsay was moving the pastoral concept into a very different context of rural reality, grounded in time and place, in distinct opposition to the hitherto standard pastoral tropes of timelessness and idealism. The level of popular engagement with the work should not be underestimated: 66 editions of it appeared in the 18th century and 40 in the 19th, and it 'had a regular place in the bookshelves of even humble homes'.[5] The shepherd of the title is Patie, and it is in his relationships with those around him rather than the daily routines of his profession that we see literature reflecting life in this particular case. Ramsay sets the scene:

> Beneath the sooth side o a craigy bield,
> Where crystal springs their halesome waters yield,
> Twa youthfu shepherds on the gowans lay,
> Tentin their flocks ae bonny morn o Mey.
> Puir Roger granes, till hollow echoes ring;
> But blyther Patie likes to lauch an sing.

Ramsay's near contemporary, James Thomson (1700–48) from Ednam in the Borders, is often seen as belonging to the English tradition, having moved to London in 1725 where he composed his pastoral quartet of poems, collectively labelled 'The Seasons', which appeared from 1726–30. While traditionally viewed as 'an anglocentric apostle of British Imperialism'[6] – he was, after all, the composer of 'Rule Britannia' – recent assessments have begun to reclaim Thomson for Scotland, suggesting that 'The Seasons' 'might be seen to be more Scottish in its signature than is sometimes thought'.[7] Thomson marks the highs and lows of traditional rural living – 'Winter' sees the death of a shepherd caught in a snowdrift, while the hay-making and sheep-shearing of 'Summer' evokes an altogether more pleasant scene, and 'Autumn' rounds off with a celebration of 'the pure pleasures of the rural life.' Again, we have here a strong candidate for an early seed of 'Westlin Winds': 'Autumn' was a firm favourite of the young Burns who

was introduced to Thomson's work through one of his school books, Masson's *Collection of English Prose and Verse*.[8]

Moods and Mist

My own schooling two centuries later brought me face to face with those of another masterly verbal painter of the countryside, Lewis Grassic Gibbon. *Sunset Song* in particular settled itself down in my psyche, presenting as it does one of the finest prolonged engagements with the complex love/hate relationship between the individual and the land to have emerged from the Scottish literary tradition. I didn't realise that at the time, of course, as we read it week by week in Mr Townes' Higher English class at Breadalbane Academy, but it hit the spot with me all the same. In Chris Guthrie, the personification of this confused duality, we have a young woman who at times yearns to be free of the daily grind of life on the land, and yet cannot escape its magnetic pull, for

> two Chrisses there were that fought for her heart and tormented her. You hated the land and the coarse speak of the folk and learning was brave and fine one day and the next you'd waken with the peewits crying across the hills, deep and deep, crying in the heart of you and the smell of the earth in your face, almost you'd cry for that, the beauty of it and the sweetness of the Scottish land and skies.

This land is so deeply woven into her being that its metaphors seem to populate her every action, her every thought. Here, she lies awake, silently tholing the pain as her unborn child stirs within her, 'not wakening Ewan, for this was her rig and furrow, she had brought him the unsown field and the tending and reaping was hers, even as with herself when she lay in her own mother's body.' This was her duty, as her mother's before her and her grandmother's before that, and so on back, all the way to the folk of the standing stones of the ancient past which loom so large in Chris Guthrie's present. This is the deep well of continuity, of *tradition*, which grounds her to the soils of the Mearns as the world changes so drastically around her.

Moods changed with the seasons. John Guthrie was especially susceptible, 'for every harvest there came something queer and terrible on father, you couldn't handle the thing with a name, it was as if he

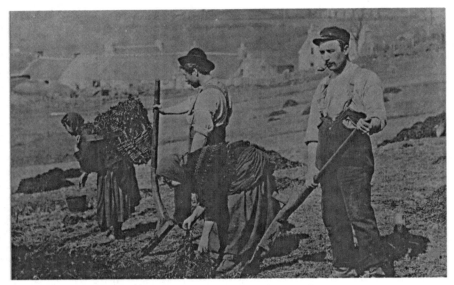

The Toil of the Land: Potato Planting, Skye
(G W Wilson, School of Scottish Studies)

grew stronger and crueller then, ripe and strong with the strength of the corn'. It was a time of risk, of chance, of potential disaster, but also of great pride, as 'down the bout, steady and fine, spread the reaper, clean-cutting from top to bottom, with never a straggling straw as on other farms, John Guthrie saw to that'. This reaper was John's one nod to modernity. He had no binder – 'wouldn't hear of the things' – and even his second-hand old reaper, a source of much embarrassment to his son, was somewhat reluctantly pressed into action ahead of the scythe which 'would yet come back to its own when the binders and reapers rotted in rust and folk bred the old breed again'.

But the past was not coming back. Nor was Chris's husband, Ewan Tavendale, shot for desertion in the mud and blood of Flanders. The pathos of his fate, his final thoughts of Chris, her voice, her song, the birds, the land, the corn, moved me nearly to tears when we read it for Higher English all those years ago. But there was no stopping them from flowing when I first heard Michael Marra tell the story in song:

Happed in mist, these 25 eventful years, seem to me now;
And in all but one, a friendly haze, a ghost of gladness by my side.
With horse and plough I marched with pride of the purest kind;
Then a blink of light and its Flanders field, and the end of time.

And through the flash and cannons' roar,
I saw my Christine's smiling eyes;
With no more thought of blood or shell I made my way to hold her near.
But Truth and Honour's henchmen found me, leaving here –
A madman's rave and a coward's grave for the volunteer.

And in his eyes flew snipe and curlew, in his nose blew moistened air
And in his mind the wood the king stole, that robbed the land, and
 laid it bare.
And in his heart, his lover's memory, singing on their wedding night,
Where once the parks flowed thick with corn.
That sullen tune was with him now

Happed in mist, the King's Own Rifles. 'Ready, Aim!'
The Flooers o the Forest, are a wee'd away.

A hint of a nod, perhaps, to 'Now Westlin Winds' once again, with flowing parks, moistened air, snipe and curlew. But the slaughtering guns here are not aimed at the birds: this, surely, is tyrannic man's ultimate dominion as he slaughters his own kind. The song spoke to me on so many levels. For a piper, 'The Flooers o the Forest' is a very special piece of music. It's said to be bad luck to play it for entertainment alone, and should only be tackled in mourning. I well recall my first time doing so, at the graveside of Mrs Gray, our maths teacher at Pitlochry, who died far too young of a brain haemorrhage. I didn't know if it was appropriate to pause to tune my drones before starting, so I didn't. They sounded sour, but somehow that felt OK, and I got through it. I was 15, the same age as Burns when he composed those wonderful lines of 'Now Westlin Winds', and it was the same year I first heard Dick Gaughan's rendering of it on *A Handful of Earth*. And there it was

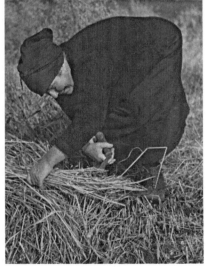

Reaping with the Sickle, Portnaguran, Ness, Lewis (James MacGeoch, 1952, School of Scottish Studies)

right in front of me, a handful of earth being scattered on Mrs Gray's coffin. Her husband was our headmaster, and he cried at that year's prize giving when giving his report on the school year. That touched us all, a public outpouring of grief from the strongest and safest of community guardians, the dominie. But that felt OK too, like my untuned drones.

Horsemen

I had not yet heard Michael Marra's musical eulogy to Ewan Tavendale, but it was later to touch me in other ways beyond the memory of that graveside encounter. Most of my own forebears including my grandfather and several of my uncles had also 'marched with pride of the purest kind' behind the plough. They were horsemen, in that very particular meaning of the word, for the working pair – Clydesdales invariably – had been the farming symbol of man's mastery of nature for at least two centuries. Taming the horse was the first step towards taming the land, and elevation to the status of 'horseman' was a coming-of-age initiation which stood as a mark of deep pride for generations of young male farm hands. This secret society, The Horseman's Word, with its anti-establishment rhetoric, diabolical leanings, at times violent initiations and regular drunken revelry was of course the very stuff of song!:

> First I gie'd on for billie loon
> And syne I gie'd on for third.
> And syne of course I had to hae
> The Horseman's grip and word,
> A loaf o bried tae be ma piece
> A bottle for drinkin drams;
> And ye cannae gang through
> The caff hoose door
> Withoot yer nicky tams.

This verse from the bothy ballad 'Nicky Tams' relates to the initiation ceremony used to induct new members into the society. The clandestine and ritualistic nature of this rite of passage served to cement the experience in the initiates' minds and memories, and reinforced the philosophy that the ploughmen were 'different' – that they were unique

LANDS AND LYRICS

within the structure of local rural society, kings among labourers. But it was a tough journey getting there. The young hopefuls would be summoned to attend their initiation after dark in some out-of-the-way barn somewhere in the district, and would be taken there by existing members once the way was clear. The 'minister', a senior horseman who took charge of the ceremony, was already inside, and as the members arrived they would go through some form of ritual before being allowed to enter (going through the 'caff hoose door'). In some cases this involved knocking three times and correctly responding to the questions posed from inside:

> Who's there?
> A Brother.
> What of?
> Horsemanship.
> How am I to know that?
> I've often been tried and never been denied and willing to be
> tried again.
> Ah well, pass in friend.

Those who were attending for the first time, of course, knew nothing of this process and were guided inside and then blindfolded, ready for their initiation to commence. It was common for the 'victim' to be told to remove some articles of clothing – perhaps one boot and one sock – and to kneel on the ground with his arms stretched above his head. The minister would then deliver his 'sermon', warning of the dangers of ever giving away any of the Society's secrets, and would instruct the young lad to take an oath. In most oral accounts, it has been claimed that he would then be given the actual 'word' which could be used to control a horse, and this was never to be written down, although some informants claim that no such word existed. Their first test came immediately, for they were given a pencil and told to write down what they had just been told, in order to check whether they remembered it. Having just promised never to write it though, compliance brought trouble, and many were given a blow from a fist or even a chain as punishment, and as a reminder of their oath. Before graduating into the world of the horsemen, the initiates finally had to 'tak a shak o auld horny' – shake hands with the ultimate horseman, the Devil. Still

Horse teams, Tibbermore, Perthshire, 1918
(Sue Grierson, Tibbermore, School of Scottish Studies)

blindfolded, their outstretched hand came into contact with a hoof (usually of some unsuspecting goat) and the bargain was complete.

Old horsemen, recalling these days in later age, vary in the mood of their reflections of that part of life now gone. For some, membership of the society was merely a bit of fun, a chance for a drink and a song, and a bit of crack at the bosses' expense. For others, though, it was a part of their very being which was not to be taken lightly: they had taken an oath never to reveal the secrets of horsemanship and that was to be respected until the day they died. My uncle, Will West, was one such. Here he was a guest on a local radio show on Heartland FM in Perthshire, voicing *his* Scotland:

HEARTLAND FM: And what happened if you went on to a job, and you were given your two horses and one was absolutely useless. Were you just stuck with it, if you had a bad horse, or were they all good horses?
ww: Well, they werenie all good eens you know, there was whiles we had a bad een. You had tae tie it back and keep the other een forit, sort o thing.

HEARTLAND FM: And did you break the horses yourselves?
ww: I've had my session at that as well.

HEARTLAND FM: And this is, what a year old colt?
ww:Oh no no, they were risin three maybe, risin four, afore they were broken. It didnae do tae break them too young. They never got

142

developed right, matured right if they were broken too young.

HEARTLAND FM: And how do you go about breaking a plough horse?
ww: Oh, I cannae tell ye that min!

HEARTLAND FM: [laughing] Why not?
ww: [not laughing] Because it's one o these things a horseman keeps tae himself.

HEARTLAND FM: And how did you learn it, then, if a horseman keeps it to himself?
ww: 'Cause I was learned how to dae it, by older men.

HEARTLAND FM: Did you look on your horses as loved animals or... it wasn't like a tractor at all?
ww: Oh no no no. You could just get them tae speak tae ye, min.

HEARTLAND FM: What kind of horses did you use?
ww: Clydesdales, mostly.

HEARTLAND FM: Do you remember any of them by name?
ww: Them all. Every one that a drove, I could tell you their name.

HEARTLAND FM: Start at the beginning and let's hear them.
ww: Dick, Muss, Tink, Charlie, Dan, Sport, Jimmy, Nell, Jock, Prince, Punch, Chance, Charlie, Punch again, Tip, Nell again, and Jock and Tam.

HEARTLAND FM: Which was your favourite?
ww: Punch.

HEARTLAND FM: Why?
ww: I don't know. He wis a show beast, pit it that way. He could just walk at the right pace and set heself and he'd good markins, good body, good legs, you know...

HEARTLAND FM: You must have cared a lot about them to have remembered their names all this time.
ww: Oh aye. Just loved them.

I always feel there's poetry in Will's words and others have felt it too. Shortly after he joined the Battlefield Band, I gave Davy Steele the transcript of that interview. I was very moved when some months later

a new song appeared, 'The Last Trip Home', based on Will's poetic narrative and imagining his last day working with his beloved horses:

A've ay worked on ferms, and frae the start,
The muckle horses won ma heart.
Wi big broad backs they proudly stand,
The uncrowned kings, o a the land.
And yet, for a their power and strength
They're as gentle as a summer's wind.

Chorus
So steady boys, walk on.
Oor work is nearly done.
No more, we'll till or plough the fields,
The horse's day is gone.
And this will be oor last trip home,
So steady, boys, walk on.

I've aye heard men sing their songs o praise
Of Arab stallions, in a race,
Or hunters that fly wi the hound
To chase the fox, and run him down.
But nane o them compare, I vow,
Tae a workin pair that pulls the plough.

Of a the years I've plied ma trade
Of a the fields I've ploughed and laid,
I never thought I'd see the time
When a Clydesdale's work would ever end.
But progress runs its driven course,
And tractors hae replaced the horse.

As we head back our friends have lined
The road to be there one last time.
For nane o' them would want tae miss
The chance tae see us pass like this,
They'll say they saw in years tae come,
The muckle horse's last trip home.

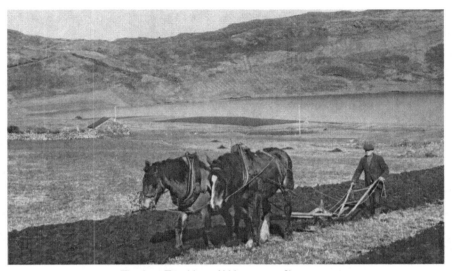

The Last Trip Home? Waterstein, Skye, 1949
(Eric Meadows, School of Scottish Studies)

'The Last Trip Home' is a fine example of a revivalist song reflecting back on a way of life now gone, based on the sentiments of one man who lived through that change and who witnessed it actually going. As such it is contemplative, nostalgic perhaps. But for the composers of the cornkisters or bothy ballads who were making their songs while the horses were still very much part of their lives, their lyrics could support the stamp of the matter-of-fact. They could complain when they were given poor specimens to work with, curse when an ill-tempered beast lashed out, swell with pride when winning a prize at a ploughing match. One of the finest, 'Drumdelgie', outlines the daily work for the servants on a Deveronside farm in the north-east of Scotland, where the farmer is 'kent baith far and wide' as an employer who is 'hard and sair', sending his workers out in the worst of weather to work the land. Up at five in the morning, their first task is to see to the feeding and grooming of their horses, before a quick breakfast of brose and milk. They have scarcely got their brose 'weel supt' when they are ordered to the threshing mill until daybreak, then it's off to the fields to plough or 'drive the neeps', choking on the cold wind as 'the snow dank on sae thick and fast' and they struggle to make any impression on the frost-ridden ground. This marvellous, tuneful ballad opens our eyes to the gritty reality of the daily winter toil on a 19th century marginal farm. This is no quaint kailyard ditty, no romantic pastoral celebration, and

the narrator shows only relief as he takes his leave of the place in the final verse:

> Sae fareweel, Drumdelgie,
> I bid ye a' adieu;
> I leave ye as I got ye –
> A maist unceevil crew.

Musical Groundings

The relationship between instrumental music and the land intrigues me. With words, it is fairly straightforward to evoke this connection, but rather less easy in their absence. Many composers claim to be inspired by landscape and if we're looking for a starting point to discover just exactly how, then E Marshall's study, *Music in the Landscape: How the British Countryside Inspired our Greatest Composers*, is a highly accessible introduction. Ethnomusicologists, who tend to deal with the native, indigenous or traditional music of the world's peoples, have also spent some energy on exploring musical landscapes, although perhaps not as much as we might have expected.

A few years ago, I was driving from Edinburgh to Melrose to teach on a Scottish bellows bagpipe weekend being run by the Lowland and Border Pipers' Society. I had been brushing up on some Borders' repertoire for the course, and was merrily humming the tunes to see if they had yet found their way into my memory bank when it suddenly dawned on me that this was the perfect mental soundtrack for the rolling countryside I was driving through. Many of these Lowland tunes feature undulating melodies that rely on a subtle pulse rather than a rhythmic beat as they gently meander their way through their variations. The dotted crotchets and spiky 'Scotch snap' peaks and troughs of the Highland pipe repertoire – marches and strathspeys in particular – are notable by their absence. I sang one or two of these tunes from the north and west as a wee experiment and they were just plain wrong for the valley of the Tweed! They belonged to the mountains and glens, sharp and rugged, not this green and open pastoral canvas all around me. And so I arrived at the George Hotel in Melrose with the cocky confidence one gains from an epiphany, sure in myself that music emerges directly from the landscape within which it is conceived. Science based on deep and thorough research this is not, but the idea

continues to intrigue me nonetheless. And it has got me thinking about that most Highland of Highland artforms, the so-called classical music of the bagpipe, pibroch. It seems to me that this music, which Scotland can genuinely call her own, is music that sings out from the soils of its birth.

Having presented *Pipeline* for a decade now, it's notable how many people say to me that they enjoy the more jaunty tunes but go to make a cup of tea when the pibroch comes on! I can understand that, for it is certainly esoteric, and is far from easy listening material. Like all complex music, it does require a proactive engagement and at least a basic understanding of what it is all about. But it's worth that investment, as the piper and scholar Barnaby Brown has assured us:

> Pibroch is like fine wine – it adds a touch of class to any occasion, attracts myth and obsession, holds secrets to aficionados, and a small sip leaves a wonderful feeling. In the 16th and 17th centuries, pibroch roused men's courage in battle, gathered clans when scattered, immortalised heroes, chieftains, and great events, and uplifted people's spirits when feasting, marching, rowing, or harvesting. Considered the highest form of piping (known in Gaelic as *ceòl mór*, the 'big music'), pibroch carries a bouquet of superiority, dignity, mystery, and romance. It brings to life the late-medieval history of Ireland and Scotland and endows Highland culture with a majestic nobility. Yet, the bagpipe is linked in most people's minds, not with great music, but with the clichés of Scotland: kilts, massed bands, buskers, and 'Scotland the Brave'. The ceremonial music of the Gaelic chieftains, 1550–1750, has kept a low profile. Why is this? Opportunities to hear pibroch or have it explained to you are scarce, unless you are a Highland piper; or married to one. Its full glory is often concealed. Once discovered, however, its intricacies and delights continue unfolding for years.[9]

In order to understand pibroch, one first has to consider the materials and mechanics of the bagpipe. It is an instrument with a strongly organic feel, leather, hardwood and reed combining to form an iconic item of material culture which the player virtually wears. The bag serves, of course, as the air reservoir to allow a constant flow through the reeds, maintaining a sound that is not interrupted by the player taking a breath. The same effect can be achieved without a bag by using the cheeks as the reservoir and employing the technique of circular breathing, as used by didgeridoo players in Australia, or by exponents of the remarkable 'bagless bagpipe', the Sardinian launeddas, where several reeded tubes are inserted into the mouth all at once producing

a rich and melodic sound that belies the simplicity of the technology involved. The bag makes life that much easier, however, and in order to take advantage of the constancy of sound, almost all examples of the international bagpipe family use drones to provide a background tone against which the melody of the chanter is played. In most cultures the drones are fairly quiet relative to the chanter, but not so with the Highland bagpipe, where the combination of three drones with large split cane reeds produces a prodigious wall of sound, enveloping the player with a deep bass timbre, wonderfully rich in harmonics. Tuned to the key note of A (or nowadays somewhere sharp of B flat), the melody floats above this, and it is the varying relationships between the notes of the melody and the drone which create mood, the central aesthetic element of this music. Some melody notes will harmonise with the drones, while others will cause a tension which we perceive as an aural clash. That pairing of consonance and dissonance constitutes the essence of pipe music, and of pibroch in particular, which is constructed in such as way as to take maximum advantage of these moods, giving us 'happy' or celebratory music in praise of people, places or events, and melancholy music, mourning death and loss.

The word pibroch is an Anglicisation of the Gaelic, *piobaireachd*,

Recording *Pipeline*. Pipe Major Brian Donaldson (left) with Gary West
(BBC Radio Scotland)

which simply means the art or practice of piping, but the English form has come to be used to denote the particular genre which in Gaelic is labelled ceòl mór, or 'big music'. This is very different to the marches, strathspeys, reels and jigs which form ceòl beag, or 'little music', which on the whole is accessible, easily identifiable and often danceable. Ceòl mór sits at the opposite end of the mood spectrum, and emerged from within Highland society mainly from the 16th to the 18th centuries, most likely building on earlier traditions relating to the voice and the clarsach or small harp. It has a theme and variation structure, beginning with the 'ground', which sets out the basic melody, usually according to one of three structural forms, and this is then explored in a series of variations which build in complexity and required dexterity. Each tune is a musical odyssey – in fact one of the early variations is called the *siubhal*, or 'journey' – and most of the variations have both a singling form, punctuated with pauses or cadences, and a doubling, played a little faster and straight through, unencumbered by such momentary reflections. Players are discouraged from thinking in conventional time signatures and bars, feeling for a pulse rather than a distinct beat, and within reason, tempos can be 'felt' rather than strictly adhered to, slowing towards the end of each variation, for instance.[10]

Those are the basics, then, but why my contention that this belongs in a chapter which deals with music of the land? Well firstly, this is rural art, rural Highland art, rural highland Gaelic art. To make that last point tends to upset people these days, as few of our top players now speak that language, but I am by no means saying that non-speakers of Gaelic cannot play this music. Of course they can, and do, including a large number within the new generation coming through, and not a few from well beyond Scotland. The point is that there are very few of the 300 or so extant tunes which were composed by people who did not converse, feel and think in Gaelic. This is reflected in the terminology of the variations and finger movements required to make the music, and of course in the titles of the tunes themselves.[11] And traditional Gaelic society was nothing if not 'land' centred: water was for travel, land was for living. But it is also music which demands space. Drones in particular both create and expect space, their richly layered harmonics evoking a sense of expansiveness that is without doubt stifled within certain enclosed acoustic settings. Urban-based pipers like myself rarely get the chance to play on real land, and it produces a whole different

feel when we do. It just feels right, and I suppose that is what counts.

And then there are the stories behind the tunes. These serve as the explanation and justification of their very existence. They may not be of the land in the same manner as, say, a McTaggart painting is of the sea, for while they certainly share the same scale of space and drama, the inspiration to create *ceòl mór* rarely seems to have materialised on happening upon a vision of nature's mysterious grandeur. Rather, they deal with human lives and deaths acted out upon such a stage, helping to create the cultural landscape of Highland history, marking key events, flowing through time and reaching high peaks of artistic beauty.

Let me take just one example. 'The Lament for the Viscount of Dundee' is a piece of music which speaks strongly to me, a tune local to my part of Perthshire, for it was composed to commemorate the death of John Graham of Claverhouse, 'Bonnie Dundee', following the Battle of Killiecrankie in July 1689. This was a key event in the first stirrings of Jacobitism in Scotland, for the Scots Parliament in Edinburgh had recently voted to pledge allegiance to King William of Orange and his wife, Mary, replacing her father, the exiled King James VII. Claverhouse could not accept this decision and was declared a fugitive as a result. With significant support from the Highlands, especially forces under Ewen Cameron of Locheil, he raised an army which eventually met the 'redcoat' government troops under General Hugh MacKay just south of the strategically important stronghold of Blair Castle. Killiecrankie forms a narrow pass between the Garry and the high braes of Atholl. The Jacobites arrived first and took up their position high on the slopes, leaving MacKay with, literally, an uphill struggle. At this point for me, history and imagination give way to memory, for when I was very young I was taken to see the Sealed Knot Society re-enactment of the battle, and the terrifying sight and sound of the swift and decisive downhill charge of the kilted highlanders is etched indelibly inside my head. Their victory was marred by their leader's fatal injuries, and the campaign dissolved following defeat in the streets and fields around Dunkeld cathedral in August.

The tune itself is a masterpiece of the genre, with a gripping and soulful melody line that makes economical yet devastating use of that saddest of notes, the 'flattened seventh' of the pipe scale, the 'G' natural which simply weeps against the 'A' of the drones. Octave leaps heighten

the drama as the pathos builds towards the end of the ground, while the singling and doubling of the first variation are considered by many to be among the finest ever composed. In fact we don't know who did compose the tune, or how soon after the battle it emerged, but a fragment of it does appear in the earliest detailed written record of Highland pipe music, Joseph MacDonald's *Compleat Theory of the Scots Highland Bagpipe* of 1760.[12] I realise I cannot do justice to the magnificence of the rest of this tune in words, but for me it is music which paints a dramatic and moving picture of the Atholl Braes and the deaths it hosted.

One day per year, in late October, the ballroom of Blair Castle plays host to ten of the best pipers in the world, as they gather for the most prestigious solo contest of the year, the Glenfiddich Championship. Only the most 'in-form' players of the elite professional class are invited, guaranteeing a day of excellent playing within this most splendid of settings. The air is thick with history, and every player will tell you that there is nothing quite like the experience anywhere in the world. A few years back, Roddy Macleod, one of our very best competitors and director of the National Piping Centre in Glasgow, was tuning up in one of the side rooms before taking the stage. His tune that day was 'The Viscount' as it is fondly known. Just before leaving the tuning room Roddy happened to glance at one of the display cases and noticed an old fragment of uniform, complete with bullet hole, with a label that informed him it had belonged to John Graham of Claverhouse, killed near that spot in 1689. The inspiration hit him like a slap. He won!

Before I move away from the big music, I'd like to introduce a recording from the School of Scottish Studies Archives, and available online on the *Tobar an Dualchas* website.[13] It demonstrates just how seriously pipers take their pibroch, how much emphasis is placed on its transmission down through the generations, and the importance placed on pedigree and orality. It features Pipe Major William MacLean recalling his early training in pibroch from Malcolm MacPherson, better known as Calum Piobaire (Calum the Piper), one of the players considered to be a master of the art form through the second half of the 19th century. Having received some initial instruction from him at the MacLean family home in Greenock, at the age of 18 William's father felt it was time for him to return to the great man for more intensive tuition, and so arranged for him to make the journey to Badenoch to

stay for two months. For this skilled but green young lad, eager to make his name and to immerse himself in the tradition to which he was so committed, it was a hugely exciting time, so much so that almost 60 years later he could recall the entire experience in intimate detail. Speaking in 1954, three years before his death, he takes up the story:

> My father said, 'Well, you've been winning a good many prizes now, and I think you should go to Malcolm MacPherson to his own home now, up in Badenoch. Would you manage the journey?' I said, 'Oh, I'll manage it alright, if you put me on the train'. He took me to the station and put me on the train from Greenock, and he told me that I was to go to Buchanan Street and a friend met me at Buchanan Street. A Mr Henderson, the bagpipe maker, the famous Peter Henderson,[14] and he took me to his house, I stayed with him overnight, and he and his sister were very kind to me, and I remember fine that they had a parrot in the room – a great talker, a green parrot – I was put to bed anyway, and Mr Henderson came with me to the station to catch the morning train. An early start – very early, I remember that – but I was up, fresh as a bee, and I got to Dalwhinnie. And I was watching every station to see when I was coming to Dalwhinnie. And when I got to Dalwhinnie I jumped out, with my pipe box and my little portmanteau. And then I was told to go to the hotel keepers, people by name of MacDonald. And Mrs MacDonald said, 'Oh yes, you're Master William MacLean, aren't you? You're going to Malcolm MacPherson's. Well you'll get a dog cart and a horse and a driver to take you there, it's a journey of sixteen miles. Everything's arranged for you, so you'll be alright.'
> So I landed at Malcolm MacPherson's house, in the afternoon, and I was taken into the Highland house, thatched, a typically Highland house. And I was introduced to his wife, Mistress MacPherson, a real old highland lady from Islay, she belonged to Islay. And Malcolm MacPherson I knew, of course, having been taught with him before, and I was warming myself at the fire, it was very cold I remember and I got a good heat up from the peat fire, and then Malcolm, I remember quite well, picked up his bagpipe and he always played with his bonnet on, in the house. And he put his Balmoral bonnet – no it was it was a Glengarry bonnet I remember now, and he put it on his head and he started to play. And I was just fairly carried away with the beautiful, crisp, strong notes that was coming from his fingers. And he was looking over quietly to me as he would turn round and seeing me swallowing it all in by my ears and enjoying it well.

This is master storyteller at work, and it is the visual markers that come to the fore and punctuate MacLean's retelling so vividly: the green parrot, the pairing of pipe box and portmanteau, the dog cart and horse, the thatched highland house, the old highland lady, the peat fire,

and of course, the master piper complete with Glengarry bonnet. Yet as this 'arrival' scene nears its conclusion, and William moves towards his re-telling of the teaching and learning process itself, it is almost as if his mind is already making the shift from sight to sound. The beautiful crisp, strong notes, and the swallowing of their sound by his ears, serve as a delightfully voiced bridge to the next part of his tale, a story now underpinned by *listening* and *memory*:

> And we started then the following day. And he was very strict in his teaching. We got up a little after eight in the morning, we had our breakfast at nine, and then we started the practice chanter at ten o'clock. And I had to keep going with the chanter, himself on the one side of the fire and I on the other. No books, but memory. All from memory. He wouldn't take any pupil that couldn't memorise from his own playing. He said that was the way that the music was handed down and if he couldn't get a pupil that was capable of that, he'd prefer not to have him at all, if he had to teach him from books. I had no difficulty, I was getting one or two a day, and I could have taken more if he'd given them to me but he thought I was doing good enough. And that went on until dinner time. Then he took me out in the afternoon, from two o'clock til three, or half past three, for a walk, and then we started the chanters again until just about six o'clock, and the chanters were set aside then, we had to wash up and prepare for our supper which we got, old highland style, substantial plate, good food. And then everything I had learned on the chanter through the day, I had to play it off on the bagpipe from seven o'clock until near bedtime, on and off.

Learning from a master, then, was a most intensive business, with the same regime followed each week day, with weekends off. Saturdays were spent hunting in the hills with Malcolm's son, Angus MacPherson – later to become a very fine player himself – the two lads bringing home rabbits and hares for the pot. Each Monday, the cycle of learning would begin once more, until after two months it was time to bring the apprenticeship to its conclusion:

> He said to me, 'Well, you're to go home now. I've had a letter from your father, and you're to go home. Your time is up now, and there's only one more pibroch that I would like to teach you and that'll complete one hundred tunes that you've taken from me, more pibroch that you've taken from me than any pupil ever I had.' And the tune that he learned me – or taught me I should say – before I left, was the 'MacDonald's Salute', one of the MacCrimmon famous pibrochs. And with that I parted with him and the dog cart and the horse and the same driver came to the door and took me the 16 miles to Dalwhinnie, and

I boarded the train, arrived in Glasgow and got to Greenock and my mother and father met me there.

There's a lovely circularity to William's narrative ending with the return journey home, two months older and a hundred pibrochs richer. It's a circularity reminiscent of the pibroch genre itself, each tune laying out its home ground – it's *urlar* – then the *siubhal* or journey unfolds, building in intensity and complexity through its singling and doubling variations before reaching a climax of fingering fireworks and returning, finally, to home ground. When someone is as saturated in a musical genre as William, then it is surely not inconceivable that his aesthetic consciousness becomes irretrievably shaped by the form and flavour of that tradition. That his re-voicing of his coming of age experience may have been shaped by the form of the tunes themselves may just be a claim too far, and yet there is certainly a highly ordered structure to his narrative which does nod towards 'MacDonald's Salute' and its 99 sisters. He was thinking in the language of pibroch.

It is perhaps difficult to perceive the depth of meaning and the fundamental feel of the music of pibroch and the tradition which it represents. I made claim, above, to the importance of listening and memory in William's narrative and in his learning process, and it is these concepts which lie at the heart of the pibroch aesthetic. The principle is common to all forms of music, of course, under the very reasonable insistence that music is made real by the ears rather than the eyes, and yet principle and practice can be two very different things. Clearly, for Calum Piobaire, there was no alternative to learning by ear. It was the only way. Not the better way, the *only* way. He had at his disposal, however, a critical tool for doing so, one learned from his forebears, and passed onto his apprentices through the act of repetition and immersion. A truly oral artform, *canntaireachd* is a complex system of vocables developed over generations as a handy means of learning, teaching, remembering and refreshing one's repertoire. Here's William MacLean again:

Well Malcolm MacPherson was taught by Archibald Munro. Archibald Munro I was told was a native of Glenelg but lived in Oban. He died in Fort Augustus and he's buried there. Malcolm MacPherson told me he was a native of Glenelg, and was a pupil of the celebrated John MacKay of Raasay. And John MacKay of Raasay was taught by MacCrimmon in Boreraig in Skye so that the tuition that I got from Malcolm

MacPherson was direct right down through that source. Taught as it was taught by the MacCrimmons themselves, no books, they had no printed music and they had no use of any pupils coming to them unless they had a memory for to record in their brain the music that they were being taught in their classes. So that's the tradition of the handing down of the pibrochs that we have today, and it's undoubtedly the best system of learning pibroch because if you read a pibroch from a book you're learning the tunes from your eyes not by your ears and the memory doesn't carry it so well as what you have learned by your ear... Oh yes it was *canntaireachd* music words that he used, as we sometimes work it today in recording our notes to a pupil we would do that by the word of mouth... Oh yes, the real MacCrimmon *canntaireachd*... It must have a key before it could be understood. Like everything else it has its own alphabet.

Few players nowadays know fully developed *canntaireachd*, although most still sing a basic approximation when teaching or discussing the finer points of style. It is an example of the erosion of a tradition, probably due to increased musical literacy and perhaps the introduction of audio recordings, whether personal or commercial, that allow pupils to learn from a master remotely. Nonetheless, even although nowadays almost all pipers are musically literate, there remains a very strong conceptualisation amongst players that this is still music which demands to be passed down through ears and fingers.

Returning to the Lowlands, driving to Melrose that day I was suddenly conscious of entering a different musical place, an alternative melodic mindset to the one in which I had grown up. There was 'big music' to be found there too, much of it also following a theme and variation structure, and it also grew out of the soils of the land. Yet it was very different in mood and feel to pibroch, a bit like the jigs of the Galicians that I had discovered with Gordon Duncan all those years before, different yet somehow familiar. The French sociologist, Pierre Bourdieu, talks a good deal about the idea of 'cultural capital', the acquiring of knowledge and familiarity from a young age that provides us with the means of accessing certain modes of culture as we move through our lives.[15] Well at that moment it felt as if I somehow had the capital, but it was just in the wrong currency. I had to exchange it, then invest in this new old music, and later, hope to reap a return.

The reason it was 'new old music' is that the bellows bagpipe that I was off to teach is a revived tradition, not continuous like its Highland cousin. Thanks to meticulous research by a number of scholars, we now

know a fair bit about the deep history of the various bagpipe forms which arrived, developed, thrived and declined below the Highland fault line from as early as the 15th century.[16] We know who some of the players were, that towns and burghs supported a minority of them, providing a uniform, house and small retainer fee in return for music to accompany local life and ceremony. We know that the instruments themselves tended to be smaller and less strident than the Highland pipe and that bellows tended to replace human lungs to drive them from around the 17th century. They were played at dances, weddings and fairs, but these were not particularly high status instruments, missing out on the aristocratic patronage which was common in the north and west. We also know that the tradition died during the 19th century, although we're not sure just exactly why. The increasing popularity and dominance of the Highland pipe no doubt played a significant part in this, and one theory suggests also that the burghs could no longer afford to support their artists after the Reform Acts forced them to take more responsibility for the basics, such as supplying clean fresh water and proper sanitation. Whatever the reasons, by the dawn of the 20th century, this distinctive melodic voice which had enlivened the Lowland streets and country lanes for four hundred years, had gone.

But now it is back, or versions of it at least, for a group of enthusiastic and energetic musicians began to revive the instruments and their music in the early 1980s. Thirty years on, this lost piping art form takes its place once more in the flowing stream of Scottish tradition. I was not in on the start of the revival and cannot claim to have been a key player in it, but I did join in some half a dozen years after it began, and have been enthusiastically swept along in its flow. And it has been fascinating to watch the revival progress, for it precisely fits the scholarly models of how such things tend to operate. One of the key principles of revivalism is the links that are made back to the 'original' form, or at least the form of tradition which existed before it disappeared. In cases where that is still within living memory then the 'informants' who took part in the original are crucial to these links, and often tend to be revered and held up as 'authentic' exponents of the tradition being revived. But where no such informants survive, when the period between the disappearance and revival is just too long, then there is a problem. That is the case here, for while there is a residue of collective folk memory of one or two of the old players, the threads of transmission have been severed.

We now know a good deal about the old ways, but we know little about how people learned, how they then passed on that knowledge to the next generation, or even how they actually played the tunes which have survived on paper. We have no equivalent to William MacLean's tale of learning by the fireside of a master, no chain of transmission reaching back into the ancient past. We have had to start the chain afresh, and that brings its own questions and responsibilities. Yet it is also hugely exciting to see where this new tradition might flow.

CHAPTER 6

Cultural Contexts

I HAVE TRIED TO sketch out a few thoughts in celebration of just a handful of those who have been voicing Scotland, and who have done so largely from within a recognised tradition which we have come to label 'folk culture'. There are many definitions of 'folk' in this context, and you may have noticed that I haven't offered you any of them! That is because the term is rather problematic from the perspective of a 21st century western nation, for while to William John Thoms writing half a dozen generations ago it may have made sense to think of 'the folk' as the ordinary people, or the masses, in today's society that idea has little resonance. It is still a handy enough label, however, and one which continues to be used to put down certain kinds of markers, to flag up certain expectations, to point us in certain directions. In this concluding chapter, I would like to reconsider some of these directions, and to frame them in the wider context of some of the key debates which have been taking place in recent decades concerning the overall direction of Scottish cultural representation.

One factor which unifies all the songwriters and singers I have discussed here is that they each sing in their own voice. They sing more or less in the same dialect in which they speak, refusing to hide behind the aural mask of the 'mid-Atlantic' twang which has served most genres of popular song since the middle of last century. I find that a very honest approach to the creation of art, for as Alan Riach has shown, there are many creative masks worn in this modern nation.[1] We can live with one less. This cannot serve as a definition of folk song, of course, for there are certainly others who delight in the same refreshing verbal freedom and who would be unlikely to consider themselves as folk artists. The punk movement was one such (although even there Cockney seemed to become the lingua franca irrespective of geographical origins), and in today's Scotland the likes of The Proclaimers, Paolo Nutini, Adam Holmes and The Embers, King Creosote, Admiral Fallow and Fright-

ened Rabbit all wear their home places on their tongues. In mainstream popular music, they are the exception, however, whereas for those who move in folksong circles, to do so is the rule. And that rule operates at two levels, for while to the wider world Davy Steele, Michael Marra and Nancy Nicolson all voice 'Scotland', to those who still possess the necessary cultural capital of recognising dialect they also voice the Lothians, Dundee and Caithness – or perhaps even Prestonpans, Lochee and Wick.[2] The same applies to those who sing in Gaelic, for Cathy-Ann MacPhee, Margaret Stewart and Arthur Cormack all sing out for Gaeldom, but they do so specifically for Barra, Lewis and Skye too. It is both a matter of what they sing and how they sing it, and that linguistic variety is surely something to cherish as a continued contribution to our cultural richness.

Another important fact which binds our folksong makers together is that as well as performing their own material, they each also give full space to 'traditional' songs and tunes in their recorded and live repertoires. For a professional musician to choose to perform any given song there has to be high value placed on it: reputations and livelihoods cannot thrive on lip service alone, and so we can rest assured that traditional material that does make it onto the set list must have significant meaning for its performer. That meaning can take many different forms of course, but to sing it or play it publicly is to say, 'Listen, this is old, it is from the past, I don't know where or when or by whom it was crafted, but it has made it through, it has been reshaped on its journey, and it has something important to say to me. Come with me and I think it will have something to say to you.' And to have such invitations regularly interspersed with new work, on the same album or within the same concert, is also to assert that they belong happily together, that the combination makes sense, artistically, creatively, philosophically. We are back, then, to that carrying stream of tradition, of that appreciation of a flowing continuum which in my experience folk musicians take very seriously indeed, and to which they consider they belong. They are aware of the roles of the collectors of whom I talked in Chapter One, for instance, those whose perseverance and energy has given them the access to a good deal of 'tradition' in the first place. They are aware, too, that they are part of a process of both survival and revival, and that the latter is needed when the former fails. They know that only two generations ago it would have been very

difficult for them to do what they do, for the zeitgeist of the most recent major folk revival, that of the mid-20th century, had yet to take root. For today's folk artists, that is the bridge that allows their own art to be married with that of their forebears – the bridge to tradition.

The story of that Scottish folk revival, and those of the wider international movements of which it was a part, have already been told by others.[3] However I don't believe that it has been given its proper place within Scottish cultural discourse and debate, and so I would like to turn to that task now. The final quarter of the 20th century witnessed a major re-assessment of what the term 'Scottish Culture' actually means, what it should mean, how it should be approached and how it should be represented. A rich discussion emerged from this debate, fuelled by academics, the media, creative artists and the general public. So what was involved in this? What part, if any, did 'tradition' play in this reflection? And why did it take place when it did?

Scotch Myths

The simple answer to the latter question is that the time was right, and a number of factors can be seen to have combined in order to make it so. First of all, we cannot ignore politics, for the 1970s of course saw a rise in the fortunes of and support for the Scottish National Party. Scottish nationalism had first been manifested in a formal sense with the foundation in 1928 of the mainly left-wing National Party of Scotland, which later combined with the centre-right Scottish Party to form the SNP in 1933. But despite the occasional success in the intervening period, (one MP in 1945, Robert McIntyre, held Motherwell for all of six weeks) it wasn't until the late 1960s and early '70s that it really began to emerge as a serious contender for parliamentary seats. Its membership rose from 4,000 to 100,000 in two years in the late 1960s and in the second of two elections held in 1974 the party won 11 seats and 30 per cent of the Scottish vote. And as is often the case, the rise of political nationalism was accompanied by a closer look at what it meant to be Scottish: what is Scotland anyway? What, if anything, is different about Scottish culture from that we may be voting to break from? We are asking ourselves the same questions again as I write.

The key figure who placed himself at the epicentre of these cultural

debates was the Marxist intellectual Tom Nairn. Today Nairn is one of the world's leading theorists on the subject of nationalism, but his impact on the Scottish culture debate was significant in that he was one of the most outspoken critics of the kitsch nature of our prevailing cultural output which he believed had become 'deformed' due to the poisoning influence of two toxic phenomena, tartanry and kailyardism. Tartanry refers to the hackneyed conceptualisation of Scotland as a land of tartan, heather, whisky and yes, bagpipes, while its partner in crime was the kailyard school of literature produced by a handful of Scottish writers in the early years of the 20th century that collectively portrayed Scotland as a bucolic paradise and ignored the harsh realities of urbanisation.[4] For Nairn, tartanry and the kailyard became the double-headed monster, the twin pillars upon which our culture was built, and which together represented a hegemonic influence which had overwhelmed all else. Their influence, he felt, was still with us in those final decades of the 20th century.[5]

Nairn's work was powerful and polemical and his forthright approach stirred up the debate perhaps more than any other writer. While he was by no means alone in pointing out the somewhat deformed nature of Scottish cultural representation he was amongst the first to come up with an explanation as to why it came to be that way. The answer, he argued, lay in the *absence* of nationalism as a significant force in Scotland through the 19th and early 20th centuries, for political nationalism is able to use cultural difference as a powerful tool, presenting the nation's own indigenous art forms as a rallying call and a catalyst to the forging of a separate identity, helping to fuel political support. As such, vernacular speech, music, clothing, beliefs, literature, visual art, folklore and so on are placed high on the national agenda by the movers and shakers of nationalism. The romanticism which took so much of Europe by storm through the 19th century was a product of this.

Scotland certainly shared in that cultural romanticism, led so effectively by Sir Walter Scott, helped on its way by Queen Victoria and culminating in the cosy rurality of the kailyard school. The problem, according to Nairn, was that political nationalism did not take root in Scotland as there was no need for it to do so, as nationalism tends to emerge as a reaction against economic disparities caused by differing rates of industrialisation. Scotland, however, shared in the British

imperial success story, it was on to a good thing, and so why rock the boat? And so there was no political brain controlling the cultural romanticism, no agenda to tame it and reel it in when it began to do more harm than good. As a result it was allowed to grow wild, ravishing the cultural landscape like a pernicious weed, resulting in a deformed and neurotic 'sub-culture' – a mindless eclectic assortment of symbols and icons which had no real substance or meaning and no basis in reality.

Nairn's explanation was well received by many commentators at the time who accepted his arguments and formed a powerful anti-tartanry lobby, calling for a re-evaluation of Scotland's cultural landscape. Their cause was boosted by the public horror that greeted *Scotch Myths,* an exhibition held in Edinburgh in 1981. Curated by Murray and Barbara Grigor, it brought together a substantial body of material culture, film and television output and literature that was displayed as a representative manifestation of tartanry and kailyard kitsch. The impact was considerable and it spawned a new generation of reflexivity on a national scale as the followers of the Scotch Myths School began to see evidence of such false icons and invented traditions everywhere they looked. The result was a tendency towards 'the Scottish cringe' – an embarrassed rejection of any cultural form or policy that appeared on the surface to promote the mythical Scotland of tartan and kailyard. It is my belief that this created a substantial barrier to the wider acceptance of folk music and other forms of cultural tradition, for on the surface they seemed just too close to Nairn's double-headed monster for comfort. The folk revival, which began so promisingly in the 1950s and '60s, was not able to break through to the next level of popularity and acceptability despite the high quality of its output. It is beginning to do so now, but its absence from that critical cultural debate is an omission which is only now beginning to be put right.

Of Balmorality

The folk revival actually found itself sandwiched between two periods of cultural reflection and rejection, for a similar debate had been taking place earlier in the 20th century within the context of the launch of the literary renaissance led by Hugh MacDiarmid and the first stirrings of

mainstream political nationalism in the 1920s and '30s. Tartanry had its precursor in the form of 'Balmorality', a term invented by George Scott-Moncreiff who used it as the title of an essay published in 1932 in a volume entitled *Scotland in Quest of Her Youth*.[6] Scott-Moncrieff was later to become a fairly well-established writer on matters of Scottish cultural history covering such themes as historic buildings, Border Abbeys, the history of the catholic faith in Scotland and a volume telling the story of the National Trust for Scotland entitled *Scotland's Dowry*, published in 1956, which rather ironically given his vitriolic early views on the Balmoral phenomenon, included a preface written by the Queen Mother. He was only 22 when he wrote the 'Balmorality' piece, and as one later critic remarked, 'Youth, in this case, was certainly having its Highland Fling'.[7] The essay lamented what had become of Scottish culture and identity for exactly the same reasons as for the Scotch Myths pupils half a century later, and his language would have been quite at home in one of Tom Nairn's polemics, referring to 'the deadening slime of Balmorality, a glutinous compound of hypocrisy, false sentiment, industrialism, ugliness and clammy pseudo-Calvinism'. He went further, complaining that in the Scotland of Victoria

> all the treacheries and sordidness of the clan life and of Scottish history were forgotten; a tartan patchwork quilt was laid over these, for the industrial age was here, an age that considered history as something utterly dead, of use simply as a tickler to replace genuine sentiments that had been jettisoned from life as unpractical or indecent.[8]

'Industrialism' was not a process, not 'industrialisation', but rather a state of mind, an attitude towards the past that failed to see history as diachronic, as flowing, but rather viewed it as 'utterly dead', and therefore ripe for reinvention and sentimentality. And as his 'clammy pseudo calvinism' reference implies, he was no fan of the established church either, considering it to be 'a Defeatist Creed, and until the kirk as it has been is dead Scotland will continue to be the Home of Lost Causes'. It was a sentiment Tom Nairn was to loudly echo a generation later when he quipped that Scotland will only be reborn the day the last minister is strangled with the last copy of the *Sunday Post*!

The few writers who have offered a critique of Scott-Moncrieff's essay have been of varied opinion as to its worth. Writing in the first issue of the *Saltire Review* in April 1954, Walter Keir admitted that its tone had been too harsh, its scope too sweeping and its bias too

blatant, and yet he was still moved to conclude that 'its main outline seems to me to be true'.[9] Ivor Brown, on the other hand, was incensed that such a learned group of cultural commentators as the editorial board of the Saltire Society, publishers of the *Saltire Review*, should be seen to be lending even tacit support to Scott-Moncrieff's views. Brown saw the 'Balmorality' essay as

> but the foolish observations of an emerging pamphleteer... They are only relevant because the title he gave to his essay has stuck in the familiar manner of mud that has been flung and is continually reappearing in the disputations of Scottish intellectuals.[10]

Brown was correct in that the essay is now little known and very rarely quoted or cited, but the term 'Balmorality' itself has lived on and has been firmly planted within the canon of Scottish cultural discourse down to the present day.

Renaissance to Revival

The timing and sentiment of the Balmorality essay places it within the same radical framework as the literary renaissance (in fact the only copy of it I have ever seen is in the Special Collections section of the University of Edinburgh library as part of the collection of books bequested by the estate of Lewis Grassic Gibbon.) Hugh MacDiarmid, for one, spoke in similar tones. Writing under his own name of Chris Grieve in his journalism of the 1920s, it was not so much royal patronage which he detested as cultural mediocrity, a malaise which he saw all around him in his native land. He preferred to be 'whaur extremes meet', an epithet which he certainly lived by, skirting for example with the politics of both right and left. He joined the Communist Party of Great Britain in 1934 having earlier shown a fascination for Mussolini's fascism and calling for Scotland to embrace its own version, although he rejected the whole concept once the Italian leader began to show his true colours of inhumanity.[11] But what he certainly did do was raise questions about the nature of Scotland and her culture in the contemporary world, and was determined to lead from the front in forging a new approach to cultural creativity of a modernist hue. For the rest of his life his politics were left wing and nationalist, and his project involved a sweeping away of what he considered to be the intellectual poverty of the 19th

century cultural romanticism of his beloved nation. Actually, he was no great fan of the 18th century either, refusing to join in the usual chorus of approval of the works of Robert Burns, declaring instead that it must be 'back to Dunbar'.

In his formative years before the Second World War, Hamish Henderson was devouring MacDiarmid's writing, both poetry and prose, and when the time came, his vision of a new and fresh Scottish culture took much inspiration from MacDiarmid's energy and intellect. He saw the revival of a strong and earthy folk culture as a natural bedfellow of the new literature, the two projects together representing a confluence of ideas which allowed the creativity of both the individual artist and the communal folk process to take their place side by side. Henderson's philosophy was derived from the thinking of the Sardinian Marxist, Antonio Gramsci, co-founder of the Italian communist party and a victim of the politics and prisons of Mussolini.[12] To the Partisans, amongst whom Captain Henderson felt at complete ease while serving in the Intelligence Corps in Florence towards the end of the war, Gramsci was a hero and a martyr, having died in prison in Rome in 1937 aged 46. During his 11 years of incarceration he wrote prolifically in a series of notebooks, developing his philosophy to an extent that was later to gain him recognition as one of the key Marxist thinkers of the west (as recognised by Tom Nairn, amongst others). Hamish Henderson undertook a translation of these *Prison Letters* between 1948 and 1951, and was especially intrigued by Gramsci's brief yet penetrating discussion of the concept of folklore.[13]

For this Sardinian, folk culture had been a central part of his early childhood experience. His family may have been impoverished in economic terms, but there were great riches of imagination to be explored in the dark supernatural stories of his home village, orally delivered in the archaic vernacular of the island. Reflecting back on those formative years from his prison cell, he saw folk culture as a conception of life which stood in opposition to official culture: it was subaltern rather than hegemonic. I recall Hamish trying to explain this to us in tutorials, aware, I suspect, that these were words we did not understand. He did so by applying it to the folk revival here in Scotland, a process he would describe as 'Gramsci in action'. The community-based singers he had recorded in various parts of Scotland and had brought to Edinburgh to perform on stage belonged to a subaltern culture, it was 'underground' in the sense

that it was largely hidden from official view and was not part of the hegemonic culture as represented by, for example, the BBC (with which he had a long running battle concerning the absence of folk music from the airwaves). Like Gramsci, Hamish saw the central task of revivalism as being the bridge which could unite these two key elements of society, forging a new and modern culture in the process, one which was rooted in the local but international in outlook and aspiration. It would rid us of our obsession with tartanry and Balmorality, and replace the kailyard fantasies with a much deeper cultural grounding. One of the first

Jessie Murray, Buckie Fishwife and one of the Stars of the first Edinburgh People's Festival Ceilidh, 1951 (Alan Lomax Collection, American Folklife Center, Library of Congress; reproduced courtesy of the Association for Cultural Equity)

ways of achieving this, Hamish explained to us, was to bring these traditional singers to the capital and place them on stage for the world to see and hear what it was missing. The vehicle for this was the establishing in 1951 of the first Edinburgh People's Festival, a 'subaltern' complement to the 'hegemony' of the Edinburgh International Festival, established four years earlier, and perceived by some to be elitist and irrelevant to the people of the city and indeed of the nation. I say it was elitist and irrelevant to some, but not to all, and certainly not to Hamish who warmly welcomed the arrival in Edinburgh of such high quality international art, recognising that it represented a golden chance to also highlight the living tradition of Scotland's folk. As Hamish recalls:

Shortly before Christmas 1950, a meeting was convened by Martin Milligan, a Communist Party member and a man of

great brilliance. He had just returned a short time before from Oxford, where he had studied philosophy, although his philosophy was hardly the establishment kind. The meeting took place at the Scottish Miners' HQ in Rothesay Place, Edinburgh. The central idea behind the discussion was that, far from opposing the 'big' festival, the left should welcome its existence, take advantage of the presence of so many five-star foreign actors, singers, etc. on Scottish soil, and try to present an Edinburgh People's Festival which would complement its senior brother, and in some select zones of cultural enterprise, actually outdo it. And this is in fact what happened.[14]

A committee was set up comprising around 40 people and led by Milligan, and in August the following year they brought together drama by the likes of the Glasgow Unity Theatre performing Joe Corrie's play, *In Time of Strife* and also Joan Littlewood's radical Theatre Workshop which performed Ewan MacColl's anti-nuclear protest play, *Uranium 235*. There were literature readings and lectures, a concert by the Scottish miners, and performances by community choirs. Hamish was charged with organising the folksong event, and with help from Alan Lomax who was collecting here at the time established the Edinburgh People's Festival Ceilidh. Hamish has left us his account of this whole process in print,[15] but I remember how proudly he spoke in class when recalling the initial success of that first night in the Oddfellows Hall in Edinburgh, in late August 1951, and his view that this was the first public flowering of the modern Scottish folk revival, the first testing of the idea of 'Gramsci in action'. There are many kinds of revival, he explained, and this one was one of rediscovery rather than reinvention; a reassessment of what might be considered important and worthwhile in our art, a reminder to ourselves and to the world of what riches were still out there in communities up and down and across this country. So when the likes of Jimmy MacBeath, John Strachan, Jessie Murray, John Burgess, Flora MacNeil and Calum Johnston took to the stage that night, what was happening was a re-awakening, bringing to the nation's attention a content and style and ethos of a cultural form that was far removed from either of the two main platforms of representing Scotland's music which was prevalent at that time: it was neither dressed up in the tartan self parody of the popular music hall nor the satin and silk finery of the classical concert hall. It was rather the bunnet and galluses of the streets and fields, the headscarf and peenie of the quayside and the scullery. Tartanry and Balmorality were being banished.

Hamish Henderson and Alan Lomax (holding microphone) recording student revelry at the University of Edinburgh, 1951 (Alan Lomax Collection, American Folklife Center, Library of Congress; reproduced courtesy of the Association for Cultural Equity)

So what on earth, some may ask, was it doing on an elevated stage in the capital city? Had it gone from headscarf and peenie to fur coat and nae knickers? That process did cause some people unease at the time and indeed later. Perhaps it still does, dressed up in slightly different clothing as we continue to debate the relationships within folk culture of commercialisation versus authenticity, of marketing versus substance, of national stardom versus community participation. But for Hamish, and indeed for Alan Lomax who was busy compiling a 40-disc series of records of the traditional music of the world for Columbia Records, popularisation was not in itself a problem. In fact it was an essential element of the project. Certainly in later years he showed some impatience with some of the weaker revivalist performers who he felt were jumping on the commercial bandwagon without the commitment or understanding needed to do justice to the material and the tradition from which it came, but for those who did understand, he had nothing but encouragement. His branding, from his final sick bed, of Martyn

Bennett's work as 'brave new music' was a case in point. Perhaps he saw that as one marvellous manifestation of what he himself had been all about, of the celebration of the deep well of tradition in the context of what Gramsci had called 'the birth of a new culture among the popular masses, so that the separation between modern culture and popular culture of folklore will disappear'.[16]

Political events, and particularly the spread of McCarthyism to the labour movement in Scotland, doomed the People's Festival to a very short life span, but it has nonetheless enjoyed a rather long afterlife. It lives on today as the Fringe, while the name itself was revived in 2002 by Colin Fox, the new People's Festival taking creative work into many communities throughout the city, including Saughton Prison. And the People's Ceilidh lives on in the genes of all organisations and enterprises concerned with the promotion and development of folk culture in Scotland. There are many of them, doing excellent work: the Feis movement, Feis Rois, Hands Up for Trad, Celtic Connections, Greentrax Recordings, Piping Live, The Traditional Music and Song Association, The Scottish Storytelling Centre and Storytelling Forum, The Traditional Music Forum and a new organisation bringing several of these together, Traditional Arts and Culture Scotland, to name but a few. To what extent that community still shares that same ethos and agenda is open to debate, and of course it operates within a very different political, social and cultural environment from the 1950s, but my own view is that there does remain a strong sense of purpose, of understanding, of appreciation that is in tune with the Henderson philosophy. I hope I have captured something of that in this book.

Not everyone welcomed the folk revival. Hamish Henderson's contention that it followed on naturally from the literary renaissance was not shared, for instance, by its main protagonist, for while Hugh MacDiarmid initially offered support he was later to dismiss it as being of little relevance to the project of cultural renewal. There was no sign of that mood when he accepted the invitation to become Chairman of the People's Festival in 1952, nor indeed when he offered the vote of thanks at that year's Festival Ceilidh which had been held in honour of his 60th birthday:

> One thing that must have struck you, I think, in the programme tonight
> – that is, the extent to which all the items on the programme have been
> correlated to the lives of the common people, to the work of common

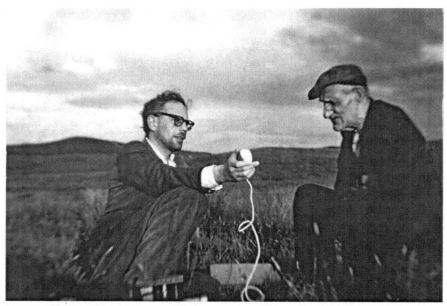

Hamish Henderson interviews the blind traveller and storyteller Ali Dall, Sutherland in 1958
(School of Scottish Studies)

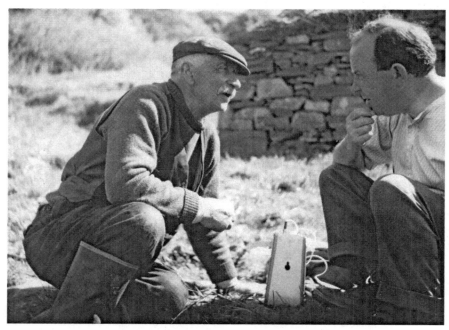

Calum Maclean interviews Angus MacNeill in Moidart, 1959
(School of Scottish Studies)

people, the daily darg of the common people. We are not going to be taken from that – we're not going to be persuaded by the advocates of snob art, that some mystical palaver is better than that which comes from the working life of our own people.[17]

A dozen years later, though, his mood was considerably less cheery when he found himself in combat with Hamish Henderson, the literature scholar David Craig and others in a remarkable exchange of letters in *The Scotsman* in 1964. The 'Folksong Flyting' as it has come to be known, was essentially a debate concerning the relative merits of communally shaped folksong and individually crafted 'art' poetry, and it offers a fascinating insight into the inner workings of the minds of their two respective champions. A flyting is a form of verbal jousting, a traditional 'debate' in which the participants attempt to score points over each other by landing a blow which cannot be convincingly refuted or returned. It is a competition, and like all competitions, the idea is to win. That this was what was happening was recognised by Henderson after a few letters had been published, as he noted in one of his contributions that 'this correspondence is taking on with every letter more and more of the high mottled complexion of a Celtic flyting'.[18] We have to be careful, therefore, in lending too much weight to every statement that was made on either side, as it's a hard task to winnow out the point-scoring chaff from the deeply held seeds of conviction. Nonetheless, it is a crucial contribution to our understanding of the cultural landscape of Scotland in the second half of the 20th century, and its almost total absence from any of the major discussions about that wider landscape is a disservice which has only much more recently begun to be made good.

The letters have been published in full in Alec Finlay's edited volume, *The Armstrong Nose: Selected Letters of Hamish Henderson*,[19] and Finlay's excellent essay in his 'Afterword' to the volume offers a perceptive contextual analysis. I recommend reading them in full, but you can get the gist with just couple of quotes from MacDiarmid's letter of 7th March and Henderson's reply of the 15th. With reference to folksong, MacDiarmid complained

I for one have been bored to death listening to more of it, including the renderings of Jeannie Robertson, Jimmy MacBeath, and others, than I venture to suggest Dr Craig has ever suffered, and I certainly never want to hear any more of it... The demand everywhere today is for

higher and higher intellectual levels. Why should we be concerned then with songs which reflect the educational limitations, the narrow lives, the poor literary abilities, of a peasantry we have happily outgrown?

Henderson came back strongly, accusing his adversary of ignorance, and reminding him of his own earlier support for the folksong cause, and indeed its influence on his own poetry:

> I well remember how keen Mr MacDiarmid was to stress the fruitful interaction from which folksong and art-poetry have always benefited in the Scots literary tradition... There can be no doubt that by denigrating Scots popular poetry now, Mr MacDiarmid is trying to kick away from under his feet one of the ladders on which he rose to greatness.

It is strong, entertaining stuff, and compulsive reading once you get started, and made all the more intriguing when we remember that the two were actually fairly close friends.

Final Thoughts

Much has happened in the half century since those intellectual squabbles appeared in one of our national daily newspapers over a period of four months in 1964. It is hard to imagine such a rigorous debate taking place on that platform today, sadly, but there are of course other vehicles now for such things (although it would take an awful lot of tweets to cover that range of issues in such depth!). The revival went on in its own way, with a few performers breaking through the barriers and making it into our homes via the small screen, Robin Hall and Jimmy MacGregor and The Corries leading the way, while many others produced excellent 'subaltern' new work which was recognised amongst a more limited, but faithful audience, Matt McGinn being one of the best examples.[20] From the following decade, the era of the folk band took off. Those were my own formative years, listening to The Battlefield Band, Ossian, Silly Wizard, The Tannahill Weavers, Jock Tamson's Bairns and others before getting the chance to work myself with many of the artists whose music and song I have discussed in the preceding chapters. Since then, happily, a new generation of artists are being filed under folk, many emerging from such initiatives as the Feis movement in the Highlands and Islands, the National Centre of Excellence in Traditional Music at Plockton High School and the BA in

Scottish Music degree course at the Royal Conservatoire of Scotland (formerly the Royal Scottish Academy of Music and Drama). I've had the pleasure of serving a four-year term as external examiner for the performance element of that course, and have been impressed by the levels of skill and understanding to be seen and heard there. That is testimony to the wisdom prevailing both there and at Plockton of using the key performers of the previous generation to coach them, they in turn providing that link back to the 'tradition bearers' upon whom the whole revival was based. It may not be the kind of intense, direct relationship we have seen that was enjoyed between William MacLean and Calum Piobaire, but it is an essential one all the same. And that, together with less formalised methods of learning outwith the classroom has given us a new community of performers who will continue to take the music in their own direction. Their story will be told one day too.

Coming full circle to the points I raised at the outset, we live in most interesting times, and whatever constitutional outcome emerges in the years ahead, as individuals and as a nation we will continue to contemplate our place in the world. That particular debate is currently being dominated by economics rather than culture, but that will change, as history has shown it always does. At present, it seems to me that Hamish Henderson's plea that folk culture should be allowed to sit comfortably alongside other genres is indeed being acted upon, and our rich cultural ecology here in Scotland is more welcoming of tradition than at any point in my lifetime so far. Folk is cool, yet we must guard against it simply becoming another brand, a musical style worn lightly, floating casually on this liquid society so depressingly outlined by Zygmunt Bauman. But if it continues to be deep, to consider its roots as well as its onward journey, not to be shackled by them but to be nourished and inspired, then it can continue to speak to the world in ways which can help to build a positive globalisation, voicing humanity, voicing Scotland.

Endnotes

Introduction

1 These include such titles as *Liquid Modernity* (2000), *Liquid Life* (2005), *Liquid Fear* (2006), *Liquid Love: on the Frailty of Human Bonds* (2003), *Liquid Times: Living in an Age of Uncertainty* (2007) and *Culture in a Liquid Modern World* (2011), all published by Polity.

2 Creative Scotland, *Investing in Scotland's Creative Future*, Corporate Plan 2011–14, available at www.creativescotland.org.uk.

3 Scottish Government, *Traditional Arts Working Group Report*, 2010.

4 Scottish Government, *Response to the Traditional Arts Working Group Report*, 2010.

5 Donald Smith, *Storytelling Scotland: a Nation in Narrative*, Polygon, Edinburgh, 2001.

Chapter 1

1 Henry Glassie, 'Tradition', *Journal of American Folklore*, 108: 430, Autumn 1995, 395.

2 Dorothy Noyes, 'Tradition: Three Traditions', *Journal of Folklore Research*, 46: 3, 2009, 233–68.

3 E Hobsbawm and T Ranger (eds), *The Invention of Tradition*, Cambridge University Press, 1983.

4 Neil Gunn, 'On Tradition', *The Scots Magazine*, November 1940, 34: 2, 131-34.

5 http://whc.unesco.org/en/list

6 http://www.unesco.org/culture/ich/

7 As of March, 2012.

8 Valdimar Hafstein, public lecture, University of Edinburgh, 2009. His PhD, 'The Making of Intangible Cultural Heritage: Tradition and Authenticity', University of California, Berkely, is one of the leading academic studies of the whole issue of ICH.

9 *Going Further: the National Strategy for Scotland's Museums and Galleries*, published by Museums, Galleries, Scotland, 2012, states 'the sector is collectively responsible to current and future generations for safeguarding Scotland's tangible and intangible cultural heritage' (p 10).

10 For a more in-depth telling of this whole story see Robert Crawford, *The Bard: Robert Burns, a Biography*, Jonathan Cape, 2009.

11 Letter to *The Athenaeum*, No. 982, 22 August 1846.

12 *Essai Sur L'education Intellectuelle*, Lausanne, 1787.

13 Andre-Marie Ampère, *Essai Sur La Philosophie des Sciences*, 1834.

14 James Porter, '"Bring Me the Head of James Macpherson": the Execution of Ossian and the Wellsprings of Folkloristic Discourse'", *Journal of American Folklore* 144:454, Fall 2001, 396-435. This was a special issue focusing on the Ossian controversy.

15 For a forensic examination of his methods, see Tom McKean, 'The Fieldwork Legacy of James Macpherson', *Journal of American Folklore* Vol, 144, No. 454, Fall 2001, 447–63.

16 Richard Dorson, *The British Folklorists: A History*, London: Routledge and Kegan Paul, 1968, 115).

17 Sylvia Robertson and Tony Dilworth, (eds), *Tales from Highland Perthshire: collected by Lady Evelyn Stewart Murray*, Gaelic Text Society, 2009.

18 A research project examining, contextualising and digitising the Carmichael Watson papers is ongoing at the University of Edinburgh. See www.carmichaelwatson.lib.ed.ac.uk

19 Neil Gunn, 'On Magic' in *Landscape to Light*, Whittles Publishing Ltd, 2009, 74–75. The original essay was published in *The Scots Magazine* in 1940, Vol. 33, No. 6.

20 Pat Shuldam-Shaw and Emily B. Lyle (eds), *The Greig-Duncan Folk Song Collection*, Vols 1-8, Mercat Press, Edinburgh for the University of Aberdeen in association with The School of Scottish Studies. See also Katherine Campbell, *Songs from North East Scotland: a Selection for Performers from the Greig-Duncan Folk Song Collection*, John Donald, Edinburgh, 2009.

21 www.tobarandualchais.co.uk

22 Henry Glassie, 'Tradition', *Journal of American Folklore*, 108: 430, Autumn 1995, 396.

23 Glassie, *Passing the Time in Ballymenone*, Indiana University Press, 1995, 11.

24 Glassie, 1995, 37.

Chapter 2

1 John Purser, *Scotland's Music*, Edinburgh, 1992, 82.

2 Popular tradition suggests that King James V was given to touring his kingdom dressed as a beggar. The ballad entitled *The Gaberlunzie Man* is reputed, by some of its singers, to have been inspired by his exploits.

3 'Smuaintean Aonranach' (Solitary Thoughts) is the title of one of the many evangelical hymns that have been popular in Gaelic-speaking Presbyterian areas since the eighteenth century. This song can be heard on the CD, *Music From the Western Isles*, Scottish Tradition 2, School of Scottish Studies. 'The Secret Songs of Silence' is a collection of 'blue' songs gathered by the north-east collector, Peter Buchan (1790–1854).

4 Purser, 1992, 129.

5 Queen Victoria, *Our Life in the Highlands*, Newton Abbot, 1972, 21-3.

6 D Scott, *The Singing Borgeois: Songs of the Drawing Room and Parlour*, Oxford, 1989, 93-94.

7 Quoted in Francis Tolmie, *One Hundred and Five Songs of Occupation from the Western Isles of Scotland*, Llanerch, 1997, vi.

8 Margaret Fay Shaw, *Folksongs and Folklore of South Uist*, London, 1955, 6.

9 Purser, 1992, 127. According to tradition, sleep music is one of the three basic strains of Celtic music, the others being the music of laughter and the music of sorrow.

10 As reported by the Rev. Malcolm MacPhail, Kilmartin, in a letter to the *Oban Times*, October, 1898.

11 David Daiches, *Two Worlds*, Edinburgh, 1987, 5.

12 Douglas,1992, 8.

13 Stuart Eydmann, 'As Common as Blackberries: the first hundred years of the accordion in Scotland, 1830-1930', *Folk Music Journal*, 7, No, 5, 1999, 595-608.

14 John Niles, 'The role of the strong tradition-bearer in the making of an oral culture'. In Porter, J, ed, *Ballads and Boundaries: Narrative Singing in an Intercultural Context* University of California, 1995, 231-240.

15 Tom McKean, *Hebridean Song-Maker: Iain MacNeacail of the Isle of Skye* 1996, 111.

16 J Porter and H Gower, *Jeannie Robertson: Emergent Singer, Transformative Voice*, East Linton, 1995.

17 J Parakilas, 'Classical music as popular music', *Journal of Musicology*, 3, 1984, 1-18.

18 J Sterne, 'Sounds like the Mall of America: programmed music and the architectonics of commercial space', *Ethnomusicology* 41 No. 1 (1977), 22-50.

19 Briggs, A *The Birth of Broadcasting*, Vol. 1, Oxford, 1961.

20 W Donaldson, *The Highland Pipe and Scottish Society, 1750–1950*, East Linton, 2000.

21 Stewart Cruickshank, 'Scottish rock music, 1955–93'. In Scott, P H, ed, *Scotland: A concise cultural history*, Edinburgh, 1993, 191-194.

22 L Holden, *Encyclopedia of Taboos*, Oxford, 2000.

23 H Clarke and E Carnegie, *She Was Aye Workin': Memories of Tenement Women in Edinburgh and Glasgow*, London, 2003.

24 Maclagan MSS, School of Scottish Studies Archives, p7396. Recorded from Miss Maclachlan, Ardrishaig, Argyll. Published in *Tocher*, No. 38, 40.

25 W Gregor, *An Echo of the Olden Time*, London, 1874, 84.

26 Gregor, 1874, 86.

27 Neil Martin, *The Form and Function of Ritual Dialogue in the Marriage Traditions of Celtic-language Cultures*, Lampeter, 2007, 284.

28 Morag MacLeod, 'Rèiteach', *Tocher* 30, 1978, 375-6.

29 Martin, 2007, 225.

30 School of Scottish Studies Archive, SA1961.27.

31 TC Smout, *A Century of the Scottish People, 1830-1950*. London and Glasgow: Fontana Press, 1986, 34.

32 Dr JB Russell, quoted in Smout, 1986, 34.

33 Gregor, 1874, 137.

34 Anne Gordon, *Death is for the Living*. Edinburgh, 1984, 24-25.

35 Gordon, 1984, 9.

36 M Banks, *British Calendar Customs: Scotland*, Vol II, London and Glasgow, 1939, 29.

37 Alexander Carmichael, *Carmina Gadelica: Hymns and Incantations Collected in the Highlands and Islands of Scotland in the Last Century*, Edinburgh, 1992, 94.

38 Rev. J MacDonald, 'Stray Customs and Legends.' In *Transactions of the Gaelic Society of Inverness*, vol XIX, 1893–94, 273.

39 The archives of the School of Scottish Studies, University of Edinburgh, contain many recorded accounts of such activity. See for example, SA1981.79, Finlay Maclean, Lewis; SA1971.43, Donald Alasdair Johnson, South Uist; SA1980.106, Donald MacDonald, Lewis.

40 Captain Basil Hall's 'Journal' (MS), Abbotsford, 1 January 1825, printed in JG Lockart, *Memoirs of the Life of Sir Walter Scott, Bart*, Edinburgh, 1837,

385. The 'host' referred to was Sir Walter Scott.

Chapter 3

1 Neil Gunn, 'Highland Space' in *Landscape to Light*, Whittles Publishing Limited, Dunbeath, 2009, 111.

2 http://www.martynbennett.com/Martyn_Biography.html

3 http://www.martynbennett.com/Album_BothyCulture.html

4 Quoted on Omar Faruk's website, at http://www.omarfaruktekbilek.com/biography.html

5 John MacInnes, 'Sorley Maclean's Hallaig: a note', in *Dùthchas nan Gàidheal: Selected Essays of John MacInnes*, ed. Michael Newton. Edinburgh: Birlinn Limited, 2006, p. 420.

6 Ceolbeg, *Not the Bunnyhop*, Greentrax Recordings, CDTRAX 053; Various Artists, *Steele the Show: the Songs of Davy Steele*, Greentrax Recordings, CDTRAX358.

7 *Hansard*, HC Deb 25 February 1987, vol 3, 253-6.

8 For example, John Foster and Charles Woolfson in *Track Records: the Story of the Caterpillar Occupation*, London, Verso, 1988.

9 For a discussion of this with Adam, see Jennie Renton's interview on the *Textualities* website at http://textualities.net/jennie-renton/adam-mcnaughtan/

10 For this, and a fine representation of Adam McNaughtan's other songs and performances, see the double CD release, *The Words That I Used to Know*, Greentrax Recordings, CDTRAX 195D.

11 On *The Easy Club*, originally released in 1984.

Chapter 4

1 'Childhood's End' can be heard on the Clan Alba double album release, 1995. The lyrics to this, and indeed all Dick Gaughan's songs referred to here, can be found on his website, www.dickgaughan.co.uk.

2 On the album, *Sail On*, CDTRAX 109, 1996.

3 On *Call it Freedom*, CM041, 1988.

4 Gillian Slovo, *Every Secret Thing*, Virago, 1997.

5 www.dickgaughan.co.uk published April 2003.

6 In Donald MacAulay (ed), *Nua-Bhardachd Ghaidhlig, Modern Scottish Gaelic Poems*, Edinburgh, 1976.

7 Drumcorry can be heard on Ceolbeg, *Cairn Water*, Greentrax Recordings, CDTRAX188.

8 School of Scottish Studies, SA1952.23. The word 'bastards' sung here by Hamish was later changed to 'swaddies'.

9 Hamish Henderson, *Elegies for the Dead in Cyrenaica*, Polygon, 2008. The poems were first published in 1948 by John Lehmann Ltd, while the edition given to me by Hamish was that of EUSPB, 1977.

10 If you missed it live, you can see it on DVD from the BBC or see the script, Gregory Burke, *National Theatre of Scotland's Black Watch*, Faber and Faber, 2007.

11 Reproduced on the National Theatre of Scotland website at www. nationaltheatrescotland.com.

12 Davey Anderson, interview on www.nationaltheatrescotland.com.

13 There are at least half a dozen recordings of Jimmy MacBeath singing 'The Gallant Forty-Twa' in the School of Scottish Studies Archives, and these can be heard online at www.tobarandualchais.co.uk. Search under 'Gallant Forty-Twa'.

14 Martyn Bennett, *Glenlyon*, Foot Stompin Records, 2002.

15 School of Scottish Studies, SA1960.139.

Chapter 5

1 As quoted in Maurice Lindsay, *Scotland: an Anthology*, London, 1974, 364.

2 As presented (with glosses) in RDS Jack and PAT Rozendaal eds. *The Mercat Anthology of Early Scottish Literature, 1375–1707*, Mercat Press, Edinburgh, 1997, 136.

3 Derrick Thomson, *An Introduction to Gaelic Poetry*, London, 1974, 36.

4 D Gifford, S Dunnigan and A MacGillivray, eds., *Scottish Literature in English and Scots*, Edinburgh University Press, 2002, 133.

5 Alexander Law, 'Ramsay and the Gentle Shepherd', *Library Review*, 22:5, 247-251, 1970, at 247.

6 Gifford *et al*, 2002, 186

7 Gifford *et al*, 2002, 186.

8 See Robert Crawford, *The Bard: Robert Burns, a Biography*, Jonathan Cape, 2009, 38-43.

9 Barnaby Brown in his notes to the CD, *Dastirum*, featuring the playing of Allan MacDonald, siubhal.com

10 There are many places to find a much more in depth discussion of the history, structure and culture of pibroch, but the Wikipedia entry is, in this case, a very useful starting point, with an excellent range of sources and links provided.

11 Roderick Cannon, 'Gaelic Names of Pibrochs: a Classification', in *Scottish Studies*, 2006.

12 See William Donaldson, *The Highland Pipe and Scottish Society, 1750–1950*, Tuckwell Press, East Linton, 2000, pp. 39-40. Donaldson has also produced an excellent series of pibroch commentaries on the website, www.pipesdrums.com

13 http://www.tobarandualchais.co.uk/fullrecord/78365/1

14 To this day many of the world's top pipers play instruments made by Peter Henderson.

15 Pierre Bourdieu, *Distinction: A Social Critique of the Judgement of Taste*, English Edition, Routledge, 1984.

16 Much of this research appears in *Common Stock*, the journal of the Lowland and Border Bagpipe Society, while one of its office bearers, Pete Stewart, has published two excellent book-length studies, *The Day it Daws: the Lowland Scots Bagpipe and its Music, 1400–1715* and *Welcome Home my Dearie: Piping in the Scottish Lowlands, 1690–1900*.

Chapter 6

1 Alan Riach, *Representing Scotland in Literature, Popular Culture and Iconography: The Masks of the Nation*, Palgrave Macmillan, 2005.

2 Nancy Nicolson discussed this point with me: 'although my accent is always heavily rooted in Caithness colorations, it adapts automatically to where I am and in what role and what company I find myself. The first time taking my intended from Leith to Newton Hill on the Waverley to Wick rail line, he was somewhat bemused to find my accent changing as we travelled North. It had altered markedly by Inverness, and he could hardly recognise the sound of me by Georgemas Junction and Wick!' (personal communication).

3 See, for example, Ailie Munro, *Folk Music Revival in Scotland: the Democratic Muse*, Scottish Cultural Press, Aberdeen, 1996, Neil Rosenberg (ed), *Transforming Tradition: Folk Music Revivals Examined*, University of Illinois Press, 1993 and John Szwed, *The Man Who Recorded the World: a Biography of Alan Lomax*, William Heinemann, 2010.

4 The principal kailyard writers were Ian Maclaren (1850-1907), SR Crockett (1860–1914) and JM Barrie (1860–1937). For a succinct account of the kailyard school, see G Shepherd, 'The Kailyard' in D Gifford, ed. *The History of Scottish Literature*, vol 3, Aberdeen University Press, 1988.

5 Tom Nairn, *The Break-Up of Britain: Crisis and Neo-nationalism*, NLB, 1977.

6 George Scott-Moncrieff, 'Balmorality', in David Thomson (ed), *Scotland in Quest of Her Youth*, Oliver and Boyd, Edinburgh, 1932.

7 Ivor Brown, *Balmoral: the History of a Home*, Collins, 1955: 14.

8 Scott-Moncrieff, 1932: 78.

9 Walter Keir, 'Scottish History and Scottish Fiction' in *Saltire Review*, 1:1, 1954: 29.

10 Ivor Brown, 1955: 14-15.

11 Alan Bold, *MacDiarmid: Christopher Murray Grieve, a Critical Biography*, Paladin Grafton Books, 1990, 169-71.

12 For discussion of Gramsci's influence on Hamish Henderson see Timothy Neat, *Hamish Henderson, a Biography*, vol 2, Polygon, Edinburgh; Corey Gibson, ' "Gramsci in Action": Antonio Gramsci and Hamish Henderson's Folk Revivalism' in E Bort (ed), *Borne on the Carrying Stream: the Legacy of Hamish Henderson*, Grace Note Publications, Ochtertyre, 2010: 239-56; and for a detailed analysis of Gramsci's wider legacy in folklore studies, Diarmuid O Giollain, *Locating Irish Folklore: Tradition, Modernity, Identity*, Cork University Press, 2000: 153-9.

13 Antonio Gramsci, *Prison Letters*, translated and introduced by Hamish Henderson, Pluto Press, 1996.

14 Hamish Henderson, 'The Edinburgh People's Festival, 1951-1954' in E Bort. *'Tis Sixty Years Since: the 1951 People's Festival Ceilidh and the Scottish Folk Revival*, Grace Note Publications, Ochtertyre, 2011: 37.

15 Henderson, 'The Edinburgh People's Festival, 1951–1954' 2011: 35-44.

16 Antonio Gramsci, *Selections from Cultural Writings*, David Forgacs and Geoffrey Nowell-Smith, Laurence and Wishart, 1985: 191 and quoted in Corey Gibson, 2010: 251.

17 Reproduced in *Cencrastus*, 48, 1994: 9 and quoted in Henderson, 2011: 42.

18 Hamish Henderson to *The Scotsman*, 3 April, 1964.

19 Alec Finlay (ed), *The Armstrong Nose: Selected Letters of Hamish Henderson*: Polygon, Edinburgh, 1996.

20 See www.mattmcginn.info for in-depth coverage of McGinn's life and work.

Select Bibliography

Andre-Marie Ampère, *Essai Sur La Philosophie des Sciences*, 1834.

M. Banks, *British Calendar Customs: Scotland*, Vol 2, London and Glasgow, 1939.

Zygmunt Bauman, *Liquid Modernity*, Polity, 2000.

— *Liquid Love: on the Frailty of Human Bonds*, Polity, 2003.

— *Liquid Life*, Polity, 2005.

— *Liquid Fear*, Polity, 2006.

— *Liquid Times: Living in an Age of Uncertainty*, Polity, 2007.

— *Culture in a Liquid Modern World*, Polity, 2011.

Margaret Bennett, *Scottish Customs From the Cradle to the Grave*, Polygon, Edinburgh, 1993.

— *'It's Not the Time You Have...' Notes and Memories of Music Making with Martyn Bennett*, Grace Note Publications, Ochtertyre, 2006.

Craig Beveridge and Ronald Turnbull, *The Eclipse of Scottish Culture: Inferiorism and the Intellectuals*, Polygon, Edinburgh, 1989.

Alan Bold, *MacDiarmid: Christopher Murray Grieve, a Critical Biography*, Paladin Grafton Books, 1990.

Eberhard Bort, (ed), *'Tis Sixty Years Since: the Edinburgh People's Festival Ceilidh and the Scottish Folk Revival*, Grace Note Publications, Ochtertyre, 2011.

— (ed), *Borne on the Carrying Stream: The Legacy of Hamish Henderson*, Grace Note Publications, Ochtertyre, 2010.

Pierre Bourdieu, *Distinction: A Social Critique of the Judgement of Taste*, English Edition, Routledge, 1984.

Asa Briggs, *The Birth of Broadcasting*, Vol 1, Oxford, 1961.

Gregory Burke, *National Theatre of Scotland's Black Watch*, Faber and Faber, 2007.

Katherine Campbell, *Songs from North East Scotland: a Selection for Performers from the Greig-Duncan Folk Song Collection*, John Donald, Edinburgh, 2009.

Alexander Carmichael, *Carmina Gadelica: Hymns and Incantations Collected in the Highlands and Islands of Scotland in the Last Century*, Edinburgh, 1992.

Roderick Cannon, *The Highland Bagpipe and its Music*, Birlinn, Edinburgh, 2008.

— 'Gaelic Names of Pibrochs: a Classification', *Scottish Studies*, 2006.

Hugh Cheape, *Bagpipes: A National Collection of a National Instrument*, NMS Publishing, Edinburgh, 2008.

Helen Clarke and Elizabeth Carnegie, *She Was Aye Workin': Memories of Tenement Women in Edinburgh and Glasgow*, London, 2003.

Ivor Brown, *Balmoral: the History of a Home*, Collins, 1955.

Cairns Craig, *Out of History: Narrative Paradigms in Scottish and British Culture*, Polygon, Edinburgh, 1996.

Robert Crawford, *The Bard: Robert Burns, a Biography*, Jonathan Cape, 2009.

Creative Scotland, *Investing in Scotland's Creative Future*, Corporate Plan 2011–14.

Stewart Cruickshank, 'Scottish rock music, 1955–93', in Scott, PH, ed, *Scotland: A Concise Cultural History*, Edinburgh, 1993, 191-194.

David Daiches, *Two Worlds*, Edinburgh, 1987.
Joshua Dickson (ed), *The Highland Bagpipe: Music, History, Tradition*, Ashgate, 2009.
William Donaldson, *The Highland Pipe and Scottish Society, 1750–1950*, East Linton, 2000.
Richard Dorson, *The British Folklorists: A History*, London: Routledge and Kegan Paul, 1968.
Sheila Douglas, *The Sang's the Thing*, Edinburgh, 1992.
Stuart Eydmann, 'As Common as Blackberries: the first hundred years of the accordion in Scotland, 1830–1930', *Folk Music Journal*, 7:5, 1999, 595-608.
Alec Finlay (ed), *The Armstrong Nose: Selected Letters of Hamish Henderson*: Polygon, Edinburgh, 1996.
John Foster and Charles Woolfson, *Track Records: the Story of the Caterpillar Occupation*, London, Verso, 1988.
D Gifford, S Dunnigan and A MacGillivray, (eds), *Scottish Literature in English and Scots*, Edinburgh University Press, 2002.
Henry Glassie, 'Tradition', *Journal of American Folklore*, 108:430, Autumn 1995.
— *Passing the Time in Ballymenone*, Indiana University Press, 1995.
Anne Gordon, *Death is for the Living*, Edinburgh, 1984.
Ian Green, *From Fuzz to Folk: Trax of My Life*, Luath Press, Edinburgh, 2011.
Walter Gregor, *An Echo of the Olden Time*, London, 1874, 84.
Neil Gunn, *Landscape to Light*, Whittles Publishing Ltd, 2009.
Valdimar Hafstein, 'The Making of Intangible Cultural Heritage: Tradition and Authenticity', Unpublished PhD, University of California, Berkely, 2004.
Euan Hague, 'Nationality and Children's Drawings – Pictures "About Scotland" by Primary School Children in Edinburgh, Scotland and Syracuse, New York State', *Scottish Geographical Journal*, 117 (2), 2001: 77-99.
Hamish Henderson, *Elegies for the Dead in Cyrenaica*, Polygon, Edinburgh, 2008.
— with Alec Finlay (ed), *Alias MacAlias: Writings on Songs, Folk and Literature*, Polygon, Edinburgh, 1992.
— *The Armstrong Nose: Selected Letters of Hamish Henderson*, Polygon, Edinburgh, 1996.
Eric Hobsbawm and Terence Ranger (eds) *The Invention of Tradition*, Cambridge University Press, 1983.
Lynne Holden, *Encyclopedia of Taboos*, Oxford, 2000.
Richard Holloway, *Godless Morality: Keeping Religion Out of Ethics*, Canongate, Edinburgh, 1999.
RDS Jack and PAT Rozendaal (eds), *The Mercat Anthology of Early Scottish Literature, 1375–1707*, Mercat Press, Edinburgh, 1997.
Alexander Law, 'Ramsay and the Gentle Shepherd', *Library Review*, 22:5, 247-251, 1970.
Maurice Lindsay, *Scotland: an Anthology*, London, 1974.
Donald MacAulay, (ed), *Nua-Bhardachd Ghaidhlig, Modern Scottish Gaelic Poems*, Edinburgh, 1976.
Rev. J MacDonald, 'Stray Customs and Legends.' In *Transactions of the Gaelic Society of Inverness*, Vol XIX, 1893-94.
John MacInnes, 'Sorley Maclean's Hallaig: a note', in Michael Newton *(ed)*, *Dùthchas nan Gàidheal: Selected Essays of John MacInnes*, Edinburgh, 2006.

Morag MacLeod, 'Rèiteach', *Tocher* 30, 1978, 375-6.

Tom McKean, *Hebridean Song-Maker: Iain MacNeacail of the Isle of Skye* 1996.

— 'The Fieldwork Legacy of James Macpherson', *Journal of American Folklore*, 144:454, Fall 2001, 447–63.

Neil Martin, *The Form and Function of Ritual Dialogue in the Marriage Traditions of Celtic-language Cultures*, Lampeter, 2007.

Ambrose Merton, Letter to *The Athenaeum*, No. 982, 22 August 1846.

Ailie Munro, *Folk Music Revival in Scotland: the Democratic Muse*, Scottish Cultural Press, Aberdeen, 1996.

Museums, Galleries, Scotland *Going Further: the National Strategy for Scotland's Museums and Galleries*, 2012

Tom Nairn, *The Break-Up of Britain: Crisis and Neo-nationalism*, NLB, 1977.

Timothy Neat, *Hamish Henderson, a Biography;* Vol 1, *The Making of the Poet (1919–1953)*, Polygon, Edinburgh, 2007.

— *Hamish Henderson, a Biography;* 2 *Poetry Becomes People (1952–2002)*, Polygon, Edinburgh, 2009.

John Niles, 'The role of the strong tradition-bearer in the making of an oral culture'. In James Porter (ed), *Ballads and Boundaries: Narrative Singing in an Intercultural Context* University of California, 1995, 231-240.

Dorothy Noyes, 'Tradition: Three Traditions', *Journal of Folklore Research*, 46: 3, 2009, 233–68.

James Parakilas, 'Classical music as popular music', *Journal of Musicology*, 3, 1984, 1-18.

James Porter, '"Bring Me the Head of James Macpherson": the Execution of Ossian and the Wellsprings of Folkloristic Discourse', *Journal of American Folklore* 144:454, Fall 2001, 396-435

— and Hershel Gower, *Jeannie Robertson: Emergent Singer, Transformative Voice*, East Linton, 1995.

John Purser, *Scotland's Music*, Edinburgh,1992.

Queen Victoria, *Our Life in the Highlands*, Newton Abbot, 1972, 21-3.

Alan Riach, *Representing Scotland in Literature, Popular Culture and Iconography: The Masks of the Nation*, Palgrave Macmillan, 2005.

Sylvia Robertson and Tony Dilworth, (eds), *Tales from Highland Perthshire: collected by Lady Evelyn Stewart Murray*, Gaelic Text Society, 2009.

Neil Rosenberg (ed), *Transforming Tradition: Folk Music Revivals Examined*, University of Illinois Press, 1993.

Derek Scott, *The Singing Borgeois: Songs of the Drawing Room and Parlour*, Oxford, 1989.

Scottish Government, *Traditional Arts Working Group Report*, 2010.

Scottish Government, *Response to the Traditional Arts Working Group Report*, 2010.

Gillian Slovo, *Every Secret Thing: My Family, My Country*, Virago Press, 2007.

Francis Tolmie, *One Hundred and Five Songs of Occupation from the Western Isles of Scotland*, Llanerch, 1997.

Margaret Fay Shaw, *Folksongs and Folklore of South Uist*, London, 1955.

Pat Shuldam-Shaw and Emily B. Lyle (eds), *The Greig-Duncan Folk Song Collection*, Vols 1-8, Mercat Press, Edinburgh, for the University of Aberdeen in association with The School of Scottish Studies.

Donald Smith, *Storytelling Scotland: a Nation in Narrative*, Polygon, Edinburgh, 2001.

TC Smout, *A Century of the Scottish People, 1830-1950*. London and Glasgow: Fontana Press, 1986.

Jonathan Sterne, 'Sounds like the Mall of America: programmed music and the architectonics of commercial space', *Ethnomusicology* 41 No. 1, 1977, 22-50.

Pete Stewart, *The Day it Daws: the Lowland Scots Bagpipe and its Music, 1400-1715*.

— *Welcome Home my Dearie: Piping in the Scottish Lowlands, 1690-1900*.

Domhnall Uilleam Stiùbhart (ed), *The Life and Legacy of Alexander Carmichael*, Islands Book Trust, Port of Ness, 2008.

John Szwed, *The Man Who Recorded the World: a Biography of Alan Lomax*, William Heinemann, 2010.

Derrick Thomson, *An Introduction to Gaelic Poetry*, London, 1974.

For regularly updated sources, discographies, links and blogs see Gary West's website at www.garywest.co.uk

Fuzz to Folk: Trax of My Life
Ian Green
ISBN: 978 1 906817 69 5 PBK £14.99

Fiddles & Folk
Wallace Lockhart
ISBN 978 0 946487 38 7 PBK £7.95

An immensely enjoyable read...So poignant in parts and also so very, very funny. In well chosen words Ian tells it exactly as it was in a language we can all relate to and with such brutal honesty and great humour. CELTIC MUSIC RADIO

In *Fuzz to Folk* Ian Green chronicles his life so far, from Nation Service call-up to regular Army Service, to 30 years as a policeman and finally to founder of Greentrax, Scotland's leading traditional music label. Green has played a significant role in the resurgence and vitality of traditional and folk music in Scotland. His inspirational autobiography includes details of his involvement in the careers of Brian McNeill, Dick Gaughan, the McCalmans, Eric Bogle and many others. With Green's unique insight, Fuzz to Folk is an authority on the Scottish folk scene, and a fascinating glimpse into the life of the policeman on the street.

In *Fiddles & Folk*, his companion volume to *Highland Balls and Village Halls*, now acknowledged as a classic on Scottish dancing, Wallace Lockhart meets up with many of the people who have taken Scotland's music around the world and come back singing.

Today people are singing and making music the way the mood takes them. I believe this not only stimulates creativity, but, coming from the heart (or grass roots if you prefer) strengthens the culture.
WALLACE LOCKHART

The Merry Muses of Caledonia
Robert Burns
Edited by James Burke and Sydney Goodsir Smith, with contributions from J DeLancey Ferguson and Valentina Bold, illustrated by Bob Dewar
ISBN 978 1 906307 68 4 HBK £15

Poems, Chiefly in the Scottish Dialect: The Luath Kilmarnock Edition
Robert Burns
With contributions from John Cairney and Clark McGinn, illustrated by Bob Dewar
ISBN 978 1906307 67 7 HBK £15

Lusty in language and subject matter, this is Burns unabashed. Labelled in the 19th century as 'not for maids, ministers or striplings', *The Merry Muses* still has the power to shock and titillate the modern reader. This special edition is enticingly illustrated by Bob Dewar.

One or two poetic bagatelles which the world have not seen, or, perhaps, for obvious reasons, cannot see.
ROBERT BURNS

Poems, Chiefly in the Scottish Dialect was the first collection of poetry produced by Robert Burns. Published in Kilmarnock in July 1786, it contains some of his best known poems including 'The Cotter's Saturday Night', 'To a Mouse', 'The Twa Dogs' and 'To a Mountain Daisy'. The Luath Kilmarnock Edition brings this classic of Scottish literature back into print.

New material includes an introduction by the 'Man Who Played Burns' – author, actor and Burns expert John Cairney – exploring Burns' life and work, especially the origins of the Kilmarnock Edition. Looking to the future of Burns in Scotland and the rest of the world, Clark McGinn, world-renowned Burns Supper speaker, provides an afterword that speaks to Burns' continuing legacy.

Blind Ossian's Fingal: Fragments and Controversy
Compiled by James Macpherson, Introduced and Edited by Allan Burnett and Linda Andersson Burnett
ISBN 978 1906817 55 8 HBK £15

James Macpherson's 18th-century translations of the poetry of Ossian, a third-century Highland bard, were an instant success. These rediscovered Ossianic epics inspired the Romantic movement in Europe, but caused a political storm in Britain at the time and up to recently have been denounced as one of the greatest literary hoaxes of all time.

Editors Allan Burnett and Linda Andersson Burnett take a fresh look at the twists and turns of the Ossian story. This volume includes Fragments of Ancient Poetry and Fingal along with contemporary commentary.

They contain the purest and most animating principles and examples of true honour, courage and discipline, and all the heroic virtues that can possibly exist.
NAPOLEON

Arts of Resistance: Poets, Portraits and Landscapes of Modern Scotland
Alan Riach and Alexander Moffat, with contributions by Linda MacDonald-Lewis
ISBN 978 1 906817 18 3 PBK £16.99

The role of art in the modern world is to challenge and provoke, to resist stagnation and to question complacency. All art, whether poetry, painting or prose, represents and interprets the world. Its purpose is to bring new perspectives to what life can be.
ALEXANDER MOFFAT and ALAN RIACH

... an inspiration, a revelation and education as to the extraordinary richness and organic cohesion of twentieth-century Scottish culture, full of intellectual adventure... a landmark book. TIMES LITERARY SUPPLEMENT

The Whisky Muse: Scotch Whisky in Poem & Song
Robin Laing
ISBN 978 1 906307 44 8 PBK £9.99

Whisky – the water of life, perhaps Scotland's best known contribution to humanity

Muse – goddess of creative endeavour. The Whisky Muse – the spark of inspiration to many of Scotland's great poets and songwriters.

This book is a collection of the best poems and songs, both old and new, on the subject of that great Scottish love, whisky.

This splendid book is necessary reading for anyone interested in whisky and song. It encapsulates Scottish folk culture and the very spirit of Scotland.
Charles MacLean, Editor at Large, WHISKY MAGAZINE.

Great Scottish Speeches
Introduced and Edited by David Torrance
Foreword by Alex Salmond
ISBN 978 1 908373 27 4 PBK £9.99

Some *Great Scottish Speeches* were the result of years of contemplation. Some flourished in heat of the moment. Whatever the background of the ideas expressed, the speeches not only provide a snapshot of their time, but express views that still resonate in Scotland today, whether you agree with the sentiments or not.

Encompassing speeches made by Scots or in Scotland, this carefully selected collection reveals the character of a nation. Themes of religion, independence and socialism cross paths with sporting encouragement, Irish Home Rule and Miss Jean Brodie.

Ranging from the legendary speech of the Caledonian chief Calgagus in 83AD right up to Alex Salmond's election victory in 2007, these are the speeches that created modern Scotland.

… what has not faded is the power of the written and spoken word – as this first-rate collection of Scottish speeches demonstrates.
PRESS AND JOURNAL

100 Favourite Scottish Poems to Read Out Loud
edited by Gordon Jarvie
ISBN 978 1 906307 01 1 PBK £7.99

Stuart McHardy
ISBN 978 1 906817 41 1 PBK £5.99

Poems that roll off the tongue. Poems that trip up the tongue. Poems to shout. Poems to sing. Poems to declaim. Poems that you learned at school. Poems that will stay with you forever.

Do you have a poem off by heart but always get stuck at the second verse? Can your friends and family members recite at the drop of a hat while you only have a vague memory of the poems and songs learned as a child? Or do you just want an aide-memoire to the poems you know and love? This collection includes many popular Scottish poems, from *The Wee Cock Sparra* to *The Four Maries*, *The Wee Kirkcudbright Centipede* to *John Anderson My Jo*; as well as poetry by Sheena Blackhall, Norman MacCaig, Jimmy Copeland, Tom Leonard and many others.

Scots have ample opportunity to let rip with old favourites on Burns Night, St Andrew's Day, or at ceilidhs and festivals. Whatever your choice, this wide-ranging selection will give you and your audience (even if it's only your mirror) hours of pleasure and enjoyment.

The truth is of course that whisky was invented for a single, practical reason – to offset Scotland's weather.

Whether dodging the men of the excise, fighting with government troops or simply indulging in a spot of the national sport of drinking whisky, Scots have long had a true love affair with their favourite amber nectar. In this book, writer and storyteller Stuart McHardy, known to take a dram or ten himself, draws upon the wide range of tales associated with the world's finest tipple, to make you laugh, cry and wonder! Raise your glasses and toast this collection of delightful tales, all inspired by Scotland's finest achievement: whisky.

We see how the amber nectar can help get rid of a pesky giant, why you should never build a house without offering the foundations a dram and how it can bring a man back from the brink of death.

Whisky has a long and colourful history in Scotland, causing riots and easing feuds, and McHardy has gathered together stories which have been passed down through many generations, often over a wee nip. *Tales of Whisky* is a tribute to the Scottish sense of humour and love of fine storytelling.

Luath Press Limited

committed to publishing well written books worth reading

LUATH PRESS takes its name from Robert Burns, whose little collie
Luath (*Gael.*, swift or nimble) tripped up Jean Armour at a wedding
and gave him the chance to speak to the woman who was to be his wife
and the abiding love of his life. Burns called one of the 'Twa Dogs'
Luath after Cuchullin's hunting dog in Ossian's *Fingal*.
Luath Press was established in 1981 in the heart
of Burns country, and is now based a few steps up
the road from Burns' first lodgings on
Edinburgh's Royal Mile. Luath offers you
distinctive writing with a hint of
unexpected pleasures.
Most bookshops in the UK, the US, Canada,
Australia, New Zealand and parts of Europe,
either carry our books in stock or can order them
for you. To order direct from us, please send
a £sterling cheque, postal order, international
money order or your credit card details (number,
address of cardholder and expiry date) to us at
the address below. Please add post and packing as
follows: UK – £1.00 per delivery address; overseas
surface mail – £2.50 per delivery address; overseas
airmail – £3.50 for the first book to each delivery address, plus £1.00
for each additional book by airmail to the same address. If your order is
a gift, we will happily enclose your card or message at no extra charge.

Luath Press Limited
543/2 Castlehill
The Royal Mile
Edinburgh EH1 2ND
Scotland
Telephone: +44 (0)131 225 4326 (24 hours)
Fax: +44 (0)131 225 4324
email: sales@luath. co.uk
Website: www. luath.co.uk